For

Helen With congratulations
for her academic
freedom

Best Wishes for an old
fashioned Christmas
in this book's old fashioned
format

Russel

Dec 1959

THE WORLD OF

James McNeill Whistler

BY HORACE GREGORY

Amy Lowell: Portrait of the Poet in Her Time. 1958

THE WORLD OF
James McNeill Whistler

by

HORACE GREGORY

"It takes a long time for a man to look like his portrait."
—John Singer Sargent quoting James McNeill Whistler

THOMAS NELSON & SONS

Edinburgh　　NEW YORK　　*Toronto*

THIS BOOK IS INSCRIBED TO

Joanna and Howell Ziegler

 Note

For encouragement in the writing of the following pages I am deeply indebted to Henry Allen Moe of the Guggenheim Foundation from which I received a grant; to John and Ruth Stephan, to Dr. Frank Millett, to Sir John Rothenstein, to William Rubin, to James Johnson Sweeney.

For the last draft of the book I am grateful for a translation of a passage in the *Goncourt Journals* made by Patrick Bolton Gregory, for the understanding and thoughtfulness of my editor, Gorham Munson, for the assistance of officials in the following institutions: The Freer Gallery of Art (Washington, D.C.), the Frick Museum (New York), The New York Public Library, The Library of Congress (Washington, D.C.), The British Museum (London), The Tate Gallery (London), the University of Glasgow (Scotland).

My thanks also to New Directions for permission to quote on page 233 lines from Ezra Pound's "To Whistler, American," from *Personae,* copyright 1926 by Ezra Pound.

H. G.

Author's Foreword

This book does not pretend to be a definitive biography of James McNeill Whistler. It is rather an interpretation of his life and art. Some readers may complain that I have not recited all the Whistler anecdotes of which there are so many, yet it is my belief that very few have improved with age.

The legend of his showmanship still tends to overshadow Whistler, "the serious artist," who in his generation made enduring contributions toward an appreciation of Oriental art. His work became an influence that survives today. In retrospect and in relationship to contemporary painting, his work, however slight and tenuous it may seem, can be recognized as more American and more "modern" than it seemed to be twenty years ago. It is to be hoped that "the serious artist" in Whistler will gain another hearing.

In respect to Whistler's genius one should not confuse solemnity with seriousness. He was never solemn. However improvident he was, however lavish he became in the spending of his energy or his creditors' money, he could never afford the luxury of being dull. He was both gallant and courageous, and as someone said, requoting a remark made by Samuel Johnson, "Where there is no courage, no other virtue can survive—except by accident."

<div align="right">H. G.</div>

Palisades, N. Y.
May 1, 1959

Contents

List of Illustrations

THE WORLD OF

James McNeill Whistler

Prologue

ON the last Monday of November, 1878, a dark-eyed, slender, middle-aged American made his presence felt in the dimly lit chamber of the Exchequer Court, Westminster Hall, London. The American was James Abbott McNeill Whistler, and he announced from the witness box that he, the plaintiff, in the libel suit of Whistler vs Ruskin, had been born in Russia in the city of St. Petersburg, a statement which was literally untrue. He went on to say that he had spent ten or twelve years in St. Petersburg and that his father had been a major in the United States Army. The latter statements had a greater measure of factual truth and they supported the impression that he so artfully created in the minds of London jurors who had been called upon to decide difficult questions of morality and art in a crowded courtroom.

The famous trial which was commented on at length in the London newspapers had also caught the attention of another American who had taken up residence in London. He was Henry James, and through a friendly arrangement with William Godkin in New York he had agreed to write a series of unsigned articles for Godkin's new weekly, *The Nation*. James was in his middle thirties, an age at which the gifted writer, if he happens to be writing criticism, is inclined to take a top-lofty and acid view of the scene before his eyes. He was nine years younger than the American in the witness-box; his greater distinction and his fame were yet to come. He had written three impressive novels and a memorable long short story, "Daisy Miller"; his celebrity was as yet unformed; he was as critical of other Americans in Europe as he was of Europeans who preyed upon American innocence and idealism.

The occasion of Whistler bringing suit against John Ruskin for

saying in print that the artist had flung a pot of paint in the public's face was appropriate for a neat measure of James's acidity. His own appearance either in Bond Street or Piccadilly was not remarkable; he was bearded, square-shouldered and correctly, decorously dressed. His manner was brisk, yet stolid, and one that stood in contrast to Whistler's dark cloak, short, light step and glittering monocle. In his own way James was no less aggressive, but the distinction he sought was of a different order. His manner was in keeping with the intent stare from his blue eyes and the self-conscious pauses in his speech. It had been his choice to write anonymously his London notes on arts and letters for Godkin's New York periodical.

James regarded with a dubious air the publicity that his fellow American had welcomed. His etchings, James thought, were good, but his productions (by which he meant Whistler's paintings) were very eccentric and imperfect. By praising Whistler's etchings, James ventured what was then a safe opinion, and he let fall the larger portion of his acid on the progress of the two-day trial, in which a Titian was mistaken for one of Whistler's canvases, on the judge, the attorney general, the witnesses, the jurors: "If it had taken place in some Western American town," he wrote, "it would have been called provincial and barbarous; it would have been cited as an incident of low civilization."

Whistler had entered, midway in his career, a precarious and even dangerous notoriety. He had set himself apart from the English painters who may have rented ill-kept and dusty studios in London but also maintained luxurious homes in the suburbs and the country. They were of a world, despite romantic irregularities and shreds of gossip, that Victorian England regarded with an affection that was not unmixed with moral solicitude. To the half-amused and slightly skeptical British public that cared nothing about art but read the daily papers, Whistler's small figure, his dark skin, his brilliant dark eyes gave the general impression that he was an Italian, the living archetype of the Italian villain in Victorian fiction. It was from this majority public that the jury was drawn, and the obvious question before the court and jury was: How could such a foreigner be taken seriously?

In a court chamber so dark that no painting could be shown intelligently to any juror, Whistler did well to stress an exotic foreign

origin. Since Ruskin's charge against him concerned the validity of his art Whistler chose St. Petersburg, where he first went to art school, as his place of birth. In this particular courtroom the literal fact that he was born July 10, 1834, in Lowell, Massachusetts, was irrelevant to the origins of his painting. His life as a painter was on trial in court. He was neither the coxcomb nor the cockney that Ruskin had called him. If the origins of his art were urban, they were urban in the continental European sense, well removed from the immediate associations that were either British or American; they were of St. Petersburg, Paris and Japan. The eccentricities of Whistler's appearance in court were not those of the London bohemian; he was neither ill-washed nor shaggy. The whiteness of his freshly laundered linen, the nearly military cut of his blue-serge jacket resembled the uniform of one who was captain of a yacht. He had already made the point that his father had been a major in the Army, which implied that Whistler, the artist, would not speak solely in terms of artistic nonsense; his dress implied the standard, if not the weight, of military precision behind it.

As for being an American, Whistler also disassociated himself from the kind of American who had so recently caught up and held the enthusiasm of London society. That kind of American was Joaquin Miller, the poet, the Bard of the Sierras, who delighted his London hostesses by wearing ten-gallon hats, high-heeled boots, pistols and flowing hair. On his visit to London Miller looked as though he had stepped out of a genre painting of the Wild West as Holman Hunt, one of John Ruskin's highly favored Pre-Raphaelites, would have imagined it to be. Miller was what the British public, even in literate circles, anticipated of American looks and manners; he was entertaining in a way that Whistler was not. He could be readily patronized and easily forgotten.

From the darkened chambers of the Exchequer Court Whistler's inspiration came when the Attorney General referred directly to the painting that had been the object of Ruskin's critical remarks:

"And that was the labor for which you asked 200 guineas?" said the Attorney General.

"No, it was for the knowledge gained through a lifetime."

As Whistler spoke, the courtroom felt, rather than understood, the shocking vitality of truth behind the histrionic manner of the dark

little man in the witness box. Something quite unamusing was being said and in it was an appeal to human feeling and experience, something beyond the troublesome, abstract question, "What is art?" It was then that the sharp, military accents of his speech held their authority; yet even then, at the moment when his sincerity was felt by the jurors and the court, Whistler's candor was of the kind that fosters legend. The jurors then believed that the heritage of fighting was in his blood, which was something they could understand. The truth of what the little man had said carried authority to those who were certain of almost nothing else that had been told them in the progress of the trial.

Whistler, who had instinctively recalled at a crucial moment that his origins in respect to art had begun in St. Petersburg, might well have said, if his hearers could have understood him, that he had been cradled in The Hermitage and that he had learned to walk upright by strolling through the mauve and green corridors of the Catherine Palace. Nor did it lack significance that the *Arrangement in Gray and Black,* the well-known portrait of his mother, had been exhibited at the trial. It was she as well as his father who had aided his "knowledge gained through a lifetime" by guiding him through the gardens of Tsarskoe Selo, and she who had pointed out to him the beauties of the Chinese Room of the Catherine Palace, the branches of cherry blossoms on its walls and delicate sprays of Oriental ferns and grasses. Was it that knowledge that many years later gave Whistler in Paris the inspiration to find examples for his art in Japanese prints? This was a question that could not be raised in the Exchequer Court. Yet the mention of St. Petersburg, the most Oriental of all North European cities, held an echo of magic that could not be denied. Something very like an appeal to British "sporting instinct" had been aroused. The son of an officer in the United States Army had proved that he did not fall into the usual classification of a coxcomb or a cockney. So far then a fragment of truth in an obscure situation had come to light and a fragmentary token of victory, one farthing, was given to Whistler by order of the court. This was, to say the least, a singular and minimum token of victory over the most persuasive of Victorian moral critics, John Ruskin.

I

FACTS concerning the origins of Whistler's paternal ancestors are obscure. In that highly unreliable but entertaining work, Aubrey's *Brief Lives,* a Dr. Daniel Whistler (1619–84), Fellow of the Royal College of Physicians, London, was the indirect cause of a fellow mathematician's death. He entertained a certain Dr. Pell so lavishly with food and drink that the results, according to Aubrey, were "the cause of shortening his daies." Whistler made no claims to being descended from Dr. Whistler or from the many English Whistlers who can be traced back to the Norman conquest, but insisted that his grandfather, John Whistler, had been born in Ireland. It is probably true that he was, and his story, as it was retold by his son and grandson, falls into the romantic pattern of their lives. It was what they wished to believe.

John Whistler ran away from his home in Ireland to England in 1775 or 1776 and enlisted in the British Army. He had happened to join a regiment that was under the command of a Sir Kensington Whistler. That gentleman was, perhaps, a relative, and it was said that he could not tolerate the disgrace of having a foot soldier who bore his name in his own regiment. He therefore transferred John to another regiment, and the young man was sent overseas to be one of those who reinforced General Burgoyne's troops in America. John Whistler's new regiment, after landing in Canada, arrived at Saratoga in time to surrender with Burgoyne.

What John Whistler did as a prisoner of the Americans is not known, but the great probability is that, in being shifted with other prisoners from camp to camp and in being sometimes on parole, he had a chance to make brief tours of Long Island, Pennsylvania, and New Jersey. He was probably underfed and underclothed in winter.

In all likelihood his visit to the New World lasted until Cornwallis surrendered at Yorktown in October of 1781. He went back to England in an exchange of prisoners, and with a show of initiative worthy of his grandson, he eloped with Anna, daughter of a Sir Edward Bishop, and then returned to America.

It is clear that John Whistler regarded soldiering as his profession, for after making his home in Hagerstown, Maryland, he enlisted in the United States Army; he assisted in the building of Forts Wayne and Dearborn. And at Fort Wayne in 1800 his son, George Washington Whistler, the father of the artist, was born. John Whistler served in the War of 1812 and received the brevet rank of Major; he lived in Kentucky for a few years, and when he retired from the Army in 1815, he moved to Bellefontaine, Missouri, where he died in 1817. Seventy years later, James McNeill Whistler spoke of being both Irish and a Southerner at heart. He also said that he had a prenatal interest in Chicago (since the city was built on the site of Fort Dearborn). This claim always amused Whistler's guests in London.

John Whistler's nomadic life was a precedent for the adventurous path of his son George's career in military engineering. From Newport, Kentucky, at the age of fourteen George Whistler was appointed to the recently revived Military Academy at West Point. The Academy had been reorganized by Congress in 1813, for the need to do so had become imperative. A report read to Congress revealed that cadets ranging in ages from ten to thirty-four had been admitted; some became officers in four months while others enjoyed the status of being cadets for a period of six years; some were maimed, others were married and some were totally unfit to carry arms. Despite this unhappy report of West Point's cadets, a tradition of training in engineering had taken root in an environment described as one of "idleness, dissipation and irreligion." The institution could be salvaged and it was. Colonel Joseph G. Swift was appointed superintendent; he had been West Point's first graduate and had an excellent reputation as an engineer. When George Whistler came from Kentucky to West Point, it housed a promising school of engineering and a general reformation in discipline had begun.

Although discipline had been reinforced at West Point, the atmosphere of the Academy on the Hudson more closely resembled a boy's preparatory school than a college. A pretty girl, Mary Swift,

niece of Colonel Swift and daughter of Dr. Foster Swift, the Academy's surgeon, was the belle of the campus. Cadets were appointed from the South and they combined the liveliness of Scotch-Irish ancestry with the sentimental graces of colonial plantation society. Into this circle where he felt very much at home stepped George Whistler. He had good looks and social gifts of his own; he could draw and paint; his attentions delighted Mary Swift; and he had earned the nickname of "Pipes" because he played popular airs upon a flute. The scene was set for romantic attachments and lasting friendships. One day in punishment for a mild infringement of military discipline George Whistler was made to face the parade grounds of West Point's campus astride a cannon as though it were a rocking horse. As he saw Mary Swift approaching, he whipped out his pocket handkerchief, and earnestly, as though he had just assumed a special duty, he began to polish the gun. Only a well-poised and attractive boy could have carried off this bit of pantomime successfully, and from his seat on a cannon George Whistler became the sentimental hero of West Point. His quick wits endeared him to his superior officers and instructors; he had proved himself fit to stand beside the superintendent's niece, the belle of West Point. His gifts of inventiveness, of making the best of an embarrassing situation, were of greater importance than being head of his class (which he was not) in mathematics.

George Whistler was an able if unconventional student of engineering and he could be trusted to face what seemed impossible to others with a boyish grin and manly hardihood. Colonel Swift approved of him; he married the Colonel's niece, and was given an instructorship at West Point which he did not hold long because he preferred a more active test of his abilities in the United States Army. Under orders from the Army he was sent out at the head of a company to fix the boundary line between the United States and Canada. He accomplished his assignment at fifty degrees below zero in a wilderness of rivers, lakes and swamps. This was the kind of work that he enjoyed, and it also showed the kind of ability that Colonel Swift respected.

After he had set the affairs of West Point in order, Colonel Swift was at liberty to act as consulting engineer for privately owned industries. In this profession he was joined by another West Point

graduate, William Gibbs McNeill of North Carolina. McNeill, Swift and George Whistler became close friends; their professional interests were the same; the women in their families moved in the same circles and McNeill's sister, Anna Mathilda, had become a intimate friend of George Whistler's young wife, Mary. Among Army engineers who were encouraged by the Army to enter railroad engineering (since lack of wars released them from military duty), the best-known were of Scotch-Irish ancestry and from the South. The Scotch-Irish engineers in the United States kept in touch with parallel developments in their profession in Scotland and the north of England, and with West Point as a center for training in civil as well as military engineering, they knew one another and furthered each other's careers. A meeting of United States Army engineers, released for the advancement of civil engineering in their adopted country, was like a gathering of the clans.

In 1833, when he resigned from the Army, George Whistler held the rank of Major and had behind him a professional record in railroad engineering. He had been employed by several railroads, including the Baltimore and Ohio; he was well known by locomotive manufacturers, including the Winans of Baltimore. In 1828 he had been sent to London to consult with British railroad engineers. Major Whistler was a young man who was listened to and admired, but it was clear that he had no Yankee shrewdness in engineering as a business; he enjoyed solving technical problems, problems of management and of cutting roads through difficult terrain, yet he could not make his employers feel that his interests and theirs were one. His appointments were of short duration, which suited his lighthearted, restless temperament. For some few years Baltimore, Maryland, was his headquarters; a half century later, his son, the artist, led some of his friends into thinking that Baltimore was his birthplace (and these were the moments when James McNeill Whistler felt patriotic about the South).

At home Major Whistler had the air of being a charming guest rather than the head of a family. His pretty little wife had given him three children; George, Deborah, and Joseph, and McNeill's sister, Anna Mathilda, hovered in the background as though she were the children's aunt, always willing to nurse them back to health when they fell ill. Whenever the Major spent a few days at home,

the occasion was like a holiday: guests were called in, the Major played his flute, his wife played hostess—and the songs were usually light and sentimental airs of Scotch or Irish origin.

In the South the musical evening at home was in high fashion and the Whistler-Swift-McNeill household followed it. Thomas Moore, the Irish poet, had been a welcome guest in London drawing rooms where he sang as prettily as a tamed bird his Irish melodies. He made a visit to the United States and wealthy families in Charleston, Baltimore and Richmond had him repeat his London successes in their drawing rooms; everyone was pleased, including the flattered and temporarily enriched poet. A musical evening at the Whistlers, following in spirit the performances of Thomas Moore, created an atmosphere of gaily inspired innocence and charm. It was Major Whistler's concession to the joys of Southern domesticity and it also showed the side of his character that resembled the kind of "artistic" temperament and sensibility made famous by his son. At the age of thirteen he had taken a precocious boy's delight in painting a small portrait of his mother which was in tribute to her (who had fifteen children) and for his own children to admire. The shadows that crossed the Whistler threshold were slight enough, yet they were there: one was the Major's lack of cleverness in handling money, which his growing celebrity half-concealed; the other was his restlessness, which was the concern of his good friends, Colonel Swift and William Gibbs McNeill.

The death of his young wife in 1827 brought none but superficial changes in his household. Anna Mathilda McNeill had nursed Mary Whistler through her last illness and in taking charge of the children had stepped into a position of matronly authority.

Within a short time she married Major Whistler and the marriage meant that the musical evenings were resumed.

The year after the Major's retirement from the Army, in 1834, he had received the appointment of engineer of locks and canals at Lowell, Massachusetts, where his first son by Anna Whistler was born. That son was named James Abbott Whistler. His first and middle names came from his father's sister, who had married James Abbott of Detroit. The family remained at Lowell for six years, and during that period the Major's friends feared that the panic of 1837 would cause a downward curve in his career; the times were hard

and the Major's optimism was wearing thin. His latest venture, which was a position with the Western Railroad of Massachusetts, seemed to lack promise. He stayed briefly in Springfield and then moved his family into a pleasant little house in Stonington, Connecticut. It was at Stonington, with the advice of Colonel Swift and William Gibbs McNeill, that the Major listened to an invitation from the Tsar of Russia.

Tsar Nicholas I of Russia thought of himself as a benevolent, progressive ruler of all the Russias, and he wished to build a railroad between St. Petersburg and Moscow which would be proof to Europe that neither he nor the Empire he ruled had dropped behind the times. In St. Petersburg news of his intentions spread throughout court circles. They reached the ears of the Envoy-Extraordinary from the United States, Colonel Charles Stewart Todd of Kentucky, a man of easy address, who, when he looked at himself in the glass, fancied he resembled Louis Phillipe of France and he enjoyed the view. After he had returned from Europe, one of the best of his after-dinner speeches included an account of how when he had stepped out of a cab in Paris he had been mistaken for the bland, bewildered monarch. When Colonel Todd, who had a politician's memory, heard of the Tsar's wish to build the St. Petersburg-Moscow railroad, he remembered his friend, Major John Whistler, and recalled that his son, George, had been appointed to West Point from Kentucky. He also remembered that George Whistler had risen to the rank of major and that he had become a promising railroad engineer. Colonel Todd was among those happy souls who are never backward in lightly giving gratuitous advice; he recommended Major George Whistler's services to the Tsar's advisers. The knowledge that Major Whistler received his training at West Point and in the United States Army increased his prestige to members of the Tsar's commission on the building of railroads. Most of the Tsar's advisers had minds of military cut; his commission on railroads and the Tsar saw themselves as heirs of the Prussian Frederick the Great, Peter the Great, the builder of St. Petersburg, and Nicholas's father, Tsar Paul; their ideas of progress were in terms of military eclat.

In 1841 Colonel Melnikov and Colonel Kraft, both members of

the Tsar's railroad commission, were dispatched to the United States. On their visit to Baltimore, where the Winans' locomotive industries were doing well, again they heard of Major Whistler, and they interviewed him at his home in Stonington. They also saw Joseph Swift who had been promoted to the rank of General, and Brodisco, the Russian Minister to Washington. Both Swift and Brodisco negotiated the terms of their offer to Major Whistler which included a salary of twelve thousand dollars a year. Before closing negotiations, General Swift was assured that the salary would provide decent living quarters in St. Petersburg and that the post itself as director of the building of the Tsar's railroad would increase Major Whistler's prestige in the United States. With the understanding that his family left behind in Stonington was to follow him a year later, Major Whistler arrived in St. Petersburg in the autumn of 1842.

Through his father's career with its touch of genius, with its changes of place, with its gallantries and its romantic sentiment, the seeds of James Abbott McNeill Whistler's romantic temperament had taken root. In his own right Major Whistler was an "original," and an "original" in his profession. But what of the McNeill side of the family history? At sixteen Whistler added McNeill to the Abbott in his name; it brought attention to the Scotch side of his ancestry, for the McNeills descended from the McNeills of Skye, and were proud of that heritage. Another and obvious reason was the acknowledged influence of his mother upon his life. James's dark-complexion, foreign air came from his McNeill grandmother, whose boyish, unfeminine good looks overshadowed the charms of her daughters; she looked strange and James looked like her. James's mother, in the presence of her mother, her sisters, her husband, her husband's first wife, Mary Swift, and her son James, always considered herself sternly, virtuously plain. Among the Whistlers, the Swifts, the McNeills, Anna Mathilda sought out the corners of a room and sat with a sewing basket in her lap or at a writing table. Like her mother, she too was small and dark. Quietly she stepped into her Episcopal church duties and into sick rooms of friends and relatives. Her father had been a successful physician, and she felt it her duty to be a consoling and efficient nurse. Her Episcopal faith

had a dark Calvinistic, almost contradictory strain within it, and a few of her friends spoke of her as "one of the saints upon earth." If she had had executive ability and a drive to power, she might well have been close in spirit to her contemporary, Florence Nightingale. She had that mysterious something that the nineteenth century called "strength of character," yet she was too feminine to assert it openly; she had always been too shy, too much reserved. Beneath the surface of her external calm, her air of resignation, she was as romantic as any Southern lady of her day; in her retreats to the corner of a room, she carried with her the novels of Sir Walter Scott and James Fenimore Cooper. She brought up Mary Swift's children and her own on readings of the Bible, yet she did not resist the temptation to enjoy Prescott's *Conquest of Peru,* which was the kind of reading that appealed to her love of faraway, exotic places, that gave her something in common with her adventurous husband—and she was as impractical as he in money matters. She worshipped Major Whistler with the fervor of Rebecca's nursing of Ivanhoe, and her marriage to him, as if by a miracle, had given her the position of Rowena.

Anna Mathilda had never competed openly with the first Mrs. Whistler. Mary Swift had gone to dances and the theatre while Anna Mathilda read tracts recommended by her pastor, and went to bed early. If she stayed up late reading the novels of Sir Walter Scott it was in the sick room of a friend or at a sick child's bedside in the nursery. Her devotion to the sick was not always without reward to the inward-looking romantic side of her character.

Her first son, James, was the object of her maternal care. From the day of his birth, he was readily subject to bronchial infections and remained so all his life, and yet he was also the center of whatever lightheartedness her stern, somewhat melancholy temperament possessed. He was so much a McNeill in looks and so much like the Major in gaiety of spirit that she could not resist his intentions to have his own way. Whatever James lacked in discipline, that lack was compensated for in George, her stepson, and in her younger son, William. The presence of James's cheerfulness was her relief from great as well as minor anxieties. Nursing was her pride, yet the Whistler family suffered several deaths: first Mary Swift's son, Joseph, then three sons of her own, all dead in infancy and child-

hood as though the angry God of Calvinism had pierced the veils of her calm Episcopal belief. Her household duties were never a pleasure to her and she felt dependent upon the advice and care of her servant, Mary. James, whom the Major agreed was beautiful enough "to make Sir Joshua Reynolds come out of his grave to paint him asleep," was one to whom she could turn for admiration and amusement.

James was quick and active, yet anything but robust; the child liked to draw and frequent colds kept him indoors with paper and pencil. The Major never forgot his early wish to be an artist and that at West Point he stood at the head of his class in drawing. The Major and his wife could not be called fatuous parents. He was too Byronic in his domestic attitudes, too close to believing "Love in a man's life is a thing apart, 'tis a woman's whole existence," and Anna Mathilda was much too reserved to indulge in overt displays of maternal affection, yet both were more than amused by the child's facility in sketching, and it is probable that their approval of it had more encouragement of James's bent toward being an artist than they realized. The Major and his wife felt with reason that they were "cultivated" people; not many a railroad engineer, however brilliant he may have been, would see his infant son as a portrait by Sir Joshua Reynolds, and then have his wife accept the remark as part of easy, almost casual, domestic conversation. She thought of it as a pretty compliment and wrote it down in her journal.

Before leaving for St. Petersburg, Anna Mathilda had promised her mother to keep a journal of her experiences in Russia; the journal would take the place of writing long letters home. In writing it she would have her mother's image before her; and if she felt strange in a distant country that image would reassure her that all was well. But she also felt the importance of the Major's commission, and in the writing of her journal, her style took on some of stiffness, some of the proprieties of Rowena's speeches in *Ivanhoe;* it is not improbable that she thought of posterity's as well as her mother's eye. After all, her journey to Russia could hope to be a footnote to history.

MAJOR Whistler left no account of what he saw in St. Petersburg when he arrived there in the autumn of 1842. He and his wife had read the memoirs of de Custine and were prepared to visit a new world. What he saw was the most remarkable city in Northern Europe, the Russian "window" to Europe, built by Peter the Great on the marshes that flanked both sides of the river Neva and was a man-made city, not unlike Venice far to the south in Italy. It had been built to glorify Peter's ambitions to be a European as well as Asiatic Tsar, and the image that he carried in his mind was the French Sun King's creation at Versailles. That image never left the minds of his descendants, including Elizabeth, Catherine, Alexander I down to Nicholas I, but it had gone through, even in Peter's day, an extraordinary mutation: in the smaller buildings there were the intimacies of Dutch interiors and German decorations, in the larger buildings the scope and magnitude of French and Italian design. In the hundred years between Peter's day and Nicholas I, Venetian architects had given St. Petersburg the air of being a larger, more austere, snow-swept, sea-lashed Venice on the Baltic; the Neva was its Grand Canal; its squares were enlarged versions of San Marco. The Great Cascade of Peterhof, piled high with neo-classical statuary and water, flowing over heights of hewn and carved stone, outshone the fountains at Versailles. Major Whistler rented apartments on the Neva which were at short walking distance from white and stone-paved Theatre Street, which had been recently laid out by Rossi, a street of Romanesque arches and neoclassical façades; it was the haunt of French, German, British and American embassies.

On his arrival he was ushered into the presence of the Tsar.

Nicholas was tall, sallow, handsome and inclined to fat. De Custine remarked that he wore corsets to preserve a youthful figure under a smartly cut military uniform. The Tsar was affable; as Grand Duke he had visited London and on his visit flattered himself that he knew more than most crowned heads of Europe about the arts and sciences; he could make himself understood in English and, since French had been the language of the Russian court for a hundred years, spoke French with ease. The Major's usual optimism responded quickly to the Tsar's air of official cordiality. The Major, as well as other American visitors to St. Petersburg, liked the Tsar. They liked his habit of walking the streets of St. Petersburg wearing a broad-brimmed black felt hat and a dark cloak loosely thrown across his shoulders; he had the external appearance of being democratic, and he seemed to be direct and efficient. He was said to like cleanliness and to forbid the smoking of cigars and pipes on the streets of the city—and this was the side of his character that he showed to Major Whistler. He briskly unrolled a map and drew a straight line between St. Petersburg and Moscow; the line represented the railroad. Cost in roubles or in time, effort, skill or human life of a route through difficult terrain was of no importance. Major Whistler was instructed to do the nearly impossible; it was what he had come to do and he took his orders.

Major Whistler's apartments overlooking the Neva were large furnished rooms, and since they were awaiting the arrival of his family, extremely large and empty. He hired a German footman, and also took under his protection an unfortunate Russian woman and her small son, whom, in the absence of his own children, he informally adopted. As in America he was infrequently at home. His assignments from the Tsar were on the roads between Moscow and St. Petersburg rather than sitting at a writing desk in his apartment. He was far too industriously employed to make many new friends in St. Petersburg.

The Major's plans for the Tsar's railroad went ahead so well that the Tsar's advisers could find no fault with him, and if the Major objected to the hardships endured by mujiks who were forced to cut their way through four hundred miles of swamp and forest in the dead of winter, there is no record of his complaints. The Major's duty as he saw it was to serve the Tsar gallantly and well, and in respect

to this task he had the spirit of an ingenious and courageous soldier of fortune.

His wife's journal is the only reliable document we have of the five and a half years the Whistlers spent in residence in St. Petersburg. But this does not mean that it told everything. If Anna Mathilda thought of herself as the recording angel of the Whistler family, and the care with which she wrote is proof that she did, candor was not among her virtues; her virtues were of wifely loyalty and family pride. The journey to St. Petersburg from Stonington, Connecticut, was faithfully recorded. One sees the party of seven make their way across the Atlantic. They were George, her stepson, who accompanied her to the shores of the Baltic before returning to his job with the Winans in Baltimore; Mary, her maid; and Anna Mathilda's four charges: her stepdaughter, Deborah, her sons, James, William, and an infant, Charles. The brightest moment of the trip and one that had meaning in the future career of James was the stop-over at Preston, on the west coast of England, on a visit to his McNeill relations.

Dr. McNeill, Anna Mathilda's father, had two daughters by his first wife who had died before he left Scotland and they had settled in Preston. Anna Mathilda's two half-sisters, Eliza and Alicia, were as lively and voluble as she was quiet—and the features of Aunt Alicia, looking like William Makepeace Thackeray's sketches of himself, rotund and neckless with steel-rimmed spectacles, were the subject of one of James's earliest drawings. But far more important than finding an early and cheerful model in his Aunt Alicia was the fact that the McNeill relations at Preston talked about art and had friends among members of the Royal Academy. From them Anna Mathilda added to her own and her husband's interests in painting, and from then onward whatever James overheard in conversations about art and painters was the kind of talk that American children of his age and in 1842 had no opportunity to hear at all. His Aunt Eliza had married Mr. Winstanly; they were close friends of the Rigbys; and the beautiful Rigby girls, as well as the young John Ruskin, were sitters to the first of the great English portrait photographers, Octavius Hill. One of the Rigby girls became the wife of Eastlake, who was later known as the President of the Royal Academy, and if Anna Mathilda had not met Lady Eastlake, her half

sisters induced her to read her book, *A Residence on the Shores of the Baltic*. From them Anna Mathilda was made aware of the latest names in British art; and she had learned them well.

On the trip northward and eastward her infant son, Charles, mysteriously and suddenly died in her arms. She then remembered how Mary Swift's son had died of typhoid and her own son Kirk had died of scarlet fever, and now came the death of infant Charles. The death darkened her arrival in St. Petersburg and made her fearful of meeting her husband. Her long-looked-for arrival would bring with it her own grief and bad news. Now more than ever and for the many years following, she turned to James whose health needed her care and whose charm could turn her thoughts away from what she felt were "morbid and unChristian" fears of death.

In the pages of her journal (which were written in sidelong glimpses from her writing desk) the personality of James began to stir to life; and the two lively members of the family in the apartment overlooking the Neva were Deborah and James. On musical evenings Deborah played a harp while James sat sketching in a corner. James was a favorite of his elder half sister and remained so throughout their lives; she had decided early that he was a genius and fifty years later, when she was Lady Haden and against the wish of her husband, she still insisted that he was.

Fears of the glittering snow-ice-sea-swept city of St. Petersburg began to enter the Whistler household. The Whistlers distrusted Russian food and particularly Russian milk; therefore they bought their own cow and stabled it in the courtyard nearby. Anna Mathilda's maid, Mary, instructed the Russian cook in the arts of making American griddle cakes which became a staple of James's diet wherever he lived and for many years of his life. To him the serving of griddle cakes was like waving the Stars and Stripes and singing "Yankee Doodle." Anna Whistler could not understand Russian servants; their passionate effusions, their reluctance to take baths, their tears of gratitude whenever she showed casual kindnesses embarrassed her. She disapproved of drink and they were often very drunk. The woman and small boy, who had received the Major's bounty before she had arrived in St. Petersburg, bewildered her. As she attempted to give them their weekly allowance, the woman sank to the floor and kissed the hem of her skirt and her

fingertips. This performance distressed Anna Mathilda so profoundly
that she instructed Mary to be the woman's weekly paymaster.

But the most bewildering experience of all was an incident of
Christmas week. The Major and the two boys, James and William,
had bought Anna Mathilda a portable writing cabinet. James and
William were delighted by the choice, and the presentation of the
gift was the center of excitement on Christmas day. The day after
Christmas the escritoire and the Major's flute disappeared. The ser-
vants were questioned; the German footman dismissed; the theft
reported to the Tsar's police. The mystery was never solved. It was
the kind of incident that modified the Major's optimism concerning
Russian virtues, that enclosed Anna Mathilda more securely than
ever within doors and off the streets of St. Petersburg; and her fears
led to her further reliance upon her eldest son, James, to make light
of all her "morbid" fancies.

From the windows of the apartment, the Winter Palace shone
like a wedding cake designed by an Italian pastry cook and at night
fireworks on the Neva blazed, burst into multicolored light, vanished,
then blazed again. James, confined to his room by one of his numer-
ous "sore throats," often stayed up half the night to watch them.
The views from his window were the earliest of his "nocturnes":
the deep sky lit by falling rockets, the blaze of fire against snow and
a cold dark sky. Unconsciously "the work of a life time" had begun,
work that was not to be realized until many years later when the
fireworks at Cremone Gardens in Chelsea on the Thames restored
the image of falling rockets out of darkness to his memory. This was
not "work" in the usual sense but pleasure and delight, associated
with the forbidden joy of being awake after his mother's instruc-
tions to go to sleep; it was a private, secret pleasure, almost like an
indulgence in one of the seven deadly sins. It was the kind of
pleasure that James held to at the height of his career. This recollec-
tion of a scene from his early childhood was one of the secrets of his
"originality."

Whether she admitted it or not, Anna Mathilda had great need of
James's ability to charm and to disobey her. When he was not watch-
ing fireworks late at night, she heard him laughing to himself at
midnight over droll passages he had discovered in Cooper's romance,
The Spy.

The Major, obsessed as he was by the task of building the four hundred miles of railroad between St. Petersburg and Moscow, spent fewer days at home than ever, and Anna Mathilda did not like the light-spirited Americans who visited her in St. Petersburg. Although James and Deborah enjoyed the brief visits paid by Colonel Todd and Mrs. Brodisco, the American wife of the Russian minister to the United States, Anna Mathilda did not. She thought Mrs. Brodisco, though handsome enough, went to too many balls, theatres, operas, and read too many yellow-covered French novels, and in matters of religious thinking, she thought Colonel Todd, if not downright wicked, was frivolous, which he undoubtedly was. She received only the Episcopal pastor, Edward Law, with confidence. She also received John Motley, who was later to write *The Rise and Fall of the Dutch Republic,* and his friend, young Mr. Maxwell, both of whom were Colonel Todd's assistants and from them she learned that the Colonel gave them a smaller salary than they expected. Their stay in St. Petersburg was short; they returned to the United States, John Motley to complete his historical studies and Mr. Maxwell to write a book on his European travels which included an enthusiastic account of how democratic the Tsar's reign was, an opinion that was not shared by de Custine or any other writer of his day.

Anna Mathilda had half approved of Mr. Maxwell because he was in dubious health and had allowed her to nurse him. Deborah, who feared him as a possible suitor, was glad to see him go. Whatever cheerfulness the Whistler apartment held depended upon the initiative of James; unlike William, he talked his way out of reciting moral verses in French to his father at the breakfast table, and produced a drawing to admire—and some of them were amusing. He had the gift of making himself the center of his family's brief release from daily anxieties. In St. Petersburg the Whistler family circle had become increasingly withdrawn.

Fortunately and with the excuse of furthering their education, the Major and his wife trooped their children through St. Petersburg museums and public buildings. The collections on the walls of the Imperial Galleries, The Hermitage and the Hermitage Pavilion were gazed at in the spirit of well-conducted family-guide-book-tours. One cannot say that James, quick as he was to see and to overhear, saw

and understood everything that was pointed out and said. Yet what he saw at the Imperial Galleries was enough to carry impressions of a courtly, polished world within his memory.

Although the Imperial Galleries could not be compared with the collections at the Louvre, the Prado and the murals of the Sistine Chapel, their large selection of paintings did not lack sophistication. The lesser Flemish painters of the seventeenth and eighteenth centuries were represented—Whistler never lost his admiration for Dutch painting—and so were the French eighteenth-century court painters, which was a consistent expression of taste in St. Petersburg. The Russian court which had taken its language and its models from the French chose that aspect of French court painting that most clearly "told a story" because it was easiest to understand. The result was that it had acquired Fragonard's *The Clandestine Kiss,* the picture of a lover, shadowed by a door, kissing a lady dressed in virginal white and modest gray. Her coloring with its glint of reddish gold hair is not unlike the most well-known studies of Whistler's white-girl symphonies.

The Russian Imperial court also expressed its taste in displaying on the walls of its galleries the domestic eroticism of Greuze, pictures of voluptuous young girls and children in torn dresses. Their own painters, particularly Firsov, Levitski and Borovikovski, reflected the lessons learned from Hogarth, Chardin and Velasquez. In later years when Whistler was at war with Victorian schools of genre painting, it could be said that he had seen better examples of their art at The Hermitage and at the Hermitage Pavilion. It is not too much to say that he was bored by genre painting. As a spectator, he had had his fill of it in childhood.

During one of James's illnesses Deborah had borrowed from a friend a folio volume of Hogarth's engravings for his amusement. Not many parents today would think that Hogarth's prints of *The Rake's Progress* and *Marriage à la Mode* were suitable entertainment for a sick child; the nineteenth-century family of Anglo-Saxon heritage thought otherwise. For fifty years children's annuals published in England and America gave their readers moral instruction by reproductions of *Gin Lane* and the famous dinner at which the Rake treated his friends—all of whom were, women as well as men, distinctly the worse for wear and heavy drinking. It is not known

whether or not the morals of the children were improved, but they did enjoy the pictures, particularly those that hinted broadly of evils and crimes they could not quite understand. "If I had not been ill," James confided to his mother, "perhaps no one would have thought of showing them to me," and he remained loyal to a nostalgic admiration for Hogarth throughout his life. In his liking for Hogarth James shared the taste of many a Victorian child.

The crowded street scenes in Hogarth's engravings, the sight of rags and squalor and picking of pockets, the violence of movement, were not unlike the pageant of St. Petersburg on a fete day or the occasion of an imperial birthday, but there were several important differences: the colors of the East against ice and snow; the broader streets, the greater crowds; the Tsar's Gardes à Cheval in jackets of blue and silver, tunics of black and gold, hussars in gold and red and green—all caught James's eye. For ten years afterwards James's sketch books and even his etchings at West Point and in the Coast Survey offices at Washington had fanciful Russian hussars waving swords and sabers in their margins.

During the five years that the Whistlers lived in and near St. Petersburg four of the summers were spent in a villa within walking distance of Tsarkoe Selo, the estate where the Catherine Palace had become to the Whistlers the most instructive of museums. The Whistlers had made a discerning and characteristic choice, one that was worthy of inspiring the kind of artist that James McNeill Whistler became in the best moments of his career. The Palace had been designed by the son of Rastrelli, the Venetian architect who had been brought to Russia by Peter the Great. The Venetian, with worldly art and subtlety, cast a bronze bust of Peter that made him resemble, if not in feature, the kingly bearing of Louis XIV of France. His son was no less gifted, and under orders from Peter's daughter, the Empress Elizabeth, he erected a summer palace. At her commission, the Rastrellis, father and son, brought to St. Petersburg the reflected glories of Palladio. Rastrelli, the son, was the greatest of Imperial Russia's architects; under his hand the high baroque of Venice moved northward to the shores of the Baltic, glittered in a new, and because of Rastrelli's genius, an appropriate setting of ice and snow. The Summer Palace, like the roofs of cathedrals in Venice, was peopled at the summit by gilded statues and its outer

walls were of pale blue—and the grounds of Tsarskoe Selo, laid out in avenues of clipped hedges, had scattered through them in a symmetrical order eighty pleasure houses and pavilions. Yet no mention of this outward splendor is in Anna Mathilda's journal; an even more important and interior view of the Palace held her imagination.

What she wrote about, what she had discovered for herself and for James was the Chinese Room of the Palace, that part of Rastrelli's baroque and neo-Venetian edifice that had been remodeled by Charles Cameron for Catherine the Great. Not much is known of Cameron, and whether or not Anna Mathilda knew he was Scotch is not recorded in her journal. It is supposed that Cameron studied under the brothers Adam, the famous interior and furniture designers in London, because traces of their teachings are to be found in his designs. It is certain that he admired the work of Vanbrugh who designed Blenheim, the Churchill estate. Catherine had heard of him because he had written a clever, if pedantic, book on Roman antiquities. She found out that he was living in Italy and she ordered him to be brought to St. Petersburg with the same imperial will and the same results with which Nicholas received Major Whistler in Russia—and he came. It was assumed that for a short time Cameron, since he was young and handsome, was among her favorites. She discovered in Cameron a genius equal to that of Rastrelli's. He became her pet architect; he designed rooms for her in the Palace of remarkable beauty at extraordinary expense. When she grew weary of the pleasure and luxury he provided for her taste, she complained that his extravagance would bring her treasury into bankruptcy. She dismissed him and little was heard of him from that day to this.

Among his masterpieces in the Palace was the Chinese Room. It was of a China that Cameron did not know but had imagined, and in his day he was not alone in imaginary views of China. The courts of Europe in the eighteenth century found much to emulate in Chinese courtly attitudes, social behavior and dress: the waxed pigtail in head dress had arrived from China and so had the fixed and courtly smile. At the French court Boucher painted scenes of an imagined China and in London Sir Joshua Reynolds made a study of Chinese manners and dress in one of his portraits of a Chinese boy. Appreciation of things Chinese was a mark of civilized and fashionable behavior. Anna Mathilda and the Major were probably

not blind to this gesture of fashion in the recent past, but if they were, their tastes were instinctively allied to Cameron's love for exotic recreations and his restraints: his flat pastel colors covered by sheets of glass upon the walls, his neo-classic sills and doors, his thresholds, and door and window frames, his sparing use of pictorial design on walls, the single sprays of apple blossom and ferns and grasses. Delicate tints of color were reflected from walls and columns on polished glass, and light flowed through tall doors and windows, the reflection of sun on snow or the green-tinted light from the trees and grasses of a summer's day.

Coolness and light flowed through the Chinese Room, a pale and somewhat abstract light which had become a polished reflection of indoor, urban beauty. This was in contrast to passionate, barbaric Russia, to serfs and peasants whose sheepskin garments stank, whose miseries of flesh in running sores and lice embarrassed visiting Americans, and whose drunkenness was combined with tears and prayers and pleas to God, to demigods like the Tsar, his noblemen, his soldiers. In the Chinese Room Anna Mathilda found a serenity that gave her and her sons protection from the Russia they did not care to know. It gave them a sense of living above and beyond the world. Was their feeling "aristocratic"? As far as Anna Mathilda's emotional restraint and her sense of being a plain woman permitted aristocratic day-dreaming, it was. Her aristocratic feeling was one of plain living and high devotion to the Episcopal Church, and it was also mixed with pride of being the wife of an American engineer who had European recognition.

The effect of the Chinese Room on James was not confided in later years to his friends. Memory of it was probably subconscious or diffused into general memories of St. Petersburg, yet it does explain the peculiar, and what might otherwise have been called instinctive, attraction Oriental art had for him. The attraction was a matter of feeling that was far stronger than intellectual conviction; it was as serious and as deeply ingrained in his response to it as any influence upon his life and work. James, as well as the Whistler he grew into, was never heavily serious nor naïvely candid, and, in a literal sense, seldom truthful. He held to certain of his deeply personal secrets; his seriousness wore the masks of levity or half fantastic, melodramatic action.

What Whistler did confess was an early proficiency in speaking

French. It was his second language and it was picked up rather than earnestly studied by James and William. The Major had found a tutor for the two boys who was an indolent, so Anna Mathilda thought, young German. In a scattered fashion he taught French as well as other grammar-school subjects. After his dismissal, another tutor made a short stay, but the most that James learned from them was a method of learning French by ear and of deftly repeating it aloud, much to the envy of his mother, who, though she could read French, was much too shy to trust herself and her American accent to the ears of her visitors. James also picked up a word or two of Russian.

It was James who became his mother's guide through the streets of St. Petersburg. It was he who asked directions in French from the Tsar's officers to point the way, he who, with his few words of Russian, ordered sleigh and carriage drivers and gave alms to beggars. On one cold day Anna Mathilda was shocked to know that a footman had frozen to death while waiting for his master to return to his sleigh; his death intensified her fear of St. Petersburg and what she considered its immorality. Winter or summer, to her the Russians seemed in need of a higher and more serious view of life. When she heard gossip of the Tsarina's illness, she concluded flatly that she went to too many balls and stayed up too late at night.

At the Whistler summer house near Tsarskoe Selo on a hot Sunday Anna Mathilda saw a group of young hussars dismounted and idling in a field on the road to Peterhof. She sent James and his brother out to distribute tracts among them; the tracts were to remind them that it was the Lord's Day and not a time to lounge and play. James delighted in the errand for reasons other than his mother may have suspected. He tossed tracts at the hussars and shouted at them in French, and the hussars, shouting back at him, cheerfully knocked each other over and rolled on the grass as they dived for the tracts. It was a game and relieved the boredom of a hot dull Sunday. James, laughing, led his mother to a window to watch the show. James's action was of a piece with his later attitudes toward social and religious reform, yet he probably agreed with his mother that the hussars were too far gone in irreverence and drink for her to offer them hopes of conversion to the Episcopal Church.

III

THE arrival of Sir William Allen in St. Petersburg was an important event in the Whistler family circle. Sir William was a member of the Scottish Royal Academy of painters and had come to St. Petersburg at the Tsar's order to paint a large canvas of Peter the Great teaching mujiks how to build ships at St. Petersburg. The Tsar's choice was logical enough: this was not the first time Sir William had journeyed to the cold northeast of Europe. In his youth Sir William left Edinburgh for London and found a patron in Sir Alexander Crighton, a physician in the British Royal household, who had faith in the boy's ability to paint. On a trip to Russia Sir Alexander took young Allen with him, and on their return to London Allen painted pathetic scenes of Polish peasants, who were among the displaced persons of that day, starving in Russian snow. On his visit to London a few years later Nicholas was impressed by Allen's pictures of scenes which the Tsar knew well, and even as Grand Duke the Tsar was an accomplished hypocrite. It was rumored that his outward liberality to Pushkin disguised a liaison with Pushkin's wife, and it was said that though the lady had another lover in the person of Georges d'Anthes (who killed the jealous poet in a duel), d'Anthes was acting as the Tsar's proxy. Allen's expression of sympathy for the fate of Poles on Russian soil touched the Tsar and gave him a chance to express his Pan-Slavic sentiments. Therefore Sir William Allen was his man; he was a vigorous genre painter, one of whose famous works was a scene of Scotch cottagers playing at Blindman's Buff. Surely he was the man to make Peter's building of ships an adventurous incident. And Sir William talked in the same fashion that he painted; on his visit to the Whistlers he fascinated James with his story of his heroic canvas of men and ships.

After James had been sent to bed, Anna Mathilda showed James's drawings to Sir William. The great man was cautious, yet he recommended that the bright boy who had listened so closely to his story be sent to the Imperial Art Academy. James was eleven years old and restless; Sir William had rescued him from idleness.

The Whistlers promptly sent him to the Academy, where he was taught to draw from plaster casts. James was the youngest student in the room where classes were held; he was a privileged character, and very happy. More than all else there was no doubt in James's mind that he and his family were superior. He was anything but shy and was untroubled by the usual trials of early adolescence.

James was not the only restless member of the Whistler family, now deeply clouded by the loss of Anna Mathilda's "Russian baby," at eighteen months, the latest visitation of the will of Anna Mathilda's Calvinist God. Deborah, her stepdaughter, suffered headaches and obvious results of boredom. At eighteen she was a little too old to regard her father as the ideal escort at balls and dinner parties which she attended with the Major on his infrequent excursions into society. Without his permission, she joined St. Petersburg crowds on fete days, and on the occasion of a royal wedding to which she had not been invited, she stayed out late at night watching the festivities that took place in front of the Winter Palace. The Major felt humiliated by her lack of an invitation, by her eagerness to attend the festival without it, and by the fact that she felt no sense of her wrongdoing. He decided that St. Petersburg was bad for her, and that she, her stepmother and James and William should take a long vacation from St. Petersburg. His decision drew James and Deborah closer together. They responded to the promise of an English holiday with the same delight they shared with Colonel Todd when he had taught James to toast the Tsar's health in champagne and in French.

The truth was that the Major's own enthusiasms for his work in Russia had declined. He had begun to feel the first, uneasy twinges of middle age, the strain of overwork under the Tsar's orders, the peculiarities of St. Petersburg climate, the extreme cold of its winters and the sudden burst of warmth in late May which transformed the countryside into something that resembled a semi-tropical forest. (The heat at least was semi-tropical.) The lack of sanitation both at Tsarskoe Selo and St. Petersburg gave rise to cholera epidemics which were

also semi-tropical in their intensity; it would be best to make sure that his family were safe with friends in England.

Deborah received an invitation to visit friends in Switzerland while Anna Mathilda with James and William joined their Preston relatives for a summer's vacation on the Isle of Wight. Deborah's Swiss journey was momentous; it was in Switzerland that she met the nephew of Kirk Boots, one of the Major's best friends. The young man was a London physician, Dr. Francis Seymour Haden, and before much time had elapsed, she fell in love with him. Nor were American romances in Switzerland rare; in that day Switzerland had become a favorite resort of the young and romantic American traveler; Louisa May Alcott wrote *Little Women* there, and Deborah, like many a fashionable American girl, shared the prospects of meeting the "right" young man there as well as a view of Lake Geneva and Mont Blanc. It did not take her long to find him. He was clean-shaven, tall, and brisk in manner and he was also interested in the arts. In his own right he was a promising etcher. To marry him would be to keep an association with the arts that Deborah had known in the Whistler household; it might well have occurred to her that her future husband would understand and perhaps appreciate James.

The Major was not overjoyed at the news of Deborah's engagement and the rapid approach of her marriage to Haden. He came to England so reluctantly to meet Haden that he almost caused the couple to postpone the wedding, which, because of his late arrival, was delayed two days. To his wife he complained of feeling middle-aged and ill at ease. On meeting Haden, he did not like him. Did he foresee that Haden within the next thirty years would be a domestic tyrant? Or was the Major himself growing into the kind of Victorian father of whom the head of the Barretts of Wimpole Street in London was archetypical? Deborah was docile, yet held firmly enough to her own wishes on this occasion not to fall into the fatherly trap that held Elizabeth Barrett, the poet, an invalid until at the age of forty she eloped with Robert Browning. We shall never have the final answer to these two questions; we know only that the Major's stay in England was extremely brief, that he seemed distracted rather than pleased, and that he commissioned Sir William Boxall of the Royal Academy to paint a portrait of James. If the

portrait of the smiling boy is to be trusted as an expression of James's feeling, James enjoyed the sitting and Boxall's attention. In later years, judging from the portraits, whether painted by himself or others, Whistler always enjoyed his own presence in a picture. The Major returned to St. Petersburg and to his duties. The Tsar had just presented him with the Order of St. Anna, which by coincidence was both his mother's and his wife's name and therefore appropriate. Deborah went with her husband to London and settled peacefully in an impressive house in Sloane Street, and James with his mother and William continued their stay with Anna Mathilda's relatives at Preston.

Anna Mathilda in her journal was not unaware of important events in Europe during that year of 1848; she knew well enough that it was a historic year. She read newspapers and began to jot down her opinions concerning world affairs. The fall of the Bourbons in France was not reassuring, nor was news of Chartists massed at Whitehall a cheerful sign of the times. She copied (in French) the Tsar's proclamation of his own security as well as his ukase asking for reaffirmation of the people's faith in him as head of church and state. As an American and in theory she held to a Puritan's dislike of kings, emperors and tsars. In practice, and because of her husband's dependence upon Nicholas's good will, she was strongly in favor of all things being settled without threats and fears. "May God so overrule in the councils of Europe that a better state of society be ordered!" she exclaimed. News from St. Petersburg continued to be bad; the cholera epidemic was unabated; she knew that her husband was neither as robust nor as optimistic as he had been in America. Then came news of his illness; he had had an attack of cholera and continued to be weak, listless and unlike himself. Late in 1848 she sent James to live with Deborah and her husband in London. She returned to St. Petersburg and on April 7, 1849, the Major was dead.

The Tsar offered to install Anna Mathilda's sons as pages in his court. She refused this courtesy but accepted the use of his private barge to carry her down the Neva to Kronstadt, and from Kronstadt she returned to England. James saw nothing of her last gloomy days in St. Petersburg. It was as natural for her to shield him from the worst of her dark impressions, so that he would remember only the

glittering façades of the Winter Palace, the fireworks at night, the joy of being admitted as the youngest member of a drawing class at the Imperial Academy. For a few years, George, his elder half-brother, living in Baltimore, was to become the protector and general adviser of the Whistler fortunes, but it was James who stood at the center of the family. It was he who took the place, if not the responsibility, of being head of the family, left vacant by the Major's death.

IV

ON a June day in 1849 the dark-eyed, smiling boy of William Boxall's portrait of James Whistler stood before the picture at the Royal Academy and approved what he saw. The image on canvas looked like a child of exceptionally good fortune; it seemed to be the mirrored reflection of red cheeks, a deeply cut, white Eton collar, dark-brown curls above the forehead, and with these the general air of a vivacious fourteen-year-old who was well cared for, well-dressed and at ease in his surroundings. The boy was accompanied by his mother and his younger brother, William. All three were pleased at seeing that James's portrait which had been commissioned by his father had been selected for a place on the Academy's walls. James's approval of the Boxall portrait meant something to his recently widowed mother. At the Hermitage in St. Petersburg she had been impressed by James's ridicule of Peter the Great's attempts at painting birds; James had laughed aloud at the Tsar's pretensions as a painter, and in her journal she noted the incident as a promise of James becoming an art critic.

The Boxall portrait was among the legacies that Major Whistler had left his family, and its place in the Royal Academy show of 1849 was proof that Whistler taste in art was above the ordinary. Nor did Major Whistler leave his family dollarless. Shortly after his death his pensions and investments brought his heirs an income of fifteen thousand dollars a year. His widow and eldest son, George, feared that it might dwindle, which it did, and they were conscious of the need to live sparingly so as to carry the future expenses of educating James and William. Anna Mathilda could not continue the style of living that the family had enjoyed in St. Petersburg as

well as on visits to Preston and her stepdaughter's new home in London. She therefore decided to return to the house that Major Whistler had bought in Stonington, Connecticut, before the family had moved to Russia.

The visit to the Royal Academy in London is the only cheerful entry in the narrative of the Whistler family return to the United States. It was the last memorable view that James had of his boyhood visits to London. In 1849 the Academy was housed next door to the National Gallery, and across the street from it stood St. Martin's-in-the-Fields, the church of so many famous weddings. St. Martin's was the most intimate, the most delicately wrought of London's early eighteenth-century churches, and the proximity of a gallery and a church was a circumstance that fell within Anna Mathilda's sense of a rare and fortunate fitness of things on earth. This last and favorable impression of London held premonitions of James's future; he was never to be attached to any city in the United States as he was to London, and his attachment was deeper than any expression of his like or dislike of London and the English.

The return to Stonington was an anticlimax for James's mother, for William and for himself. The small New England town and house meant a severe readjustment for all three, and pleasant as the environment was, it could not match the excitements of St. Petersburg and London—and most unsatisfactory of all, the town had no school that suited Anna Mathilda's plans for the boys' education. The right school, she felt, was at Pomfret. It was Christ Church Hall, and its principal was the Rev. Dr. Roswell Park who had been a West Point engineer until he heard the call to enter the church. He was not, of course, another Dr. Arnold of Rugby, and his school was scarcely more than a grammar school for girls as well as boys, but like his famous contemporary, he believed in upright Christian discipline and practiced it with conspicuous dignity.

Anna Mathilda installed herself and two sons within a few rooms of a farmhouse at Pomfret. The move meant the loss of her privacy and it also meant the keeping of two boys to barnyard chores which James neither welcomed nor could be forced to perform with decent regularity. When he was not restless, he was bored and listless, nor did he find in Dr. Park a model of behavior. Many years later a schoolmate, then an elderly woman, confessed that she thought

Whistler attractive with his brown curls and easy manner and she remembered him as being so slender that he seemed tall. The fact was that at fifteen James was at once too old in the excitements of living in large cities, too readily bored with rural scenes and entertainments, too childish in his lack of classroom discipline to be content at Christ Church Hall. He did not do well in studies in which his brother William calmly and stolidly excelled. The worthy Dr. Park lost patience with him and, by attempting to cane him, lost his own temper and dignity. The caning had been preceded by the master chasing the student round and round the classroom. Manifestly the school at Pomfret had not been made for James, and it is probable that Dr. Park advised James's mother of this and tactfully suggested that West Point was the place to send him. As far as James's education, health and behavior were concerned, the move to Pomfret as well as to Stonington was a failure; James's "sore throats" returned; he became unlike himself, and when he lacked an audience, he grew listless. He was like a small actor on an empty stage facing an empty house.

Anna Mathilda and George, who was still prospering steadily at Winans' locomotive plant in Baltimore, agreed that West Point would provide the best solution for James's difficulties. From all accounts of him, George, like James's younger brother William, was a model of virtue, but like so many models of his kind, the vague aura of his goodness outshone his personality. He was helpful, correct, industrious. He promised to do what he could to obtain James a cadetship at West Point, and with something of his father's conscientiousness and boldness, he had an interview with Daniel Webster, the New England lawyer, orator and political lion, on the subject of James's appointment to the military academy. Webster had heard of Major Whistler and passed on James's name to President Fillmore's list of recommendations of young men to West Point. Since Fillmore appointed James as cadet-at-large, and not as a strictly military appointment, it is likely that George told Webster of his younger brother's interest in art and of his ability to draw. Major Whistler had been an unconventional student—and a famous engineer. West Point could afford to discount whatever doubts there were concerning his son.

Since Major Whistler's day at the academy, West Point had

again changed for the better. Colonel Swift had been replaced by "The Father of West Point," Superintendent Thayer, whom the War Department had prepared for his office by sending him to Europe, and in particular, to L'Ecole Polytechnique. Thayer reinforced what had been a French "tradition" at West Point and with it even greater stress was placed upon the study of engineering. In West Point's drawing classes boys became familiar with French skills in making maps and architectural designs. At West Point a romantic affection for all things French began to prosper and in this atmosphere James Whistler acquired an equally romantic inspiration to see Paris, to share the life of its unmilitary bohemian artists.

Nor did the academy on the Hudson lack a setting that was attractive. Built as it was on the site of Fort Putnam, the old fort gave it the air of being an estate of a Scotch laird in Highland country, the fort a graystone Gothic pile, the Hudson River an enlarged moat that reflected walls and terraces in its waters. In 1851 West Point still had the general atmosphere of an idyllic school for boys and Presidential appointment of cadets had made it an exclusive one. Southern plantation families sent their sons to the Academy, and from this quarter the spirit of a southern aristocracy made itself visible: Jefferson Davis and Robert E. Lee were of that origin, and during James's stay at West Point, Lee became Superintendent. From Thayer's time onward West Point had gained more poise in enforcing rules of academic as well as military discipline, and with its air of social ease and polish, it had become a young gentleman's school of military engineering.

In the same fashion that Major Whistler was at home in his cadetship at West Point, James Whistler accepted West Point's hospitality; that is, he went to the Academy as though he were a welcome guest. He stretched to the limit West Point's tolerance of students who attended its art classes; he was anything but soldierly in his bearing; he tripped rather than strode or marched, and though generally neat in his appearance, he broke the rules of being tightly buttoned up in his uniform. His easy social manner, which was charming enough to please his instructors in art, was not the kind that passed inspection on the parade ground. He was regarded as the exception to West Point's sternest rules with the hope that his brightness would outshine his errors and that his talents in

drawing would justify, if not condone, his unathletic and un-
soldierly behavior.

Alden Weir, who afterwards became one of the best of his gen-
eration's American painters, was Whistler's art instructor at West
Point and he enjoyed rather than discouraged the presence of an
unconventional cadet in his classroom. It was obvious that young
Whistler had more facility in his drawings than his fellow students.
If Whistler left behind him nothing remarkable in his classroom,
his intelligent responses to Alden Weir's teachings made the in-
structor feel that his pupil's prospects could not be less than brilliant.

At West Point Whistler's near-sightedness began to play its part
in shaping his career. On the parade ground his actions too often
seemed irrelevant, and with his inability to see things sharply at a
distance, it was not unnatural that he feared and distrusted horses.
He could not guide a horse, and when in saddle he was all too
readily unmounted. For him the parade ground was far too public
for scenes of inept horsemanship, and throughout his life his vanity
was too easily cut and pierced and bled too freely to tolerate even
minor scenes of public criticism. Whenever and wherever he failed
to show himself superior to those around him, it was as though he
bled internally. His injury was the source of his verbal wit, and in
later years its signal came with the flashing of his monocle in which
his handicap of short-sightedness had become a gesture of defiance
—and the fixing of the monocle in his eye a weapon of attack. On
the parade ground if a horse refused to treat Whistler's person with
respect, it quickly followed that Whistler had no use for horses.

One day at drill and at a superior officer's cry of "Halt" Whistler
sailed over his horse's head. His commander remarked drily, "Mr.
Whistler, I am happy to see you for once at the head of your class."
Unhurt the boy leaped upright: "But I got there gracefully," he
insisted as though he had won an argument. Yet the reply did not
equal his father's gesture of polishing the mouth of a cannon. Later
Whistler told his friends that the horse was not an amusing animal;
how could any man keep a horse for the sake of entertainment?

Through the prestige of his father's professional honors in engi-
neering, Whistler was permitted to extend his stay at West Point

for three years. In all his classes, excepting those in art, he was doing badly, and scarcely better than at the school in Pomfret. Whistler knew that he was neither a mathematician nor a soldier, yet he did not dislike West Point. He had made a friend of Alden Weir; he and Weir collaborated in making a series of water colors showing views of West Point, and in the teacher-student relationship Weir gave credit to Whistler's inspiration for the sketches.

Whistler may well have tried the patience of his other instructors. They believed him to be bright but indolent, and certainly neglectful of military propriety and discipline, but to balance these demerits was the charm of his strange good looks, his social poise, his wit—and these latter qualities gave him ease among his classmates. It was felt, and he probably shared West Point's belief, that he could have been a clever engineer if he chose to be one. In actuality that choice was wishful thinking. Whistler was frankly bored by any precise study of the sciences; he needed another kind of stage for his activities; he cared nothing at all for history or economics, chemistry or physics. What he liked at West Point was its exclusiveness and, when off dress parade, its formal and yet graceful social manner. He had picked up the West Point manner with the same ease that he had learned French in St. Petersburg.

Anyone could have foreseen that Whistler at the end of two years at West Point would not be an ideal cadet. His neglect of required studies would soon involve a moral problem for his instructors and for the Superintendent at West Point, General Robert E. Lee. The General was humorless, deeply religious, an able administrator, a great general and a moralist. At West Point he was not the man to make allowances for a bright cadet's failure in chemistry and military history because that particular student talked well and had uncommon wit; he would consider the cadet's lack of industry an occasion for prayer; and if both religious and moral persuasion failed, immediate, if gentlemanly, dismissal was the next and final action. The issue was an honest one, and it involved Lee's professional as well as personal integrity.

Whistler's instructor in history reflected Lee's impress of moral and military seriousness at West Point. In class he asked Whistler for the date of the battle of Buena Vista, for during the early 1850's the Mexican War was still hot in the minds of instructors at West Point.

In the conduct of the war General Winfield Scott, "Old Fuss and Feathers," had paid the cadets recruited from West Point an overwhelming compliment; he said it was they who had won the war in quick march time. The Mexican War was West Point's undisputed victory; each battle was sacred and Whistler could not remember either the date or the existence of Buena Vista. The instructor made his last appeal, checked his temper and tried to be informal:

"What is this?" he said. "You don't know Buena Vista? Suppose you went out to dinner, and the company began to talk about the Mexican War, and you, a West Point man, were asked the date of the battle, what would you do?"

Whistler's reply was in the best form of his later manner: "I would leave the room at once; I refuse to associate myself with people who could talk of such things at dinner." The reply was a West Point heresy and could be accepted only from those whose grades in history were not less than excellent.

Whistler had learned at West Point a certain skill in distracting his examiners, and if he did not succeed in charming them into giving him passing grades, his wit earned him notoriety among his classmates and instructors. At the very least he could not be dismissed for mediocre conduct. His academic grades in all subjects except art were so ridiculously low, his facility in art so outstanding that both extremes of bad and good were in daily evidence. He had earned a kind of fame; his fellow cadets told stories of his flirting in French with the French maid at a boarding house and being discovered by her mistress, which meant that he lost his privilege of eating meals other than those served in the mess halls. They remembered his short stature, his dark, unruly hair which gave him the name of "Curls." His near-sightedness did not improve his skill at marksmanship and accounted for his lack of smartness in horseback riding, particularly in the more complicated maneuvers on the parade ground. It was like him not to complain of his physical defects, but to ignore them gallantly, trusting to his wit to save an awkward situation and to shield his vanity—to say when his commander gave him a horse named Quaker, "He's no Friend!"

As Whistler's classmates retold these stories, some of them took on a resemblance to the episodes in Thomas Bailey Aldrich's *Story of a Bad Boy*. In retrospect Whistler became West Point's "bad boy"

who had astonished his easily impressed classmates. They who were
at ease in saddle or on parade remembered his quick pen and pencil
sketches of characters out of the novels of Dickens, Victor Hugo and
Dumas; they saw him as the rare artist at West Point. In the class-
room his irregular conduct had made him a schoolboy's hero, gay,
irreverent, and "different." And as for Whistler, he did not resent
the sight of spruce, gray uniforms worn by his classmates, and when
he felt like it, he could make himself look as neatly turned out as
any of his fellows.

Thirty years later Whistler told to friends in London the cause of
his dismissal from West Point. His examiner in chemistry had
questioned him on the properties of silicon, and Whistler quickly
replied that silicon was a gas. "That will do, Mr. Whistler," said the
examiner, and Whistler always closed the story with: "Had silicon
been a gas, I would have been a major-general." The last remark
brought assurance of applause—which was what he needed for
the healing of an early injury to his pride.

To Whistler at eighteen the dismissal from West Point was
a serious reality and one that demanded a confession of failure to
his family. He went to the office of the Superintendent, General Lee,
and pleaded reconsideration of his failure in chemistry. The Gen-
eral was courteous and grave. "I can only regret," said he, "that
one capable of doing well should so have neglected himself and
must suffer the penalty." Lee, the moralist, spoke; the language was
awkward, formal, unyielding, and yet Whistler never lost his respect
for Lee. For the first and last time in his life, he consciously respected
moral authority. Something deeper than Whistler's vanity was pierced
and deflated. It had been among his dreams that circumstances being
otherwise he would have made a smartly tailored, dashing and cour-
ageous officer—perhaps, at least, a "major-general." Henceforward he
saw himself as an artist who was not without the sharp, brilliant
eclat of an idealized military hero.

Whistler's return to Pomfret was not a happy one, and the Con-
necticut summer was green, empty and dull. His mother's view of
his dismissal from West Point did not differ greatly from Gen-
eral Lee's expression of courteous regret. Family pride had been
injured, and his mother disliked Whistler's lack of a visible future
as much as he disliked the cloudy atmosphere of unspoken reproof

through the rooms of the Pomfret farmhouse. Instead of becoming at the very least "an officer and a gentleman," he faced the prospect of joining his virtuous half-brother, George, at Winans' locomotive works in Baltimore—and that was a decidedly unhappy outlook. Nor could a fortunate substitute for Whistler's stay at West Point take place on a few acres of Connecticut farm land. Cows, sheep and chickens were not his audience, and the stony New England countryside offered few attractions for him. They dulled his wits.

Part of the unhappiness of going to Baltimore and the unromantic locomotive works was that the city was not St. Petersburg, nor London, nor Paris. In Whistler's eyes the city was eminently unexciting. However, he did go to Baltimore and landed on his brother's doorstep. After a brief vacation George had re-entered Winans' firm as a partner and superintendent and had married a daughter of its founder. He was embarrassed at the thought of placing a romantic, flighty younger brother under him at a desk in the drafting room. He had already found a place for William, but William could always be relied upon to do what he was told—James could not. Whistler was as uneasy as George, for the occasion was not one of celebration, and he made it fairly clear that he did not want a life of servitude to Winans Locomotive Works. He was less of a Prodigal Son in the Whistler family than a black sheep and he acted accordingly: he strolled into the Winans' drafting rooms and scrawled fanciful drawings of Cavaliers who were locked up in dungeon cells on neatly stretched and prepared drafting paper. The Cavaliers expressed Whistler's image of himself, but they also meant that Winans' draftsmen saw ruined pencils at their desks and drawing boards on which new sheets of paper had to be laid.

Whistler solved the problem of his idleness by leaving for Washington, and Washington was less depressing than Baltimore. Although the nation's capital in 1854 had the air of a sleepy Southern town, although it was humid, swirling in dust whenever the sun shone and deep in mud whenever it rained, Pierre Charles L'Enfant's design of the city gave it the mirrored reflection of neo-classical orderliness and charm. The courtesies of Washington were Southern courtesies which were associated with much that Whistler remembered of his childhood and had been reinforced by General Lee's influence at West Point. It was a city in which family names,

including Whistler's, were not easily forgotten, and Whistler received admittance to the Secretary of War, Jefferson Davis's office. Whistler told him of hopes for reinstatement at West Point; he talked about St. Petersburg and of his father; and he hinted to Davis that a failure in chemistry was no more than a gentleman's error. Secretary Davis was as formal and grave as General Lee, yet as he bowed Whistler out of the room, he gave him permission to call a second time.

After seeing the Secretary of the Navy and pleading with him unsuccessfully to be transferred from West Point to Annapolis, Whistler returned to Jefferson Davis's office. Davis remembered that Whistler had spoken of doing well in Mr. Weir's art classes at West Point and he also remembered that a Captain Benham who had known Major Whistler was in charge of the drawing division of the United States Coast Survey. Davis said that return to West Point was an impossibility, but if Whistler cared to see Captain Benham there was probably a job waiting for him at a dollar and a half a day.

When Whistler saw Benham, Benham found that his old friend's son was amusing to talk to and he invented a job for him. Whistler was appointed to the United States Coast Survey offices on November 7, 1854. What he had learned during his visit to Washington was how to emulate his father's initiative and charm and how not to be wholly dependent on the advice and good wishes of his half-brother, George.

At West Point Whistler had been known for boyish skill in cookery, and when he settled into lodgings in Washington on Thirteenth Street, he continued what afterwards became his famous gift in serving impromptu meals out of a chafing dish. The reasons for his pleasure in being an amateur chef are not obscure. At home his mother had left the trials of cooking to her servants, and on occasions when she could not afford or failed to hire an able cook, even the simple meals served in the Whistler household suffered a decline. At West Point and in Washington Whistler preferred his own inventions in the art of making omelettes and griddle cakes to the meals served in mess halls and boarding houses—and in Washington the cost of dining out at fashionable restaurants was prohibitive. A spirit-lamp, a frying pan, a French coffee-maker were his

kitchen tools, and when he invited guests to his rooms in Thirteenth Street, he gave the coffee-maker and the frying pan the properties of Aladdin's lamp. It was a way of proving his self-sufficiency, and, incidentally, of showing he was versed in the art of being an original —and European—host. The cigarette which closed the meal was the last touch of his sleight of hand; the meal was then entirely Whistlerian: two eggs, flour and yeast, a pitcher of syrup, a cup of coffee had created the illusion of a work of art.

His meals were also consistent with his bohemian ideals of how to live in Paris. The French coffee-maker was the symbol of his intentions, and since he read and spoke French fluently, the novels of Dumas and Hugo continued to charm his imagination. Reading them, he spirited himself away from Washington and out of the routine of office hours in the Coast Survey drafting rooms. With his ability to talk French, to dance, and with the connections that his family had in Washington, he quickly became a social asset at balls and evening parties in Washington. He soon discovered that his office hours interfered with the increasing number of his invitations to dine out. In January, 1855, he spent six and one half days in his office; the rest of the month had slipped away. His memories of London and of St. Petersburg made way for easy acquaintance with members of foreign embassy offices in Washington, and at the British Legation he met Labouchere, who afterwards became the famous "Labby" and one of Whistler's best friends in London. At this moment Labouchere was an attaché of the British Legation and was one of Whistler's first instructors in the exchange of verbal wit. In Thirteenth Street Whistler was both host and chef at dinner to the Russian Chargé d'Affaires.

It was not difficult for Whistler to convince himself that he was well on his way toward being a man of the world. This was a pleasant dream and under its influence, its enchantments, its desires, the Whistler who twenty years later became a celebrity in London's Chelsea began to emerge from the chrysalis of a shabby genteel lodging-house in Washington. In Coast Survey offices Whistler's progress was less spectacular, yet it merited attention from Captain Benham. Within a short two months he had picked up the essentials of etching and engraving; his topographical maps showed a brilliant facility and an unprofessional tendency to etch irrelevant portrait

heads and topographical details on his plates. Captain Benham informed him that less art and more accurate drawing was required; that he could not go on forever spoiling plates that had been bought with the taxpayers' money. He reminded Whistler that the office was not an art school, but a branch of the government services.

Captain Benham had grown fond of Whistler and he attempted to warn him that his attendance at the office was dilatory and a shade too erratic for future employment. He sent another young draftsman to Whistler's rooms at half-past eight in the morning. Whistler opened the door and explained that he was not dressed and then cordially offered his visitor a chair. He poured a cup of coffee from his French coffee-maker and served it to his visitor. Whistler dressed slowly, carefully; he talked easily, lightly; he convinced his visitor that time was of no importance, and together they arrived at the office at half-past ten. Captain Benham did not repeat his experiment in warning Whistler.

It was in Washington that Whistler began to attract notice by his dress. He walked the streets in a Scotch bonnet and a plaid shawl tossed over one shoulder. Whistler wore Highland dress with particular reference to his mother's family, the McNeills, as well as his own liking for the novels of Sir Walter Scott. His gesture of belated Jacobinism was shared by many Southern families in Washington and it had in it a fashionable balance between levity and a romantic tribute to Southern family origins. It insured his welcome at evening parties at which the first impression Whistler made was of being French, and at the second, Scottish, and from then onward conversation was easy and never too serious. With a copy of Henry Murger's *Vie de Bohème* in his pocket Whistler enjoyed his disguise both as a Highlander and a Jacobean Cavalier, and this was the kind of social pleasantry that could be understood in Washington.

By February, 1855, Whistler's name on the payroll of the drawing division of the United States Coast and Geodetic Survey had become a cause of embarrassment to Captain Benham. Benham appreciated Whistler's presence in the office and he believed that Major Whistler's son had a touch of genius—but he was almost never in the Survey's offices, and he could not be paid for services in absentia.

Whistler spared the Captain further embarrassment by a friendly and abrupt resignation. He had made up his mind to study art, to go to Paris. Henry Murger's *Vie de Bohème* had converted him to a religion of Paris for art's sake, and he was ready to start, however limited his means might be, upon his pilgrimage.

V

THOSE who walk into the rooms where nineteenth-century French paintings are shown at the Metropolitan Museum in New York are likely to find two or three of their fellow visitors gazing at a large rectangular canvas signed "Courbet." The subject of the picture seldom fails to catch the attention of the curious: it is of an extremely naked, golden-tinted girl lying on her back, her black hair flowing in the direction of the lower left corner of the frame. Perched on her left hand is a brightly feathered parrot who seems to be sensible of the girl's charm. She is undoubtedly the mistress of the situation, an unGreek, nineteenth-century Leda who tempted a parrot and not a swan.

Aside from his own pictures shown in several museums and collections in New York, Courbet's woman with a parrot is the most vivid souvenir of James McNeill Whistler's student days in Paris—and though Whistler in his painting was never given to the kind of vividness that Courbet's canvas so obviously displays, yet the barbaric Leda has a distinct resemblance to one of the first of Whistler's models, his Eloise, his "Fumette," with whom he lived during the four years of his stay in Paris. Whistler shared models with Courbet and Eloise was a free lance in her profession.

Whistler had come to Paris in the summer of 1855 and had enrolled at the Studio Gleyre. George Whistler had agreed to send him an allowance of three hundred and fifty dollars a year in quarterly installments and he had urged his younger half brother to make the best use of his money and time by becoming a student at the Ecole des Beaux-Arts. But Whistler at twenty-one was not disposed to follow an elder brother's warnings and advice. An incident of his leaving the United States Coast Survey offices in Washington had already shown his present temperament, his resolution. As he left

the office he picked up his draughtsman's magnifying glass and on its surface etched the features of a small devil. A few days later Captain Benham found the glass on Whistler's desk and pocketed it as a memento of his departing draughtsman. Two years later in Paris Benham showed the glass to Whistler who held it up between them and said, "I recognize both of us perfectly."

In leaving Captain Benham's office Whistler was free to arrive at his own decisions, to study art and to be a devil in his own right. At home even the strongly willed convictions of his mother could not resist him. When he announced his intentions to go to Paris, his mother temporized by remaining silent; George bought boat passage for him, and he was on his way. And once in Paris Whistler decided that the disciplines of the Ecole des Beaux-Arts were not for him. Little green chairs and tables on sidewalks in front of the cafés were too inviting; the days were bland and warm and Whistler needed air. He had come to learn Paris as well as painting, and the small devil etched on Benham's magnifying glass glittered and danced in the back of his mind.

Because Gleyre was a well-liked teacher of foreign students of painting who came to Paris, Whistler chose his studio for preliminary instruction. Although Gleyre was among the disciples of David and Ingres who were the idols of the Ecole des Beaux-Arts, he held to certain unacademic principles that were his own, and from him Whistler acquired the rule that black was the foundation of tonal values in color. Gleyre's rules were few but impressive and they inspired young Englishmen who became his pupils to vigorous industry. Whistler was not inspired to strenuous effort; his choice of Gleyre's Studio was a sign of his freedom rather than a return to school, and at Gleyre's he discovered companions for the hours after Gleyre's classes were dismissed. There he found a group of young men, some of whom became well-known in their own right and several became famous as characters in fiction many years later when George Du Maurier wrote his novel, *Trilby*. They were Edward John Poynter, Alecco Ionides, Thomas Armstrong, Valentine Cameron Prinsep, Thomas Reynolds Lamont, and George Du Maurier himself.

The group formed a British colony in Paris and the atmosphere it created was one of healthy school boys on a diligent holiday:

they worked hard, played hard, but seldom stayed up too late at night. They lived as though they had stepped out of the pages of Thackeray's *The Newcomes,* and Du Maurier's *Trilby* had for its lay figure Whistler's mistress, "Fumette." Whenever the group gave drinking parties Whistler and his "Fumette" were invited. Whistler strummed a guitar and sang Southern plantation songs; "Fumette's" small feet and flights of temperament were boyishly admired by her hosts—and Whistler encouraged her to recite whole pages of de Musset's verses that she had learned by heart. Whistler, small, dark, agile, had the air of being a foreign guest in the company. Actually, square-chinned, aggressive young Du Maurier was almost a "foreigner"; he was the son of a French father and of Ellen Clarke, daughter of Mary Anne Clarke who was once mistress of the Duke of York and the "heroine" of a great *cause célèbre* during the Regency. Du Maurier's family heritage was by no means conventional, and the temperaments within it were more erratic than the wildest irregularities of the McNeills or the Whistlers. George Du Maurier suffered an affliction that would cause an artist of less enduring fibre to lose himself in drink or morphine. He had lost the sight of one eye and was threatened with total blindness, yet he seemed the most correctly British of the group and to outward appearances always looked as though he had just stepped out of a cold bath. It was Whistler who seemed ominously French and notably frail. Whistler also seemed Italian, or rather he resembled the lay figure of the Italian villain of Victorian fiction, and though in *Trilby* Du Maurier frankly intended a portrait of him in "the idle apprentice," Jos Selby, there was more than a little of Whistler in the master villain of the book, Svengali.

Whistler found other friends than those who studied at Gleyre's, and of greater importance to his early career as a maker of etchings, he found sources of inspiration that were other than those of Gleyre's English colony. Most of the younger generation of art students at Gleyre's admired Guillaume Sulpice Chevalier whose pen name was "Gavani," the illustrator of Hoffmann's *Tales,* whose doctrine was "I do a thing only because of its difficulty" and followed this by saying that his life consisted of work and women. In his dress he was conspicuous for his clean linen and smartly upturned military moustaches, and in these details one can see the beginnings of a

style, an "artistic" manner that later Whistler made his own. In his drawings "Gavani" was master of a thin, graceful, nervous line that Whistler admired.

Another source of inspiration to Whistler was in the etchings of the pathetic madman, Charles Meryon, who had been befriended by Baudelaire's art criticism. Meryon sought out the poet who had praised his etchings, but the interview only served to frighten Baudelaire. Meryon had written to Baudelaire saying that he did not believe in the existence of Edgar Allan Poe, that the poet's name had been the invention of a syndicate of spies who had written "The Murders in the Rue Morgue" to expose his (Meryon's) private life. Meryon was soon placed in a madhouse, but his published volume of etchings, *Vues de Paris,* had a moment of great celebrity, and traces of what that book taught Whistler are seen throughout the first fifteen years of Whistler's career in the art in which he too became a master.

Whistler's emulations of "Gavani" and Meryon were distinctly impersonal. "Gavani" was of a circle that was jealously guarded by Edmund and Jules Goncourt, who later were to permit Seymour Haden, Whistler's brother-in-law, to receive praise, but were careful to exclude all consideration of Whistler's gifts. Compared to his English contemporaries at Gleyre's who drew sketches of him in the shape of a question mark, Whistler was too outrageously French, and compared to his French contemporaries, he was all too enthusiastically American.

As Du Maurier unconsciously prepared himself for the writing of *Trilby,* transforming Whistler's "Fumette" into a heroine with a very Greek profile, Whistler etched a portrait of himself. The portrait was done à la Rembrandt with lighter touches of what he had learned from "Gavani" and Meryon; and most of all it was a portrait of a half-smiling young American of the mid-eighteen-fifties who was visibly enjoying Paris; there was a touch of "style" in the broad-brimmed straw hat set upon dark curls, and the small moustache and short imperial completed a fashionable picture of the artist at his ease.

The Du Maurier circle at Gleyre's was less than half of Whistler's

life in Paris. Part of his Paris was the imaginary world of Henry
Murger's *Vie de Bohème,* and he had the verve, lightheartedness,
and American innocence to adapt the book to the cut of his own
personality and behavior. Throughout his life he did little reading,
but he had a grammarian's eye, ear and memory for whatever he
selected to read or overhear; within these limitations he was seldom
in error, and as a Bohemian in the Paris that he hoped to make his
own, Whistler converted *Vie de Bohème* into his particular *Manual
of Arms.*

By the time Whistler came to Paris, Murger's sketches of Bohemia
with their urban gypsies, their poets and painters, their Mimis and
Musettes, had been produced upon the stage and applauded by
Louis Napoleon, and they also served a turn as plot and characters
for Puccini's opera, *La Bohème.* The confessions of his early
poverty had made Murger surprisingly well-to-do and outwardly
respectable.

In middle age and with ironic ease Murger assumed his place in
the cafés of Montparnasse as the hero of the Latin Quarter; he was
genuinely modest and he was never to forget that he had once been
and still was a disappointed poet: his gifts had been too facile to earn
the kind of fame that he desired. He moved and dressed with the
elegance he had once envied in other men, and was ill-prepared to
have Whistler introduce himself in a café as an ardent admirer
from America. And later when Whistler attempted to introduce him
to a friend, another American, Murger shied away.

Murger had grown too conservative to accept an enthusiastic
Bohemian from the United States. Whistler's white duck suit which
had been cut and tailored in Baltimore did not conform to the rules
of the starving art students who roamed the streets of Montparnasse,
and the strange costume merely embarrassed the author of *Vie de
Bohème.*

Meanwhile there had been nothing in *Vie de Bohème* to offend
the sensibilities of one who in his childhood and under instructions
from his mother memorized whole chapters from the Bible; the love
scenes in the book were indicated briefly by the blowing out of
candles in garret rooms, and in that sense infidelities between lovers
also remained inviolate: their bedroom scenes were not the subject
of prolonged discussions. If *Vie de Bohème* preached anything at all,

it was of the success of youthful levity against a too solemn regard of the arts, against transient failure, against poverty and middleclass attitudes toward money. All this was tonic to Whistler's spirit: his mistress Eloise became "Fumette" in direct imitation of *Vie de Bohème's* Musette, and not (as she was to become in Du Maurier's memory) a Trilby. A personal morality derived from his reading of *Vie de Bohème* remained with Whistler for the rest of his life, and it was not amazing that to British Victorian critics, it seemed less than any moral sense at all.

Sooner than even he anticipated Whistler grew bored at the prospect of continued regular attendance at Gleyre's Studio. The Louvre with its large congregation of visiting celebrities and art students was a greater attraction to him than the routine of a studio where a student labored a stipulated number of hours a day. At each successive stage in his career Whistler gravitated toward the centers of social activity, centers of gossip, centers of urban excitement and distraction. He chose to sleep till noon, stroll to the Louvre, instruct himself in the practice of copying old masters and after hours argue theories concerning art in a café with two newly discovered friends, Fantin-Latour and Alphonse Legros, who like himself haunted the chambers of the Louvre.

At the Louvre, and at what seemed to him then an impassable distance, Whistler saw the tall-hatted, lavender-gloved figure of Delacroix who bowed at him; and there he also exchanged a few words with the inspired teacher of art, Lecoq de Boisbaudran, who toured the Louvre with eager students in his wake, including Fantin and Legros. Whistler's friendship with these two young men was a way of getting an education at second-hand. Next to becoming a pupil of Lecoq, being a listener to his disciples was best, and instruction from Legros and Fantin flowed as easily as table wine.

In a café near Montparnasse Whistler arranged the meetings of a Society of Three. Of the three, Legros was the most impressive figure; his manner was precise and grave; he was slender and prematurely middle-aged with touches of gray at his temples and in his carefully trimmed beard. His high forehead, hooked nose, and severe eyes dominated the table. He was an accomplished etcher and

one of Lecoq's favorite students; his personality was of one who was born to teach, who loved teaching with all the religious gravity of his Burgundian peasant origins, and Legros had more to say than anyone Whistler had heard talk at Gleyre's. With a wine glass for his lectern Legros recited the teachings of Lecoq, of how the master insisted upon accurate drawings, of how each object, whether from life or *nature mort* or a painting by Holbein was to be faithfully reproduced, and how after this had been accomplished, the reproductions of the same subjects, recalled in memory, were done in class or on an easel placed against the blank wall of a studio. Lecoq conducted his last series of classes in the open air, in woods along the Seine, while models strolled through sunlight and shade. While the models rested, students were required to reconstruct from memory what they had lately seen, the walking figures, the glancing of light between the leaves.

Legros told how Lecoq, through the exercise of discipline, liberated the painter from too slavish a dependence upon models in the studio, and how he uncovered the hidden resources of memory. This was an example drawn from Legros' teaching that Whistler followed for many years, and under his friend's tutelage, he formed the habit of gazing at, then turning his back on, objects to sketch them or describe to a companion. As he walked with a friend through the city at night, Whistler gaily commented on scenes just passed, on light pouring from café doors and windows, on "nocturnes" of river, street, doorways and sky, or he wheeled about with his eyes closed asking others what they saw. He made a game of the practice and continued it ten years later in London where he confused his listeners who sometimes thought him drunk or mad, and if he described a scene correctly, he clapped his hands, shouted his triumphant "Ha, ha" and hummed a song.

From Legros, Whistler learned of Baudelaire and the beginnings of Symbolist poetry, and in this instruction Legros was joined by Fantin-Latour who also knew Verlaine and Rimbaud who spent their evenings within the vine-covered entrance of Closerie des Lilas, a garden-like café in the precincts of Montparnasse. Fantin in temperament and appearance stood for everything that Legros was not. Legros was the pure provincial from Burgundy; Fantin was half-Slav, bleakly depressed and high-spirited by turns; he was short,

thickly set and hypersensitive. Like Legros, Fantin was bitterly poor, and there is a winter sketch of him by Whistler: Fantin, propped up in bed, wrapped in an overcoat and muffler, a battered top hat on his head, his numbed fingers at work upon a drawing.

At the Louvre Fantin earned early but dubious notoriety for his five admirably studied copies of Veronese's *The Marriage Feast at Cana,* of which Harriet Beecher Stowe's brother-in-law bought one. To Fantin even his hack work became an act of devotion; he loved the painters of the Italian schools and Veronese in particular. Glimpses of Italian light and air entered his flower studies which in his middle-age brought him a living. Each study was illuminated by strokes of Italian color which almost freed him from the static brilliance of the Dutch school of flower painting. He worshipped at a distance the glitter, the violence, the poise of Delacroix, and, easily influenced as he was, he also came under the spell of Courbet. His various influences were seriously, sensitively acquired, and each was at work, one against the other, in his painting. The presence of dignity and high-mindedness made itself felt in all his work; his goddesses floating on clouds had indefinable charms, yet his sensitivity was of a sort that forces the beholder to admit that the artist had failed to make up his mind about anything —his very independence from the Ecole des Beaux-Arts was of the same quality. He was doomed to be a fine rather than a decisive painter; his work and his character were of one piece. When Whistler met him, he was a passionately serious young man, one whose ambitions were likely to result in the bitterest of disillusionments.

What Fantin shared with Whistler was a youthful idealism that overcame the discomforts of extreme poverty, of the near agony of working and living through the coldest nights and early mornings of winter months in drafty and unheated rooms. He sturdily faced whatever turns of fortune the Latin Quarter had to offer, and his hero-worship moved as though drawn by a field of magnetic force in the direction of Courbet.

While Whistler earned the title of being an "idle apprentice" at Gleyre's, the conversations with Fantin and Legros intensified his knowledge of contemporary French art. From Fantin he heard of the importance of Courbet and of the writings of Baudelaire, and it is more than likely that his appreciation of Charles Meryon's *Vues de*

Paris had been reenforced by Fantin's passionate respect for the opinions of Baudelaire's art criticism. At the very least, Fantin's enthusiasms ran a decade ahead of Whistler's admirations for Henry Murger and the poetry of de Musset. From Legros, Lecoq's truculent interpreter, Whistler was guided into a sphere of influence that was even now shared by Degas, Monet and Manet who were Lecoq's pupils and who valued his critical advice. Legros, however highly he regarded Delacroix and Ingres, was too severe in his tastes to welcome the polished eclecticism of the Ecole des Beaux-Arts. Like many who are radical in temperament, Legros' opinions were sharp, clear and narrow, and against them Whistler balanced Fantin's adoration of Courbet. And as Whistler's attendance at Gleyre's studio waned, he was drawn into the orbit where the paintings of Courbet were sun and moon, Venus and Mars, to the eyes of a younger generation of French artists.

When Whistler arrived in Paris the figure of Gustave Courbet represented everything desired by young and unknown artists of the Latin Quarter; he had received all the rewards of sudden notoriety, if not established fame. He defied the standards of the Ecole des Beaux-Arts by saying as if he addressed a cheering crowd, "Ugliness is beauty." The journalists of the day, including Proudhon, the anarchist critic, who stepped into the circle of Courbet's friends, read moral lessons into his paintings of fleshly young women reclining in the shade of thick foliage and of heavy nudes parading with arms uplifted in oracular gestures. Courbet's subjects were decidedly unclassical; his women, unlike the nudes of the Ecole des Beaux-Arts, could not be mistaken for goddesses. They looked as though they welcomed the fatigue that follows a long walk in the open air as well as the pleasures of the table and the bed.

It was easy for Proudhon to read into one of Courbet's fleshly bathers the following lesson for his readers: she is "that fleshy and substantial Bourgeoisie, deformed by grease and rich living; in whom flabby weight stifles all ideals, predestined to die of weakness of the will, if not of melting fat. There she is, such as her stupidity, her selfishness, her cooking have made her." It was not surprising that Zola, the novelist, joined Proudhon in praise of Courbet, and

the painter was elevated to leadership, with Daumier behind him, of a Naturalist movement in art and letters.

One suspects Courbet himself read little of Proudhon's message in his painting of *The Bathers*; he enjoyed the painting of robust nudes, and telling as far as his hand and eye could guide him, the truth about them. His protest was against the Ecole des Beaux-Arts. He was against all the so-called "ideas" of the Second Empire and its pretensions to ideal beauty; he resented the yearning of the newly rich buyers of pictures for neo-Greek refinements. Years later Whistler echoed his feeling by saying that Rome and Athens were filled with ruins. What concerned Courbet was his rediscovery of truth in Rembrandt and Titian—the kind of truth that Rembrandt painted in his picture of a more than half nude woman lifting her shift high as she wades through the waters of a brook. In writing his manifesto of 1855, Courbet said, "At no time have labels given a correct idea of things . . . Unhampered by any systematized approach or preconceptions, I have studied the art of the ancients and the moderns . . . I simply wanted to extract from the entire body of tradition the rational and independent concepts appropriate to my own personality."

"Schools have no right to existence," said Courbet, "there should be only painters."

This was a statement that many a young painter at the Louvre, including Whistler, hoped was true. Whistler walked to Courbet's studio and was received by a Courbet who at thirty-six looked like a young giant newly risen from the earth. He was bull-necked and deep-chested and his face was framed by masses of coarse black hair; he had full lips, large, capable hands, and his absent-minded gaze was of one who had just awakened from a sensual dream. He was the son of a well-to-do farmer at Ornans, a little town, near the French border of Switzerland. Throughout the day and half the night, Courbet worked enormously, drank enormously, and at irregular intervals ate enormous meals. He did not contemplate his canvases; he painted, and his work had the hardiness of work done by a peasant at harvest time. Courbet vaguely and generously accepted Whistler as another admirer, and to Fantin and Legros, Whistler announced Courbet as a "great man."

Unlike the masters of the Ecole des Beaux-Arts, Courbet had

firmly rejected "ideal beauty" and the neo-classical serenity through which historical figures moved. His scenes, which were an example to Whistler, were of contemporary life. His *The Funeral at Ornans,* a picture which in its foreshortened perspective showed the inhabitants of a rural community standing before an open grave, was received by younger artists as proof of Courbet's sincerity and depth of feeling. When Mary Cassatt, the American painter, first saw it, she burst into tears. It was unlike Whistler to weep on such occasions, and he did not, but he was impressed—impressed by what Courbet had to teach him.

Scarcely less influential was Courbet's painting, *The Studio,* which showed Courbet in a room filled with friends, including Baudelaire and George Sand. What offended the tastes of Courbet's critics was the sight of the thinly draped model standing at the painter's left shoulder—and, as if to make the scene even more embarrassing, there was the figure of a small boy gazing at both painter and model with admiration—but the picture established Courbet's reputation among young men of his day, for they understood that his conception of "truth," realistic as it may have been, had the strength of an inner vision of reality. Over and over again he insisted, "Beauty is truth."

While his fellow artists continued to admire *The Studio* and *The Funeral at Ornans,* public curiosity was attracted and repelled by *The Bathers.* The picture showed the back view of a heavily weighted nude stepping through a trickle of water, and with one arm raised in a portly gesture greeting another robust lady caught in the act of slowly undressing herself.

When Napoleon III saw the picture, he responded in a way that would have delighted the ghost of the Marquis de Sade; he struck at the backside of the portly nude with his riding crop, and his companion, the Empress Eugenie, whose favorite painting was Rosa Bonheur's *Horse Fair* with its Percheron horses, innocently inquired as her husband struck at Courbet's nude, "Is she a Percheron too?"

Whistler had inherited his family's skill in finding homes. In Paris his choices served to add a flying buttress to his morale; his rooms, however cheap, always had a "view." If they faced a courtyard, a tree flourished in a garden. If they looked down upon a

street, the greenery of the Luxembourg was within the range of vision, or the green grove of the Cimetière de Montparnasse swayed like a wave beneath church spires. What if a small, brick-floored room contained no more than a cot, a straw-bottomed chair, a basin and a pitcher? Whistler accepted his version of a Vie de Bohème with the same air of cheerfulness that as a child had made him the center of his family circle. When his washstand was held in pawn, he remarked that he'd just eaten his washstand and offered his guest the straw-bottomed chair.

There were days when he was unable to buy paints or canvas. One afternoon at the Louvre, and with an innocent, yet righteous eye, he borrowed paint, brush and canvases of an absent student. Another day, in the guise of showing others how to paint, he acquired through swift touches of his thumb and palette-knife enough paint from neighboring palettes to complete an unfinished picture. The Whistler smile, laugh and innocent eye sustained a gesture that could be mistaken for a combination of enthusiasm and absent-mindedness, and every detail of the gesture carried with it the authority of a peculiarly guileless charm. He talked Lalouette, the proprietor of a restaurant, into giving him meals and Burgundy on credit. Lalouette's was a place where Whistler entertained his friends, where the wine was good and the prices low. In return, Whistler made an awkward, yet half-affectionate etching of Lalouette's five year-old daughter; Whister was embraced by the entire family of Lalouettes and his credit was extended to the sum of three thousand francs. It was characteristic of Whistler to see to it that the sum was eventually paid.

Three less gifted artists than Fantin and Legros—Douret, the sculptor, Henry Oulevey and Ernest Delannoy, the painters—were companions of Whistler's late hours and holidays. When he grew bored with "Fumette's" recitations of Alfred de Musset's verses or her storms of temper if she grew bored—she was known as La Tigresse among other painters—Whistler turned up at Oulevey's rooms. One day, "Fumette" relieved her feelings by tearing up a number of Whistler's drawings. He wept and spent the night with Oulevey in drink. On the occasion of another quarrel Whistler met Oulevey with Lambert, an acquaintance of the night, and all three decided on a late supper and more to drink. All they lacked was the money

to pay for a night of conversation on the maladjustments of destiny to man. It was already past the midnight hour, and Whistler had an inspiration; the three marched up to the door of a flat where Lucas, George Whistler's friend, who paid Whistler his allowance from home, lived and slept. Lucas, waked from his sleep, was scarcely in a mood to listen to Whistler's story of how his rent was due tomorrow; Lucas would not advance the next quarter's allowance. The door was closed.

The three stepped into a restaurant with something less than a vague notion of how their bill was going to be paid. Whistler was violent with the idea of challenging Lucas to a duel and the anger which resembled that of a spoiled child was the obverse side of Whistler's air of boyish levity. Truly his mother had indulged him with the indulgence not unmixed with the awe that a plain woman has when she looks upon the bright and gay child of her union with an attractive husband. In his bland moments Whistler reflected the image of his mother's "Jemmy" who could do no wrong. To this was opposed another image, cast in a slightly different form, of the small devil he had etched upon a magnifying glass. He insisted shrilly that a duel with Lucas would settle the bill in a gentlemanly manner, and then suddenly fell asleep. Slowly with the orders of food and drink before them and by turns, the three woke up and fell asleep again. In gray morning light Oulevey wakened Whistler, then slept again. As sunlight struck his face, he wakened to find Whistler at his side with four hundred francs in hand and settling the bill. He had slipped away from the restaurant into the street and fell in step with another American, who was willing to lend him money on the condition that Whistler go with him to his studio and look at his pictures for half an hour. Whistler accepted the terms and the money was in his hands. As the three began walking home through the heat of late morning, they felt the not unnatural desire for further drinking. They turned in at the Café de France, and there in its cool and darkened interior, sat Lucas sipping his cup of morning chocolate. All thoughts of a duel had been forgotten; Whistler was rich again.

To what he called his "no shirt friends," his French acquaintances, Whistler remained, like so many Americans, a mystery. In their eyes he was decidedly Puritanical in matters of personal clean-

liness; he ate less to keep his shabby clothes in repair; money which might have been spent for food went to the laundress. He bought a small iron to keep his shirt and collar in press; yet on a hot day he pawned his jacket to buy cool drinks and walked through Montparnasse in a newly washed white shirt. "When he had money," Oulevey confided to a friend, "he flung it away. He had the heart of a woman, the will of a man."

For two years he endured and enjoyed the uncertain temper of his model and mistress, his "Fumette." It is also possible that he did not quite believe in the reality of her existence. She was the subject of an etching, yet she did nothing to create for him the illusion of permanence in his daily life; she shared his bed, his studio, his hours of late rising as well as the first meal of the day, but she did not enter the scenes of his midnight conversations with Fantin and Legros. Whenever he searched for new, temporary and cheaper quarters, she was absent; as Whistler established credit with a new landlord by renting a piano and moving it (to prove that he had any furniture at all) into his rooms, "Fumette" was not in sight.

It was then that Whistler and Delannoy with sketching pads, pen and ink, etching plates and their usual lack of money, decided to leave Paris behind them to simmer in the heat and to take a trip north to Strasburg. At the last moment Whistler raised two hundred and fifty francs which carried them through to their destination, but on their way back to Cologne their money had been spent with the finality of a legacy that had been acquired and vanished in a dream the night before. Whistler persuaded Herr Schmitz, his landlord, to accept the plates he had etched en route as a loan against his bill, and said that they represented the work of a great artist. Delannoy and Whistler took to the road. The episode was one of the first of many in which Whistler forced his landlord to become his banker; it was difficult for Whistler at any time to believe that he was poor, and he had the gift of making others share his optimism.

The American consul at Aix loaned Whistler fifty francs which was more than enough to pay Herr Schmitz's bill and to have the plates sent on to Aix. On their march south from Cologne to Aix, Whistler and Delannoy found that their trip was scarcely a holiday; their straw hats and light summer clothes had undergone violent transformations caused by wind, sun, rain and sleeping in barns and

haystacks along the road. Their bread, wine and cheese had been paid for at the high price of giving away sketches and pen-and-ink drawings wherever they stopped to rest. Their gain was Whistler's French set of etchings published in 1858. They were happy to be back in Montparnasse again, and Whistler, livelier than ever, was at the Café Molière where waiters were calling for coffee *pour le petit Whistler, le petit Americain.*

The publication of the French set of etchings marked the end of Whistler's student days in Paris. His apprenticeship of hack work at the Louvre copying paintings for well-to-do Americans who were willing to buy something from the hand of the son of Major Whistler was over. At the Louvre Whistler and Fantin had met one of the earliest of Courbet's friends, François Bonvin, who kept himself and his flickering talents alive by holding a small post in the government service. To younger painters Bonvin offered space in his studio and helpful criticism; Whistler and Fantin joined a small group under Bonvin's shelter, and they painted directly from the model under instruction from the inexhaustible Courbet. It is not surprising that Courbet, overworked as he was by his sustained display of muscular energy on large canvases and overwrought by wine, could scarcely remember this early meeting with Whistler, and when he did, mistook him for one of several young Englishmen he knew. It was not until later that he recognized Whistler as one apart from the little group that painted at Bonvin's.

Although Whistler had done a few portraits in oils, including a self-portrait, all in clumsy imitation of Courbet, the beginning of his career in painting came with his completion in Paris of *At the Piano.* The teachings of Lecoq through the agency of Legros inspired Whistler to draw his setting for the picture from memory. The figures in it are his half-sister and her daughter and the scene, painted in the foreshortened perspective of *The Funeral at Orans,* is the interior of his half-sister's music room in London.

Though *At the Piano* showed its indebtedness to Courbet, Whistler never agreed with Courbet's dictum, "Style is humbug"; *At the Piano* has that almost indefinable quality called "style," which had been sharpened by Whistler's emulation of "Garvani" in his drawings and what he discovered in Collet's severely disciplined line in etching. What Whistler contributed to these influences was something

that was quite his own—a memory of the walls of the Chinese Room in the Catherine Palace with their flat pale tones and their austerity in decorative detail; this was the something "new," the touch of "style" that gave At the Piano its distinction and its charm. With Courbet's approval, he sent At the Piano to the Academy Exposition in London several years later—but for the moment, and with Courbet's praise of the picture still echoing at the back of his mind, he felt it almost an honor to have At the Piano rejected by the Salon in Paris.

At the Piano announced Whistler's coming of age; the year was 1859; he was twenty-five; and he had heard from the Hadens that pictures were being bought in London by the newly well-to-do. In London it was not inevitable that the young artist was doomed to marry Poverty and share her burdens into a dubious middle age. He was invited to make a temporary home at the Hadens' house in Sloane Street and to leave Vie de Bohème behind him; he had learned much of what he wished to learn from Courbet at Bonvin's. Not the least remarkable of the French painter's extraordinary powers was the mark he left upon painters who stood at extreme distances away from Whistler; in his own country, the painter was Cézanne, and westward, across the Atlantic, Thomas Eakins; the uncommon heritage of Courbet was the only meeting of these three young artists on common ground.

VI

O N a September day in 1859 Whistler entered the doorway of his half-sister Deborah's house in upper Chelsea, near Knightsbridge in London. The Sloane Street house was material proof that Deborah had married well; it was a four-storied, cream-brick house; it was deep, narrow and tall, and less Victorian in its modest appearance than of the high-ceilinged period of the Regency. The place had an air of conservative restraint; it was a house that would inspire confidence in the professional abilities of the young surgeon, Dr. Seymour Haden, who was Deborah's husband.

As he was welcomed by Deborah and her husband, Dr. Haden, Whistler returned to a world that had been familiar to his childhood where floors were covered with Turkey carpets, where a gas-lit music room was an appropriate feature of a home, where meals were served at regular hours by well-mannered servants. In Sloane Street Deborah held to the practice of domestic cleanliness and austere comfort; she had the poise of a woman who is always discreetly fashionable in dress and manner. In *At the Piano* something of her poise was reflected in her dress and in the crisp, white frock of her young daughter. She was happy to see the brother whom she had always thought of as the genius of her family, but within his household, it was also clear that Dr. Haden was master: he was tall, his manner was professionally correct and decisive; his smoothly shaven features were less cordial than firmly set, and if he betrayed any signs of possessing an "artistic" temperament which his own gifts as an etcher may have permitted, these were shown in sudden and dogmatic fits of rage. His attitude toward his half-brother-in-law was one of generous patronage; he had no thought of dividing the authority of the household with him.

In coming to London Whistler had exchanged the sunlight of Paris which flowed through broken shutters of a garret in Montparnasse for the silver-tinted mist that gleamed in gray light through heavily draped windows in Sloane Street. There is no doubt that he found the contrast refreshing, for upper Chelsea with its fashionable shops extending in the direction of Knightsbridge had a glimpse of the carriage trade streaming westward from St. James and Piccadilly. In 1859 Victorian London had begun to glitter. The Hadens had spoken the truth when they had written of many pictures being bought that were painted by younger men. The Hadens had seen well-to-do London move westward toward Kensington Palace, the childhood home of Queen Victoria. Regency houses were being remodeled and refurnished, and new mansions were being built westward beyond Hyde Park and south of Kensington Palace Gardens. The established painters of the Pre-Raphaelite Brotherhood, their wives, their mistresses passed one another in Kensington Road on shopping tours, and in that newly fashionable neighborhood, John Millais, the painter of Ruskin's portrait, lived in Gothic graystone turreted splendor between solid walls built on the foundations of Millais' increasingly prosperous career.

Friendly as the Hadens were to their young guest and halfbrother, it was also understood that their house was not his studio, and during the day he set out to rediscover London. In making some of his early etchings of French street scenes and doorways in Paris, he chose for one of his models a sharp-tongued old woman, a flower seller, who often obliged him by lending the color of her spare figure to complete the view of the Paris that existed below stairs, below the level of its cafés, its Bohemia, its fashionable life. In this direction he followed the examples given him by Charles Meryon and Courbet and he continued the same path in London which led him to the East End, to Wapping, to the docks along the river. He found an inn where sailors boarded and set up his easel in one of its rooms.

Whistler gave dinners at the inn to which he invited Du Maurier, Ionides, and a patron, Serjeant Thomas, who was also a patron of Holman Hunt, the Pre-Raphaelite, and who had helped Millais before that painter rose to eminence in Kensington. Thomas had a print shop in Old Bond Street, at reasonable walking distance from

Sloane Street—but most important of all, the Old Bond Street shop in one of its rooms on an upper floor contained a press for Whistler's etchings. When his afternoon's work at Wapping was done, and after dinner, at an hour close to midnight, Whistler mounted the stairs to Thomas's press and proofed his etchings until early dawn next day. These hours chosen for his work had been set in Paris and continued for the greater part of his life. The dinners at the inn were of mixed company; skippers of barges met with Whistler's West End guests; Whistler drank toasts to his landlord, and to his host's discomfort, blew kisses to his wife. Whistler drank rather more than in Paris and discovered a taste for Port. As he worked correcting etchings in Old Bond Street he sipped a glass of Port, saying, "Excellent, excellent" at each stroke he made upon the plate.

Whistler had learned to etch as rapidly as other artists sketched on paper. At a glance his monocle caught the cold light between the rigging of ships and eliminated the confusion of too many objects seen within a frame. He selected his scenes with unerring firmness and felicity, everything caught within the picture as though seen for the first time and the last. In these etchings the lines of docks and warehouses framed the sight of ships with their sails furled and cargoes emptied, and at a later date, they were to establish Whistler's reputation.

Whistler strolled, plate in hand, talking to sea-captains, deckhands, stevedores, and in London it was as though he had at last begun to complete the work he had done in the United States Coastal Survey in Washington. Captain Benham's promising young etcher had fulfilled a debt due to early friends who were confident of his talents.

Seymour Haden's hospitality which had extended to Whistler's friends was also beginning to bear fruit, but this was of less hopeful character than Whistler's etchings. It was far more like the threat of an approaching storm, more like the threat of dirty weather on a dark night at sea. No two men were more profoundly unlike in temperament than Whistler and his generous host: Haden was leonine in speech and manner. In anger he was given to fits of roaring and it was said that even his sideburns bristled—in contrast, Whistler's manner was adroitly feline, and he displayed the self-sufficient boldness and agility of a cat.

Legros, Fantin and Delannoy had joined Whistler as guests under Haden's roof. Delannoy feared the sensation of having Haden's butler shadowing his movements; he distrusted the plumbing in Haden's bathroom with its miraculous shower-bath which he called the importation of Niagara to Europe. Delannoy was the unregenerate, untutored, unteachable Bohemian, frightened by London and Whistler's relatives. His stay was short; he returned to Paris, and within a few years of wandering starvation, disappeared. It was said he ended his days in a lunatic asylum.

Fantin and Legros, both less shy than Delannoy, were no less disturbed by Haden's presence in his own house and were no less disturbing. Whistler had informed Haden that Legros was in such hopeless, desperate need that it would take God or someone of supernatural powers to relieve him, and Haden, warmed by an impulse to be God, did what he could—he bought one of Legros' paintings of a church interior, and still under the influence of helpful intentions he also bought one of Fantin's copies of *The Marriage Feast at Cana*. He insisted, however, that there was something wrong with Legros' perspective and promptly took the painting upstairs to his own studio at the top of the house where he retouched it to his own satisfaction and the displeasure of the artist, who, by the way, had shown no signs of gratitude for Haden's patronage.

When Legros saw the results of Haden's work on his own canvas, his repressed antagonism to his host broke out in fury. "Run off with the picture," suggested Whistler, for he at all times and on later and more famous occasions, held to the artist's right to protect his work from the demands of the buyer. Whistler and Legros bundled the canvas out of the house, hailed a cab and wheeled it off to Whistler's studio on the waterfront. A few hours later and with considerable heat Haden followed them to discover that Legros had quickly restored his own perspective to the picture. In bad grace Haden accepted the undoing of his correction silently; host and guest had reached a stalemate in the desire to educate one another, and both had drifted far beyond the exercise of tact.

Meanwhile Haden fed his guests so well that they felt the shadow of his patronage in the dining room: at lunch sherry preceded fine cuts of roast beef; at five-course dinners, champagne was served.

As the guests listened to Deborah Haden at the piano in the music room, they felt their own talents superior to those of their host and hostess and grew uneasy at the thought of sharing respectability and comfort. In the eyes of the artists, the Hadens were rich and did not deserve to meet true artists on common ground.

Poor Haden! And in this situation he was a difficult man to pity. Himself an artist, he had hoped to find friends among his brother-in-law's friends, yet he was one who was accustomed to having his orders obeyed. In his etching room at the top of the house he smouldered with the heat of injured pride: he had expected those who received his bounty to appreciate his art which had already received favorable notice from the Goncourts—and which was more praise than Whistler had earned from that quarter. He pitied artists who were less fortunate than he; no doubt he thought them fools, only to find himself snubbed by them at his own dinner table.

Haden's attitude toward Whistler was anything but serene, and from Whistler's experience, unreliable. When Whistler took his journey from Paris to Strasbourg and back again and was in need of immediate funds, Haden had refused to send him money. On Whistler's arrival in London Haden received him as a father might welcome a favorite son. He helped Whistler edit *The French Set* of etchings and permitted the address, 62 Sloane Street, to appear on its title page. Haden showed a proprietary interest in the set; he etched a charming title page for it which showed Whistler surrounded by French children and seated with a drawing pad set like an easel on his knee. Moreover Haden had taken pains with the etching; he had etched two plates and chose the second and seemed eager to please his volatile brother-in-law.

Something like an armed truce existed between the two, the well-to-do surgeon who etched on holidays and the indigent young artist who was yet to become professional, yet both held to the ideals of the gifted amateur and both were ambitious. Obviously it was a friendship that could not last forever; it demanded a quality of tolerance for opposing wills that neither possessed.

For the time being Haden was pleased to admire Whistler's *At the Piano*; he hung the picture on a wall of his drawing room and showed it to visitors. In speaking of it he took the critical preroga-

tive of a friendly relative; he stressed what he considered its flaws
and expressed his regrets that the picture was of a kind that could
not be shown at the Academy.

In 1860 when Whistler submitted the picture to the Academy
and it was accepted, Haden's pride in his brother-in-law's brilliance
was mixed. The picture had been accepted in defiance of his opinion,
and *At the Piano* became one of the minor sensations of the Acad-
emy show. Though Whistler's etchings had more praise written of
them than the painting, *At the Piano* had its few and distinguished
admirers. George Du Maurier, Whistler's fellow student at Gleyre's,
who was now seeking employment in London, was impressed. He
wrote to his mother of Whistler's success:

> I have seen his etchings which are the finest I *ever* saw.
> The other day at a party where there were swells of all
> sorts he was introduced to Millais, who said: 'What! Mr.
> Whistler! I am very happy to know—I never flatter, but I
> will say that your picture is the finest piece of colour that
> has been on the walls of the Royal Academy for years . . .'
> And Sir Charles Eastlake took the Duchess of Sutherland
> up to it and said 'There Ma'am, that's the finest piece of
> painting in the Royal Academy.'

Du Maurier's letter showed the flash of excitement, which was
not without a small blue flame of envy, that *At the Piano* had
aroused—and there were others who stopped to look at the picture.
Among them was the rapidly aging Thackeray, who as he gazed at
little Annie Haden's white frock did not conceal his pleasure at
seeing a child transfixed and yet at ease listening to her mother
playing unheard music at a square piano. The worldly novelist,
the cynical sentimentalist, was charmed. Two years later Thackeray
expressed a wish to meet Whistler, but the wish was not strong
enough for him to keep the appointment made by Val Prinsep and
Du Maurier. His memory of *At the Piano* had dimmed and his
enthusiasm for its charm had waned.

William Michael Rossetti, whose activity as a critical journalist
was the mainstay of support for the aesthetic aims of the Pre-Raphael-
ite Brotherhood as well as the material needs of the Rossetti family,
did *not* like the picture. He wrote that it was an eccentric, uncouth,

smudgy, phantom-like portrait of a lady at a piano—a statement which, more than all else, echoed Pre-Raphaelite opinions against their French contemporaries, and it was clear that Whistler had newly arrived from Paris. In his first showing at an annual exhibition Whistler had done better than any of his friends; even Rossetti's attack created interest in his picture, and Haden was forced to admit that his brother-in-law's gifts were not mediocre; at the very least they were worthy of vigorous criticism.

In speaking of these early months and years in London, Whistler remarked that at first all doors were open to him, but on second encounter, the doors were mysteriously closed again. Millais' cordiality was extremely short-lived and soon it was clear that Whistler had failed to sustain the friendships of the Du Maurier circle. He was soon glad to sell *At the Piano* for thirty pounds to a Mr. Phillips.

The truth was that mere notice for a month or a season could not establish a young artist in what was virtually a closed market where reputations, guided by the invisible will of the Royal Academy, commanded high prices. The wealthy artists of the day were Royal Academicians who were slow to admit (then as always) a young artist of probably irreverent attitudes to their company. Whistler's manner was irreverent; he did not speak the language of Frith and Millais, who in 1860 received sums in the neighborhood of five thousand pounds for a picture; they were rich men. Whistler was fortunate to find in John Phillips, who was also a member of the Academy, a sympathetic buyer of *At the Piano*. Phillips had just returned to London after a journey through Spain and he shared Whistler's admiration for Velasquez.

It is probable that Frith and Millais overheard rumors of what Whistler thought of them, for one day he asked a new model the names of artists for whom she posed and when she said, "Frith, Watts and Tadema," he exploded with "Golly, what a crew!" The girl archly replied with cockney shrewdness, "Why, they said something like that when I said I posed for you." Such knowledge of what Whistler thought of his elder contemporaries would not be welcome to them in any society in which gossip floated among the

artists; in London society of the 1860's, irreverence of Whistler's kind was a social error that was not likely to be forgiven.

The aggressive and yet humble young George Du Maurier, who did not presume to paint—the threat of blindness precluded the hope of any career above that of being an illustrator on the staff of popular magazines—began to make his way in circles where praise of Whistler was taboo.

There was never any love lost between Whistler and Frith. William Powell Frith represented all that one thinks of today when one speaks of Victorian art, the art that made its greatest appeal to the Queen herself, that contained within it the most literal and popular reflection of prosperous middleclass English life. Frith was literally a product of his time; he was the son of a Yorkshire butler, who as a boy had come down to London, had earned scholarships at art schools, and as he gained recognition, looked upon painting less as an art than a means, if one were business-like about it, of acquiring a comfortable fortune. He was honestly, half-humorously materialistic. His first patron, James Bell, was a well-to-do druggist, who bought pictures that he could understand—and what he understood were scenes of urban life, pictures of little-boy street sweepers, barefooted, ragged, begging pennies from richly dressed, respectable, bright-eyed young ladies. Frith was a Victorian Hogarth, who had none of Hogarth's candor or moral indignation; Frith painted his subjects as though they existed in the best of all possible worlds, and his optimism was rewarded by receiving—in one instance, from the Queen—an average of 3,000 guineas each for his pictures. Beyond that figure, he earned a healthy income from lithographs and engravings of his pictures, which included of course his famous Derby Day and Ramsgate Sands. In sentiment, piety and charm his rambling, crowded canvases never failed to give their admirers their money's worth; the more children, dogs, ladies, squires, mid-century fops, carriages and footmen appeared in a single canvas, the more "human interest" stories were told. One could spend a day or a week looking at the various details of a Frith picture without exhausting its cheerful, story-telling incidents; to look at one of them was a pleasure not far removed from reading a three-volume novel taken from the shelves of a lending library.

There was no "artistic nonsense" about Frith; his figures were

painted with careful respect for the minutiae of costume, clean rags on virtuous-looking small boys and girls of the lower orders, bright silks and starched linens below the rosy or languid faces of well-to-do ladies and gentlemen; his respect for realistic detail, which represented not only unusual powers of literal observation, but many hours of hard work, directly influenced the painting of the more prosperous Pre-Raphaelites including Millais and Holman Hunt. That kind of work was anathema to Whistler; he hated it.

The newspaper critics of the day liked Frith; he was of their kind, and, if anything, his pictures represented larger "slices of life" than could be written down in their articles for *The Times* or *Punch*. With the exception of Ruskin's *Modern Painters* the first volume of which was published in 1843, criticism of painting was no more than part of a journalistic routine. The critics enjoyed the vivid scene at an opening of an Academy show, held in one of the rooms of the National Gallery, where literary and social celebrities gathered. They enjoyed the chance to talk to one another, to be seen and to be met; pictures, crowded on the four walls of the room from floor to ceiling, were of secondary interest, and Frith's pictures were of a piece with the crowded walls and the crowded room.

In these assemblies Whistler walked, or rather tripped lightly through the crowd and stopped before a Frith. He screwed his monocle into his right eye and looked intently at the canvas—then suddenly came his expletive: "Amazing! This picture tells a story! See, the little girl has a pussy cat, the other little girl has a dog— and that little girl has broken a toy; there are real tears rolling down her cheeks. Amazing." He straightened up, dropped the glass from his eye and tripped away. A few people laughed, but the genial atmosphere of gossip and praise among the critics was broken, and the incident was cause for another reason why English artists did not care to meet Whistler a second time—if they could help it.

Whistler went down into Chelsea looking for rooms and a studio; he had spent two seasons in London moving restlessly from Wapping to Old Bond Street to Newman Street where his old friend Fantin had found a cheap flat but furnished it so brightly that it was there that Whistler painted *The Music Room*. Fantin's taste had transformed a dark interior with heavy hangings into a harmony of green and rose with the aid of white enameled woodwork and cheap chintz

curtains, the kind of furnishings usually reserved for summer houses and suburban cottages. Whistler (unlike the British Bohemian artists of the day, who lived in smoky squalor whenever they took rooms in the city) sought rooms that gave the illusion, even in London, of light and air. He walked along the Thames at Cheyne Walk, and from number 16, down the steps and through the high iron gate of Dante Gabriel Rossetti's house, came Charles Algernon Swinburne. Swinburne (to whom he had been introduced in Paris) was no less remarkable to look at, no less foreign to English eyes than Whistler: he was slightly shorter than Whistler, had a slender, girlish, swan-like neck, and nervous, yet childishly small feet and hands, flaming red hair, red moustache and imperial and green eyes. Like Whistler, he recalled to conventional minds an apparition of the Devil, something that had tripped lightly on the fringes of a half-forgotten nightmare.

Whistler reintroduced himself; the two men strolled and talked. Swinburne had a particular attraction for Americans who came to London. He was gentlemanly in manner and talked in an unworldly fashion; he was quick in gesture—since he was an aristocrat, he dispensed with the more conscious formalities of his Victorian contemporaries—and he was almost always a little bit drunk. Even an American as distant from Whistler as Henry Adams was impressed by Swinburne. To Adams Swinburne fitted into a picture of what a poet should be, but in England so seldom is; his voluable courtesies, his graciousness to strangers, his paradoxical air of childlike innocence and evil caught the imagination of those who were bored or annoyed by the conventions of Victorian social behavior. Swinburne, acting on impulse, as he so frequently did, immediately introduced Whistler to Dante Gabriel Rossetti.

At this moment Rossetti was beginning to suffer the early stages of melancholia which followed upon the death of his wife, Elizabeth Siddall Rossetti; he was haunted by rumors of her suicide, and he had the vague feeling that whether she committed suicide or not, he was responsible for her death. He had begun to have hallucinations of her presence in the chattering of swallows and starlings and in the noise of doves. The habit of taking laudanum and doses of chloral at night brought fewer hours of sleep than half-awakened dreams. He invited friends to share his handsome, disorderly household in

Cheyne Walk—and among them was Swinburne. The experiment of having George Meredith join their company had already failed. It was the manifestation of Rossetti's sudden fits of good health that horrified him. After a few scenes at breakfast, Meredith left. Rossetti had grated on Meredith's sensibilities, but Rossetti also had sensibilities that were not soothed by Swinburne's presence. Because of a nervous affliction that made his skin excessively tender, Swinburne, after drinking a half bottle of wine, would shed his clothes, slide down the bannister, and wander from room to room of number 16 Cheyne Walk stark naked.

To Rossetti, Whistler was a new face and an American one, and Dante Gabriel joined his brother William Michael in admiration of the American poet, Walt Whitman, and so did Swinburne. One suspects that Rossetti thought of Americans in much the same light as he viewed his pet wombat and his peacocks that he kept with the rest of his exotic menagerie in his back garden. Among his diversions, Rossetti was an inveterate collector, and to his collection, though he never cared too much for his art, he added Whistler. He liked Whistler's cheerfulness and he shared Whistler's eye whenever it glanced in the direction of a good-looking young woman.

Tenuous as Rossetti's friendship seemed, it was of greater endurance and of greater value to Whistler than any of the new friendships he made during his early years in London. It was true that Rossetti did not invite Whistler to meet Ruskin or any of his elder friends of the Pre-Raphaelite circle (many of whom now wearied him anyway); Rossetti with the instincts of one who knew how to manage his affairs extremely well never allowed unlikely groups among his friends to mix. He reserved Whistler for the exchange of masculine jokes and gossip that could not be shared by the somewhat emasculated hangers-on of the neo Pre-Raphaelites. When he grew annoyed at Swinburne's excesses in drink and nudity, which were harmless enough, yet were embarrassing in the presence of his buxom mistress, Fanny Cornford, he turned to Whistler with relief.

It was fortunate for Whistler to discover—all within ten minutes' brisk walk from Cheyne Walk and five minutes from Carlyle's house in Cheyne Row—the very rooms and studio he sought in Lindsay Row. Here there was plenty of air and light; the narrow house faced the Thames and it was also fronted by a deep nar-

row attractive grass and garden plot. The brick-front garden wall
created a respectable illusion of privacy, and the view from the rooms
where later Whistler painted in the second storey looked out across
the river to the south bank; the view embraced a panorama of river
barges, low skylines of factories across the river, and Battersea.

He was no less fortunate in finding a model, a red-haired Irish girl,
Joanna Heffernan, daughter of a witty, shiftless, whisky-drinking sea
captain. The girl resembled one of Titian's bathing Venuses; she had
rich lips, full breasts and a classical torso; she carried herself with
an air of unconscious physical dignity. She had come from the streets
of Chelsea as untutored as Rossetti's Elizabeth Siddall, but she had
none of the languid, almost passive will to death of Rossetti's half-
tragic Beata Beatrix, nor the dreamy sensual propensity toward error
which brought romantic doom to the wife of William Morris. Jo was
not a Pre-Raphaelite type. She had a critical intelligence and the
desire to be well read and at ease in Whistler's company; she was
by no means the ordinary model and casual mistress. She managed
household affairs with more knowledge of how to make shillings and
pence provide a meal than Whistler. Care of her improvident
father had taught her how to make five shillings do the work of a
pound. In meeting Whistler she had found a way out of back alleys
where she had lived and was free of the social stigmata to which
lower-middle-class Londoners consigned the Irish.

DURING the winter of 1861–62 Whistler took Jo with him for a short stay in Paris; this was one of the rare occasions that his visit to the city was not within the charmed circle of Montparnasse. He found a studio not too far south of Montmartre in Boulevard des Batignolles near the house where in later years Stéphane Mallarmé held his celebrated evenings at which he gave advice to younger poets. It was evident that Whistler had small wish to renew his earlier career in Paris, that the only connection he sustained was with Courbet. He introduced Jo to Courbet and Courbet responded by painting a curiously Pre-Raphaelite-like portrait of her as La Belle Irlandaise. Was Courbet in painting this picture vaguely carrying in the back of his mind the story of Tristan and Isolde, the legend that gave romantic character to the coasts of Cornwall, Brittany and Ireland? It is probable that unconsciously he was, that like many painters he responded to unformed sensibilities that were "floating in the air." Consciously the portrait was as contemporaneous as any of Courbet's canvases and one could view it as reflecting the feminine sensuality of a handsome girl overcome by the sight of herself in a hand mirror. Yet there is no greater proof of the contrast between Whistler and Courbet than what can be seen in La Belle Irlandaise and Whistler's The White Girl: Symphony in White No. 1. The same girl is there; it is Jo in a white dress standing on a white bearskin rug before a heavy, opaque white curtain; the sunlight of the studio in Boulevard des Batignolles is also there, radiating from draped wall and floor. Aside from the tour de force of painting white against white with almost abstract skill and passion, the picture was the first of Whistler's wholly remarkable psychological portraits. After the abstract qualities of the picture are discerned and

accepted, the personality of the model floods the canvas. The fair-skinned red-haired girl was anything but passive; her stillness in paint on canvas was the stillness of intense, arrested motion. Where Courbet saw the dreamy sensualist, Whistler perceived the restless, inquiring young woman, whose manner—in the portrait of her disorderly hair and searching eyes—was one of tempestuous elegance, not coarseness. Perhaps the compliment that Whistler paid her in painting her in a style that anticipated the work of the early Impressionists, was not entirely conscious; the portrait was one of his happiest inspirations.

During this period of Whistler's life, much can be made of Courbet's influence on his painting—Courbet's hand can be seen in Whistler's brush stroke, in his drawing of the figure, in the feeling of warmth with which he conveyed the objects within a picture to those who saw it. These were the obvious contributions made by Whistler's brief friendship with Courbet; yet the essentials of what Whistler said in painting were his own; for better or worse, his painting was never mindless; however far he was removed from genre painting and the making of book illustration, the half-literary, psychological nature of his portraits created a gulf between him and the painters of various French schools. His painting was marked by intelligence and ingenuity, and by a touch of elegance in his subjects and treatment of them that became his signature—and at times his weakness.

His stay of fifteen months in France was in some respects the most fortunate period of his life; his relationship with Jo steadied his intentions and yet carried with it few domestic responsibilities. During the fall and winter Paris itself had never been lovelier; Napoleon III had begun to open up its boulevards; it had become "the city of light" that was to charm the entire world beyond the nineteenth century itself. Suddenly Whistler fell ill; it was suspected by those looking at *The White Girl* in his room where Jo served him meals that he had been poisoned by the white lead in the picture. This was possible but highly improbable; Whistler always ate fitfully and with indifference to punctuality at meals. He lived on what is vaguely called "nervous energy." At work he frequently forgot to eat and held gaily to his theory and practice of timelessness by neither heeding clocks nor carrying a watch. The result was a return of his childhood

"sore throat," the slight, yet chronic illness that followed a session of protracted hours before a canvas in his studio.

A Dr. Chapman recommended a change of air, a trip across the Pyrenees, and bathing in salt water. At Guethary his attempt to follow doctor's orders nearly drowned him; he was an agile swimmer, but weakened by his recent illness, he was erratic; the sea was high and waves drew him beyond safe distance of the beach. The more he swam, the farther out he drifted into sea. Finally his calling out for help was heard on shore, and Jo, assisted by a burly brakeman from a train, effected a rescue, and he was hauled to shore.

The incident cast a shadow across his plans to visit the Prado, to see as he had long wished to see Velasquez' painting in all its variety; he got as far as Fuenterrabia where he said the children looked like little Turks and all the natives put together looked like characters dancing on the stage of the Opéra Comique. He wrote to Fantin, urging him to join his travels southwestward to Madrid; but the fine edge of Whistler's Spanish curiosity suddenly dulled; Fantin could not come and Whistler returned to Paris and, a short time later, put up for a brief stay at the Hadens' in London.

Whistler's *White Girl*, being as she was, slightly in advance of her time, did not please the judges of the Academy—she was sent on to hang, surrounded by Frith and Maclise and Augustus Egg—Egg the most extraordinary of the genre painters—in the newly opened Berners Street Gallery under the title of *The Woman in White*. In the age of storytelling pictures, it was to be expected that the Berners Street Gallery saw in Whistler's portrait of Jo a likeness to Wilkie Collins' popular novel and gave it the same title. Its inappropriateness to Collins' *The Woman in White* confused the critic of *The Athenaeum* and moved him to say that Jo's face was the face of *The Woman in White*. The entire picture had no resemblance to Collins' story and his heroine, to which Whistler replied that he had not read the book, nor was he responsible for the picture's title. Yet he merely translated the title to *La Dame en Blanc* when he showed it at the Salon des Réfusés in Paris a few months later, and to his friends he said *The White Girl* had achieved her place in the world through a *succès d'exécration.*

Whistler's ambiguity in naming his pictures was consistent with the evolution of his theories about painting: his pictures were *not*

to tell a story; if the picture happened to be a portrait the name of the sitter was subordinate to the arrangement of the entire picture and what the artist perceived. Whistler at this moment had effected in theory, at least, a break with the steadfast naturalism of Courbet— and he took a hint from the title given to *The White Girl* by Paul Mantz, the French critic, who reviewed the show at the Salon des Réfusés, who called her, as though he were paying a compliment to a lady, a "Symphonie du Blanc." With deeper seriousness than such a compliment might be taken to imply, paintings were beginning to be compared to music; that comparison was of a kind that floated through shop-talk in cafés and gossip in studios; fifteen years later Walter Pater was to give it a rationale in his essay on Giorgione, to say as brilliantly and as plainly as he could—"All art constantly aspires toward the condition of music—" a conclusion that Pater probably arrived at through his readings in contemporary French literature.

For Whistler the idea embodied a release from a literal interpretation of what he saw and reinforced his belief in the teachings of Lecoq. The idea paid its respects to the uses of memory and endowed painting with the instantaneous effects of hearing a piece of music for the first time.

 VIII

AS Whistler settled into Lindsay Row, his friendship with Rossetti brought with it fateful consequences: it opened the way to a commercially valuable acquaintance with Murray Marks and a jocular, erratic friendship with Charles Augustus Howell. His relationship to Marks was one that in the minds of those who overheard gossip about painting without understanding its meaning confused Whistler's name with those of the Pre-Raphaelites. And Whistler's association with the disreputable Howell kept him on the nether side of polite society for some few years to come.

In the figure of Charles Augustus Howell, a fair-skinned, dark-haired young man with a black moustache and long eyelashes who claimed to be, but with the vaguest of proof, related to noble Portuguese families, the Rossetti household in Cheyne Walk touched the fringes of London's underworld. Howell lived with his wife and mistresses—all women of extraordinarily good looks, surrounded by a half-dozen children—no one knew who their mothers were, yet it was agreed that Howell was the father—in a large, pretentious house in Fulham Road.

Howell's house was situated in a neighborhood which lay between semi-fashionable Kensington and Bohemian Chelsea; the address gave Howell the necessary pretense of ultra-respectability. Fulham was a likely place for ambitious young men of growing families to make their start toward getting on in the world; it was only much later in the period between two World Wars that the run-down mid-Victorian respectability of Fulham began to acquire a sinister air. Howell used Fulham and his house as a base for his thoroughly peculiar business and professional activities.

He was something of a painter and an able teacher of the graphic

arts. But his skill was directed toward the art of making forgeries of "old masters" and disposing of them to unscrupulous art dealers. Among his mistresses, who were handsome girls possessed by a yearning for the arts, he formed a small artists' workshop whose specialty was in making forgeries of which he was director and teacher. The most gifted and the handsomest of his girls was the slender, brown-haired Rosa Corder whom he taught to make a good living through her accurate copies of the obscene drawings of Fuseli—each set sold to the buyer as the "originals," as though they had been filched from the archives of the British Museum. Howell had the advantage of being far better looking with his Greek profile, slender waist and broad shoulders than a young man in his chosen profession had a right to be.

Howell had excellent taste in clothes—he always dressed smartly. He shared a love of horses with Rosa Corder and wore well-tailored riding habits. His taste in objets d'art and a nearly faultless eye in selecting beautiful women made him a hero in the Rossetti household. Rossetti, tortured by memories of his dead wife and housed with a florid blonde mistress, Fanny Hughes, afterwards known as Mrs. Cornford, who had grown enormously overweight, turned with relief to the young women Howell brought to Cheyne Walk. Howell's claims to possessing large fortunes and noble pedigrees were set down as lies by the worldly Rossetti.

Rossetti knew a few facts about Howell who had been introduced to the circle at Cheyne Walk by Ruskin. Howell had been born in Lisbon, son of an English drawing teacher, and, so it was said, of a completely unknown Portuguese girl; at the age of 17 in 1857 at Oporto he was arrested and convicted by his victims of dubious practice in playing cards for money and he was deported to England and placed under the care of a rural uncle who lived at Darlington. Howell's talents and interests were anything but pastoral; his father's profession which was his only inheritance gave him a touch of authority in speaking of the arts, and when he escaped from the dull prospects of Darlington, he attached himself to notoriously artistic men of letters. Ruskin who could never resist a romantic story, since he himself had written the utterly charming fantasy, "The King of the Golden River," for the child who afterwards became his unhappy wife, trusted details of his financial affairs

to the handsome, attentive, low-voiced Howell who spoke of living in Morocco as sheik of a tribe. What Rossetti probably did not know was that Ruskin tested his young wife's faithfulness by leaving her alone in the company of Howell in the hope that he would seduce her. Ruskin, much to his discomfort, soon discovered that Howell was not the man in whom to confide either financial or domestic mal-adjustments; Howell's light manner of treating moral transgressions and capping them with startling anecdotes of his own duplicity began to frighten Ruskin who then saw himself as a ripened victim of blackmail. But Effie Ruskin, his wife, had been quicker than he; her distrust of Howell sprang from her intuitive distrust of Ruskin's behavior, and to her Howell's glittering attractions to both men and women was proof enough that there was something wrong.

Ruskin hated to distract his mind with thoughts of money; even in his fits of benevolence which were not infrequent, he preferred to make Howell his intermediary and gave Howell a salary of three hundred pounds a year. It was widely rumored that Ruskin paid the rent —for how long it is not certain—of Howell's large household in Fulham. One day Howell came to Ruskin and told him of an artist who stood in need of a thousand pounds, and Ruskin wrote out a check in the artist's name and handed it to Howell for immediate delivery. It was the last that Ruskin heard of the check, but a few months later he dropped into the artist's studio and saw his friend pacing the floor in fury.

"What is wrong?" asked Ruskin.

"Why, that man, Howell, that thief, that liar, has been getting money in my name, saying I sent him to borrow it, and then putting the money in his own pocket."

Ruskin saw the image of Howell forging a thousand pound check, but he dropped his head and said nothing. The painter saw that Ruskin felt and knew more than he would tell.

"Has he ever borrowed from you?" the painter asked.

"Perhaps—I'm not sure—I forget." Ruskin looked ashamed, embarrassed. The truth was that he could not make up his mind as to how far Howell would go in telling stories of his mismarriage to Effie Gray, whether Howell had guessed at his real condition, his auto-eroticism, that he had never slept with Effie, that he had told her when she undressed before him all women's bodies were un-

speakably ugly. Had Effie confided in Howell? And then immediately feared and disliked him? Ruskin was sure of none of this. He did not dare bring complaint against Howell for forgery and theft. Howell, upon entering any household had the fatal charms and gifts of intimacy; he inspired through his handsome, mock-candid address confidences of those who were less sensitive, less worldly than he. For the present Ruskin took the safe course of action; he did not press Howell, but recommended his secretarial services to Swinburne and Rossetti. Ruskin guessed that at 16 Cheyne Walk Howell would be occupied with domestic scandals greater than his own.

And in the Rossetti household, as a nearly daily visitor, Howell prospered: it was he who directed, engineered the midnight digging up of Elizabeth Siddall's body in the churchyard and from its coffin rescued the manuscript of "The House of Life" which Rossetti in his grief had buried with it. The adventure was as romantic as any of the tales that Howell invented to give himself an impressive oral autobiography which included on proper occasions of dinner parties a claim that he descended from Boabdil el Chico and therefore wore a broad red ribbon across a white shirt front. While William Morris emphatically swore that Howell had stolen the ribbon from an innocent compatriot, Rossetti laughed and referred to Howell as "the cheeky."

Howell became the subject of one of Rossetti's limericks; limericks, by the way, that sounded very gay and sharp as Rossetti recited them to his friends, but lacked felicity when recited by others or set down in print. It took a supper of bread and cheese and considerable wine to make Rossetti's limericks as witty as they were supposed to be:

> There's a Portuguese person named Howell,
> Who lays on his lies with a trowel:
> Should he give over lying,
> 'Twill be when he's dying,
> For living is lying with Howell.

Yet the limerick defended Rossetti from the charge of being deceived by Howell; with a touch of melancholy Italian cynicism, Rossetti made Howell useful at moments when he wished to enlarge his collection of objets d'art or when he unexpectedly, which was

often enough, ran out of cash. Inspired by Whistler's buying of Japanese prints and blue china in Paris and his enthusiasm for them, Rossetti began to collect Oriental art and craftmanship—and in these purchases, Howell was his agent. But if Howell could buy things with a discerning eye, he could also sell stray drawings, etchings, sketches, scraps of painted canvas—and within a few hours—at amazingly high prices. One great secret of Howell's success was his art of forgery, either by the skill of his own hand or those of the pretty and clever young girls who shared his affections and his house in Fulham. By a change of signature and a little aging and weathering treatment a Whistler or a Rossetti sketch became a sketch by Rembrandt or Leonardo da Vinci; these would appear in shops that were frequently fences for stolen goods. Howell's workshop also turned out faked Rossetti's, carefully reproduced, even to the interwoven D G R set in a square in the right-hand corner of a drawing. It is likely that Rossetti winked at rumors of his discarded sketches being signed Leonardo or Michael Angelo—this was a joke that carried with it more than a hint of flattery—but when he saw one of his own drawings faultlessly copied and for sale in a dealer's window at a price that was higher than he usually got, he was speechless with rage.

The wide range of Howell's connections which extended from Ruskin's house on Denmark Hill to the back doors of unscrupulous shop dealers in Bloomsbury fascinated Whistler. The figure of Howell had the same attraction to him that creatures of Henry Murger's *Vie de Bohème* had for him during his early days in Paris. Howell had a quick intelligence; he knew good things when he saw them; he could spot fine examples of China "Blue"—Chinese porcelain of the 17th and 18th centuries almost as quickly as Whistler could; and in buying them up from dealers, he could act with more celerity and get them cheaper than Whistler could—"Criminally speaking," said Whistler, "the Portugee was an artist."

Whistler loved a quick eye and a quick brain; he had an amoral love for all tricks of sleight of hand—and the light-fingered ease with which Howell stole drawings and etchings from him and from Rossetti inspired his admiration rather than his anger. Like many Americans before and since his time Whistler had an ill-concealed love of the underworld, a love of the singular breaker of laws, which was

the obverse side of his own Puritanism, his austerities in food and drink. Howell became a vicarious outlet for Whistler's delight in evil; Whistler could not, would not stoop to Howell's habitual dishonesties, his inabilities at all times to tell the truth, but he could make Howell a personal representative of his own allegiance to the devil he had etched on glass, which he promptly did.

And as for the respectabilities of Victorian London, its artists, art-dealers and art patrons, Howell to Whistler represented levity in the face of false seriousness; Howell was a gay and obvious scoundrel, while other petty business men of the arts, some of whom had no more scruples than Howell, assumed a shabby air of innocence as they sold their stolen goods across the counter. Howell was more than a salesman; he was a showman with some of the same talents and instincts that D'Oyley Carte possessed and showed to the world in his productions of the Gilbert and Sullivan operas. It was in a D'Oyley Carte-Gilbertian spirit that Howell upon being brought into court on the charge of having swindled a collector out of forty pieces of blue China pottery appeared at the trial with forty four-wheeled cabs waiting outside, each with an example of Chinese "Blue" stowed in its interior; Howell through his histrionics amazed judge and jury—and won the case; and the incident with its attendant publicity increased the vogue for blue China among collectors. This kind of publicity gave Whistler prominence as the originator of a taste for Oriental objets d'art; if his reputation was not enhanced in conservative quarters, he had caught the eye of those who were interested in "the latest thing"—and Howell's spectacular adventures in collecting Chinese "Blue" contributed its share in making Whistler a fashionable subject of conversation at dinner tables.

Meanwhile Whistler's relationships with his family were beginning to undergo internal changes—the outward sign of which was an open quarrel with Dr. Haden. Rumor credited the cause to the presence of Jo—a logical conclusion, for Jo could not be accepted at the house in Sloane Street; naturally enough Haden could not compromise his professional respectability by entertaining his half-brother-in-law's mistress. The Sloane Street house was the scene of a quarrel that resulted in the two men shouting at each other.

London knew, perhaps too well, Whistler's associations with the poverty-haunted Greaves brothers and the notoriously unscrupulous

Howell; charges of cheapness, of bad drawing, of using tricks rather than art to produce his effects, were strongly hinted; *Punch* wrote:

> "Well, sir, I'm master Jimmy Whistler, I am, and I can do this sort o' thing with a shilling box o' paints from the Lowther Arcade, a few sheets of blotting paper, and some brown paper covers off the family jam pots. I could do bigger work with improved materials, you bet!"

Whether the attack was written by *Punch's* editor or not, or for that matter by any journalist, the voice behind it was of British conservative (and moral) opinion; it spoke for those who supported the Royal Academy; it spoke for those who admired Frith; it spoke for those who regarded Holman Hunt as a virtuous if sometimes misguided Pre-Raphaelite for the obvious reason that his paintings with their painful recording of realistic detail had visible evidence of hard work in the making of them. However long Whistler posed his models, however often he rubbed out the picture he had painted and then reconstructed it again—it never looked as though months of effort had gone into it. This general appearance of Whistler's canvases was to count against him a few years later. Neither the portrait of his mother, nor the Carlyle, nor the Miss Alexander harmony in gray and green had been in circulation long enough to reach a critical public outside of those who walked in and out of the house in Lindsey Row. Another Miss Alexander, the elder Miss Alexander had been begun, the figure of a girl in a gray dress with a gray wall behind her and a vase filled with buttercups at her right side. Whistler never considered the picture finished; it lacked the movement of the *Harmony in Gray and Green*; but it had elegance and charm; placed as it is today at the Tate Gallery in London, near the white girl with a fan, it has the virtue of contrast with the other picture. It seems less "unfinished" than an example of Whistler at his second best; it is pleasant and cool, and the figure seems remote, as though she were standing undecided as to whether to move forward or backward, or to dissolve where she is standing in gray mist.

The mid-eighteen-seventies were the most productive years of Whistler's life; not all his portraits took the time to complete that his portraits of his mother, Carlyle and Miss Alexander demanded—he had also developed a certain facility in the painting of his noc-

turnes. He seemed to be able to work endlessly from day to day; he smoked little and drank less.

Scarcely a day would pass that did not witness bill collectors enter the gate at Lindsey Row and frequently go up the stairs to his studio on the second floor. When idle visitors stepped in to see him, he sent some out on errands to buy—on credit—further supplies, either paint or brushes, or canned peaches; some would be sent out with money to pay bills. Whistler viewed his creditors as an unnecessary distraction from the day's work, but he welcomed readily enough distractions of another kind; he would pay a hurdy-gurdy man by the hour to grind out music in his back garden; this was Whistler's tribute to the spirit of levity, to lightness of tone in a heavy, fog-ridden atmosphere.

Murray Marks's understanding of artists was an insight that was close to genius; he understood the points of honor they recognized, and his position as an adviser to galleries, museums and wealthy buyers of painting and objets d'art not only made him a valuable man to know, but the position also insured him against acts of faithlessness; it would have been extremely thoughtless on the part of an artist to abuse Murray Marks's gestures of benevolence—the loss of his friendship would have invited disaster. He was in a position to advance money to artists which he frequently did and was also assured that among the artists' creditors, he was the first to be repaid in full.

Only the pathetic Simeon Solomon betrayed Marks's faith in him and remained at the time of his death in debt to him. Despite the fact that he danced naked with Swinburne, screaming and laughing with him through the rooms of Rossetti's house, much to the disgust of Rossetti and his buxom mistress, Solomon's excesses did not result in a short life. Solomon came of an Italian-Jewish family that had made a small fortune by importing Leghorn hats to fashionable shops in London; Solomon was fair-haired, and to Walter Pater he looked as a young Greek god should look. Solomon painted a little and drew a little; for a short time his drawings fetched high prices, and he wrote what Swinburne thought were charmingly obscene letters. In 1905 he died of chronic alcoholism in St. Giles' workhouse—in an environment whose terror recalls the darker pages of *Oliver Twist*.

Among Marks's artists, Solomon was an extreme exception to the rule, and Marks viewed the young man's lack of plain dealing with fatherly concern—and more grief than anger. Marks's friendship with Whistler was of the usual order; the two men could and did exchange lasting favors which were of great mutual benefit. Whistler in meeting Marks spoke of Madame Desoye's little oriental shop in Paris where he, Manet, Fantin, Baudelaire and the De Goncourts had found fine Japanese prints and bits of Chinese porcelain; Marks was not slow to take the hint; he entered the business of importing rare oriental objets d'art as well as Japanese prints to London and fostered Rossetti's and Whistler's mania for collecting them. He was always careful to give Whistler credit for creating a vogue for oriental art, which was consistent with his character and of advantage in proving to his clients that he was aware of the latest fashions in art—and it was through Marks that Whistler a decade later met Frederick Leyland, the most extraordinary of his patrons.

Between Marks, Rossetti and Whistler, the turns of being in fashion were reciprocal; in the public mind, however, the figure of Whistler had become confused with those of the Pre-Raphaelites. All became part of an "Aesthetic Movement" and distinctions between them were blurred and remained so for another fifteen years. Aside from their actual paintings and theories about them, the friendship between Whistler and Rossetti, though never deep, was warm and honest. Whistler had been troubled by the placing of his signature on his canvases and etchings; Rossetti who had wit, felicity and facility in sketching designs from initial letters of a name presented Whistler the wittiest of his small creations—a "W" in the form of a butterfly. Their private joke became a public one; Rossetti's gift was both a compliment to and a challenge of Whistler's ingenuity. Whistler accepted the gift, improved upon it, made it come to life as his signature and added it to the legend of his personality. It is almost impossible to overestimate the value of Whistler's indebtedness to Marks and Rossetti.

IX

THIS phase of Whistler's life, with his quarters in Lindsey Row, one in which his friendships with Rossetti, Fantin and Legros were maintained on an even keel and which included many short trips to Paris, were years in which he established his London reputation; they were also the most productive years of his life. These were the years from 1862 to 1879—the year of the Ruskin trial. Incidents crowded upon one another. In Lindsey Row the studio like so many of the others that were to follow it was a large room with pale yellow walls reflecting light, with a Japanese fan or two tacked on the walls for decoration. But for a screen and a draped seat for the model, Whistler's palette set upon slender legs and looking like a tea table tray, his easel and canvas, the room was empty—which was in startling contrast to the Parisian and London studios of that day. Wherever Whistler worked, the quarters were as neat and bare as a commanding officer's tent behind the field of battle—and seemed as temporary. In houses where he lived, some of the rooms were incompletely furnished and decorated, as though he had not quite moved in. He seemed always to be, as they said in the language of his day, "on the wing." In Lindsey Row, when he was not actually at work on an etching or a canvas, he was on the river, up to all hours of the night in a rowboat with Walter Greaves, or sitting up in a crowded dining-room with Rossetti, Swinburne, Howell, and their friends and mistresses. At the center of the dining table in Rossetti's house a wombat or a dormouse would fall asleep to the sound of Swinburne's voice reading lines from Whitman's *Leaves of Grass;* in the back garden the peacocks would shrill (Whistler's peacock themes were undoubtedly inspired by Rossetti's peacocks) and the pet bull chained to a stake would stamp the ground and moan.

When Rossetti in his deepest fits of melancholia believed himself persecuted by Lewis Carroll and felt that he was an object of ridicule in *The Hunting of the Snark,* his instincts did not lead him far astray. If the Bellman of the poem was only faintly reminiscent of Rossetti's leadership in the Aesthetic Movement, in *Alice in Wonderland* the mad tea party did resemble dinners at Rossetti's Tudor House in Cheyne Walk.

In print Swinburne took the center of the scene by writing of art for art's sake, by disassociating morality from works of art. He also wrote a poem celebrating Jo's portrait as the white girl with a fan whose title was "Before the Mirror" and whose lines were inscribed on the frame that Whistler designed for the picture. Since Whistler did little reading at any time during his adult life, the dinner-table conversations kept him rather more than well-informed on what was being thought and talked about among the critics of the day. He had a front-row seat at an intimate drama that thirty years later was to culminate in the overthrow of moral instruction in the appreciation of painting and literature. He was near the source of a movement whose logical apotheosis was the figure of Oscar Wilde.

Everything considered, the public association of his name with Swinburne's was a gift of good fortune to Whistler, and it was reinforced by an association in Paris and through the agency of Fantin-Latour with Baudelaire. Whistler's admiration for Baudelaire was as ill-defined as his actual friendship with Swinburne, but the admiration of the French and English poets for one another was genuine enough, and in the public mind Whistler held a position somewhere near the center of the circle that their mutual admiration formed. It was there for everyone to see in Fantin's large canvas, *Homage à Delacroix,* with Whistler standing at the center of a group in which Fantin sat at his left and Baudelaire at his extreme right. None of Whistler's contemporaries painted his portrait in a more engaging manner than did Fantin in *Homage à Delacroix;* the Whistler of this assemblage is unmistakably a dandy, standing erect in a black frock coat and leaning lightly on the gloves folded over the head of his stick—but the face with lively eyes and nearly smiling lips has a curiously innocent expression and is boyish.

The picture was spectacular in its fashionable appeal, and though it may be regarded as less a work of art than a literary document,

even today it has lost none of its air of being in high fashion, and it
retains much of the charm of Fantin's almost feminine personality.

The incidents of Fantin's *Homage à Delacroix* and Swinburne's
poem, "Before the Mirror," gave Whistler the kind of notoriety that
enhanced his fashionable reputation. To a few patrons he became
more than an American phenomenon in London and Paris. His
name trailed in the wake of the startling, unorthodox reputations of
Baudelaire and Swinburne, and for the next twenty years his repu-
tation was associated with all that was new (and to some critics,
dangerously new) in art and literature.

Meanwhile Whistler at Lindsey Row had found rooms there
for his mother who had come to London, and though extremely
modest, they were delightful rooms. Mrs. Whistler, aside from her
desire to be near her stepdaughter and James, had felt the privations
of the Civil War in Pomfret, Connecticut, all the more so because
her younger son, Dr. William, was a surgeon in the Confederate
Army and the Whistler family had identified itself with the South-
ern cause. The simplicity of the rooms in Lindsey Row—the studio
was on the second floor overlooking the back garden—pleased Mrs.
Whistler: the dining room with its blue china plates set on shelves
against an archway sunk one foot into the wall, the table cloth of
printed cotton, all seeming to reflect light in pastel colors. The liv-
ing-room with its Chinese screens, the mantelpiece where Jo stood
as the little White Girl with the fan, also reflected scenes much to
Mrs. Whistler's taste formed in the modest austere places where she
lived in the United States. The Victorian fashion of crowded rooms
was absent here; in that sense, she felt at home. The presence of Jo,
however, created embarrassment, and whenever Mrs. Whistler hired
a maid to do the housework—if the girl was at all presentable—she
would find her strolling serenely naked into Whistler's studio on the
second floor. A certain air of tension developed in the small house-
hold. She had always been indulgent to Whistler's whims, yet her
sense of propriety became precariously unsettled; this was not home
according to her standards of conduct.

With this situation very much alive at Lindsey Row it is easy to
understand why Whistler's studio retained its air of impermanence,
why Whistler's journeys across the Channel to Paris were of greater
frequency, why his friendships with the Greaves family of two

brothers and a sister approached intimacy. The three were children
of a Chelsea boatbuilder; the father had rowed Turner the painter
across the Thames on many holidays, and probably through Turner,
the son Walter Greaves became interested in art. For young Walter
Greaves having Whistler as a neighbor in Lindsey was an omen of
good fortune for his devotion to painting. Young Greaves was the
Henri Rousseau of Chelsea; he was unworldly—he had an innocent,
childlike eye and purity of spirit—and he chose Whistler as his
model in general appearance and dress. Only his shyness prevented
him from imitating Whistler's behavior. In exchange for rowing
Whistler up and down the Thames, for being his errand boy, his
carrier of etching plates and canvases, as well as his midnight con-
fidant Greaves took instructions in painting from his master. Greaves
strolled about Chelsea as one who was half-cracked; he was seen
as a thin figure with a black frock coat loosely draped around him
and with a battered tophat awkwardly set upon his head. He
haunted bookstores near the British Museum and in exchange for
second-hand books, he offered pencil sketches: scenes of Chelsea,
walks along the Thames, and little portrait drawings of Whistler.

Greaves with his timid pretensions to a shabby gentility passed
like a shadow through and in and out of Chelsea. He loved Cremorne
Gardens, its open-air amusement parks, its paper lanterns, band
music and fireworks, and he guided Whistler through them; he loved
Battersea, the river and gray-blue fog above it; he joined Whistler
in the making of nocturnes, and Whistler, laughing, spoke to others
of him as "my pupil." His pupil took his master to his house and
had his sister sit to him. Greaves came to know Whistler better than
Whistler knew him—for the pupil painted portraits of the master,
posing him always in flamboyant, yet naïve attitudes—and when he
painted him in his studio, the perspectives seemed deliberately dis-
torted, as though the room held at least five walls and all its objects
were viewed, including the strident Whistler, from an angle just
around the corner. Whistler probably sensed but never admitted that
his all too humble pupil had a touch of genius in his own right.

The slow painting of Christine Spartali's portrait, which was said
to require over seventy sittings, and which was begun in the year
1864, was continued through a period of concealed emotional con-
flict in the Whistler household. In a letter written to Thomas Arm-

strong (who knew Whistler during his student days in Paris), George Du Maurier gossiped of violent scenes between Whistler and his brother-in-law, Haden, and behind these quarrels the dimly outlined forms of Whistler's mother and Jo, the housekeeper model, may be discerned:

> February 1864
> . . . Jimmy and Haden a couteaux tires; quarrel about Joe [sic], in which Haden seems to have behaved with even unusual inconsistency and violence; for he turned Jimmy out of doors vi et armis, literally, without his hat; Jimmy came in again, got his hat and went and said goodbye to his mother and sister . . . it's a deuced unfortunate thing and there is little chance of ever a raccommodement. The best part of it is that Haden has dined there [obviously at Lindsey Row], painted there, treating Joe like an equal; traveled with them and so forth, and now that Joe is turned into lodgings to make place for Jim's mother, and Jim is living in respectability, Haden turns round on him and won't let Mrs. H. go to see her mother at a house which had once been polluted by Joe's presence. Droll, eh?

There is more than a touch of smartly turned vulgarity in Du Maurier's manner, yet it echoes accurately enough one British attitude toward Whistler in the 1860's. Du Maurier went on to say:

> As for Jim I am told he stands in mortal fear of Joe, and that he is utterly miserable; I met him lately and he certainly wasn't very nice to me, and seemed to have grown spiteful and cynical et pas amusant du tout. I fancy Joe is an awful tie.
> Take warning by this, O ye who rail at the domestic hearth the 'domus and the teasing and pleasing wife.'
> The Greeks [the Ionides of course] are a providence to Jimmy and Legros, in buying their pictures.

The situation at Lindsey Row was slowly mounting toward a domestic crisis. The fact that it did not explode into a sordid, semi-public display of recriminations reflects credit on Jo, Whistler, and Whistler's mother. An atmosphere of austere dignity prevailed. In

September of 1865 Whistler and his brother took their mother to Coblentz to visit an oculist; her sight was failing, and she needed treatment. On the way home Whistler spent a month with Courbet and Jo at Trouville and began a series of sea-pieces. In November he returned to Lindsey Row for two months, then disappeared for ten months, sailing as far, so he told friends afterwards, as Valparaiso. Rumours were that he had sailed the Atlantic to New York and did not find the city to his liking; he told several stories, all of which had a dream-like atmosphere, and no conviction. The facts are these: he had left London for a ten-month period; on his return he displayed several paintings that reflected change of scene, including the beautiful canvas, *The Pacific*, now in the Frick Collection in New York, and *Valparaiso Bay*. One is inclined to believe that he actually sailed as far south as Valparaiso; what happened on his trip remains open for speculation. The Ionides and their friends had advanced him enough money for a holiday.

In the light of Du Maurier's letter of February 1864, a motive is supplied for Whistler's need to leave Lindsey Row and its domestic tensions. Another motive, hinted at in a story of his journey to Chile, is associated with the American Civil War. Whistler said he joined a group of restless exiled American Southerners sailing to South America from London. This action, unproved and romantic as it sounds, has a touch of probability in it; his brother, Dr. William, had served as a surgeon in the Confederate Army, and their mother had crossed lines to visit him in Richmond, Virginia, which was a courageous journey. American exiles (including Henry James) carried with them a sense of guilt for non-participation in the Civil War. It is probable that Whistler shared that sense of guilt as well as the restlessness inspired by it. At this point it is better not to speculate too freely but to say that two clear motives joined in a rapidly formed impulse for Whistler to leave London, to leave London mysteriously for reasons far too private for him to discuss openly. The domestic motive seems the more important. In his relationships with men Whistler was sometimes bitter, harsh, sadistic: his treatment of Wilde, Mortimer Menpes, Logan Pearsall Smith and others supply more than ample evidence of cruel conduct. In his relationships with women another aspect of his character came forward. In a highly romantic fashion, he was chivalrous, and often admirably

silent—and would avoid even a semi-public scene. In speaking of a vague, dream-like sequence in his South American voyage he mentioned a group of girls calling himself and those with him "Cowards." In other words, his trip was an action of evasion. Was he avoiding scenes between his mother and Jo? That probability seems certain. He owed loyalty to both. A ten-month trip away from Lindsey Row dulled the edges of conflict between them, and time softened his move to keep Jo as an "absent" mistress and to place his mother in ascendancy at Lindsey Row.

Whistler's restlessness in Lindsey Row produced strange results and not the least of them was one mentioned above: the semi-Japanese, semi-Rossetti-ish *La Princesse du Pays de la Porcelaine*, a *tour de force*, a portrait of the beautiful Christine Spartali, daughter of the Greek Consul-General and friend of Ionides: the Greek girl in a Japanese kimono standing among Oriental screens. The portrait was something not seen before or since in London. Later the picture was to have fatal consequences in the Peacock Room of Leyland's house in Prince's Gate. The Greek Consul-General's wife found the picture inappropriate for her daughter. On days she stood for it, the sittings were extraordinarily long; and after them Whistler's mother served the Spartalis American lunches on low tables and stools very nearly in Oriental style. The combination of sliced raw tomatoes, lettuce, roast pheasant, canned apricots and cream, Japanese screens, endless hours of posing, Mrs. Whistler's piety (Jo was at this time conspicuously out of sight) made Christine Spartali ill. She and her family began to hate the picture and when it was finished, they refused to buy it. It was not the last time that Whistler ran into difficulties of this kind with those who commissioned him to paint a portrait.

Whistler said that his white forelock made its first appearance on his South American journey. His accounts of the trip in his several versions were made acceptable for light conversation over a cup of tea or a few sips of sherry. His only proof of valor was in the paintings that had grown out of his ten-month tour; he had reestablished the manner of his nocturnes and the sight of the Pacific gave refreshed authority to what he had learned from the Japanese.

The white forelock, absent from Fantin's affectionate portrait in *Homage à Delacroix,* had made its arrival; his brother, Dr. William,

also settled in London to pursue a completely respectable, poverty-haunted medical career in the shadow of his brother's fame. The good doctor with his benign air, no longer a heroic soldier in the lost cause of the South, assumed the character of a painfully undistinguished man. He was trustworthy and slightly rotund. In money matters the two brothers offered to help one another, yet neither could bring himself to accept money from the other. Instead, they exchanged courtesies which revealed the hidden pride and sensibilities of both. In the Sixties Dr. William's imperial and moustache, his loosely fitting clothes were those of the conventional Southern colonel.

Soon after his return from the American holiday, Whistler moved a few doors east on Lindsey Row; the Greaves brothers helped with the moving, helped to paint the walls in pastel tones of yellow and blue; the studio walls on the second floor were painted Confederate gray with black moldings, foot boards, window and door frames, and the floor itself. A half century later the influences of Whistler and Huysmans—and Whistler preceded Huysmans by nearly a generation—caused floors to be painted black in Greenwich Village in New York. The silver gray of Whistler's studio walls came from the Oriental screens he knew so well, and though it is nearly certain that he had never read the writings of Ku K'ai-chih, the Chinese sage of the fourth century in translation, it was not unlikely that he had overheard echoes of them in conversations with Murray Marks and Rossetti. It is more than coincidence that Whistler followed hints derived from Ku K'ai-chih's remark: "To portray a pretty young girl is like carving a portrait in silver. You may elaborate the young lady's clothes, but one must trust to a touch here and a stroke there to bring out her beauty as it really is."

Whistler knew (again from conversations overheard in London and Paris of the late Sixties) that the training of memory was as important to the Chinese and Japanese artist as it was to the students of Lecoq de Boisbaudran. Fantin and Legros would be among the first to inform him. In Paris in 1868 the brothers de Goncourt laid claims to being the first to introduce a taste for Oriental art through their novel, *En 18 . . .*, but it can be said that Whistler was the first to give it a sea change and to transport it across the Channel, and he was certainly the first to apply its precepts directly into paint-

ing—the first to regard portrait painting as an art that trusted primarily "to a touch here, and a stroke there to bring out . . . beauty as it really is." His struggles in painting the portrait of Miss Spartali were an exercise in that aesthetic. And "carving in silver" entered into his Nocturnes, his views of the Pacific, and later his portraits of the two Miss Alexanders. It can be safely said that his applications of blacks upon blacks, of grays upon grays, of relating blues to silver helped to create the atmosphere described by Huysmans in *A Rebours* in 1884 and in the writings of Villiers de L'Isle-Adam. These were among Whistler's gifts to the generation that followed him.

X

IF the trip to South America had done nothing else, it established Whistler in relationship to the world; Whistler came to Lindsey Row to settle a few of the more important of his decisions. Henceforth, London was to be his permanent home; he was to be a figure, however foreign, in British art; he was to continue his work in a separate line from that of contemporary French painters, and at a considerable distance from Monet, Manet, Cézanne, Degas, Renoir. From this time onward he was distinctly islanded. Although he still saw Courbet on short visits to France, his acceptance of the Oriental principles of design foreshadowed an early break with Courbet. All that he retained of Courbet's influence in the placing of the full-length figure—the portrait—on the canvas was the quality of arrested motion. And his treatment of the portrait was more psychological than realistic. In his household his mother's ascendancy had become complete, which also meant that Whistler alone had charge of household credit and expenses, and this meant that the great majority of bills were unpaid.

Mrs. Whistler thought in terms of austerely moral conduct rather than of money matters. As for herself, she dressed with Puritan simplicity and disliked Americans in London who lived in and for "society." Her single indulgence was in giving in to whatever she considered Whistler's more harmless whims. If he chose to entertain a great number of people for Sunday-morning breakfasts (which he did), she thought it right for him to use this means for advancing his professional career. She had little if any concern for the warnings implicit in unpaid bills, and if she had her doubts about them, family pride was sufficient motive to hide them. Pride

in her son's ability to solve all problems kept her silent—and her reward was in being chosen as his model for a seated portrait.

As Miss Spartali learned, sitting for Whistler was an honor in which patience and endurance were not rewarded during the interval of trial. Whistler hid clocks and refused to carry a watch. As he painted, he could not and did not wish to measure time. The title of his mother's portrait was *Arrangement in Grey and Black: Portrait of the Painter's Mother*. The title described the wall against which the subject sat in profile. The resignation of the figure, the nearly Quaker-like simplicity of the white lace headdress, the plain features of the face were painted with the restraint that was as much a part of the sitter's personality as was Whistler's art in presenting her; so far the study had its psychological interest and validity. Whether the patience and air of endurance which also contribute to the expression on the sitter's face was the result of her trial in sitting for the portrait one shall never know. But her son had purged the picture of much of its merely personal relevance by making those who saw it conscious of its art, by creating a balance between personal interest in the subject and the studied arrangement of forms and tonal shades of gray and black with appropriate touches of white, near white, and flesh tones.

The restraint that Whistler employed in the painting of a "personal" subject was the obverse side of a character that was becoming anything but impersonal in its relationship to the world. He was becoming a public figure whose delight was to exhibit personality as well as the individual purpose of his art to public view.

At this moment in the late Sixties through Rossetti and Murray Marks, the Whistlers, mother and son, met Frederick Leyland, the Liverpool shipowner—and Leyland, used to doing things in a large way, invited them to his seaside estate at Speke Hall outside of Liverpool and ordered portraits of himself, his wife and all four children. The setting provided a Henry Jamesian holiday for the Whistlers, an approach to moving in society. The tall, vigorous, and bearded Leyland, through his gestures of patronage to Whistler, approached the manner of another Lorenzo de Medici. At first, Whistler found the situation ideal for painting, as well he might, and yet a peculiar sense of self-consciousness possessed him. Despite the confidence he had acquired in going his own way, he could not transform him-

self into a professional painter of portraits; in the lighter, smaller graphic medium of etchings and lithographs, he was professional enough, but once the commission for a portrait was placed before him, he became the "pure artist" hopeful of perfection. It was said he wept over his drawing of Frederick Leyland's legs in the portrait he did of him. Childish fears attacked him as well as hopes of an impossible perfection. Leyland could spare little time for posing. The same hope haunted Whistler's painting of Mrs. Leyland; the drawing of her hands obsessed him, yet he succeeded here in putting upon canvas the essential something he sought: the negligent elegance of her manner, the movement of her figure beneath the delicate traceries and drape of her tea gown. To this day, the unfinished drawing of her hands still shows the marks of his indecision, his strange lapses into an unwilled lack of professional skill.

It was evident that the Leylands did not put Whistler at his ease; as he tried to paint their children, they ran away from him. Outwardly the Leylands were and continued to be the most patient of patrons; they accepted without undue pressure his delays in completing portraits; they gave in to his whims, but there is no evidence that they actually listened to anything he had to say—or if they did, it was not more than half overheard. They were kindly, indulgent, and more than a little absent-minded. Mrs. Leyland with her attractive head of reddish blonde hair took a special pleasure in posing for and talking for hours on end with Dante Gabriel Rossetti at his house in Cheyne Walk. His exotic menagerie, his musical voice, his large eyes gave her a sense of being richly entertained, and visiting his house gave her the illusion of something imperative to do; the friendship with Whistler was never of that quality. Of course, Whistler knew it, and the knowledge was enough to supply a motive for his uneasiness.

The visits to Speke Hall were preludes to one of the most extraordinary of Whistler's adventures with a patron, and the adventure involved the friendships of Rossetti and Murray Marks. Rossetti who was fond of Whistler's *La Princesse du Pays de la Porcelaine,* which even as it is seen today is livelier, if less pure, than most of his larger canvases, urged the Leylands to buy the picture. Rossetti, to say the least, was a generous friend and a persuasive salesman; everything that he did well, he did with ease, which, of course, was

one of the secrets of his charm. The Leylands bought the picture, and with Murray Marks' encouragement, Leyland bought a house in Princes Gate at Knightsbridge. The passion for building, or rather rebuilding, had seized Leyland, and he could afford to rebuild on the scale of the Medicis. The house was to shelter the spoils of his patronage. No advice was to be overlooked, and advice was forthcoming from Murray Marks whose business was on these occasions to take things in charge. As a good omen, Leyland learned that Northumberland House was being dismantled and coming down. He bought its huge gilded staircase and installed it at Princes Gate. And to prepare the eye for the gilded wonder he had captured, he commissioned Whistler to design the approach to it, a front hall, walls of cocoa brown, dappled with gold. Rossetti's *Blessed Damosel* and *Lady Lilith* were placed in the drawing rooms; paintings by Burne-Jones, Millais, Ford Madox Brown, Filippo Lippi and Botticelli, Legros and Watts crowded the walls. The Pre-Raphaelites had scored a victory at Princes Gate. Leyland's touch of gold was the magic that for the moment had placed contemporary art with the "Immortals"—and Leyland was not averse to knowledge of his very stylish patronage spreading in conversation among artistic circles in Kensington and Chelsea. As an arrival among the newly rich in London, Leyland, the shipowner, was like a pirate come from Liverpool to take London by storm.

The time of his arrival was the spring of 1876 and a kind of March madness added fuel to the majesty of his plans; the softly spoken Burne-Jones and the robust William Morris were consulted; two architects, Shaw and Jaeckyll, were to act as foremen to the remaking of the house in Princes Gate. Whistler had already taken charge of the hall, and rooms were parcelled out to different artists, each working in his own inimitable way from room to room. A room was found for Whistler's *Princesse,* the dining room that also housed Leyland's fashionable collection of blue and white china. A place was found for the *Princesse* over the fireplace; the other three walls of the room were lined with slender shelves supported by dark brown spokes, simulating (at some distance) bamboo poles; these were to display the blue and white china. The walls had for their covering yellow Spanish leather (imported from Spain and of sixteenth-century origin) with red flowers painted on it. Marks had told

Jaeckyll to design the room, and since Leyland was prepared to spend a fortune on it, Jaeckyll was also prepared to be as lavish as his imagination allowed him to be.

But neither Marks nor Jaeckyll was fully aware of Whistler's peculiar relationship to the Leylands; they were unaware that Whistler had designed a few of Mrs. Leyland's dresses for her, that he had proposed marriage to her younger sister, that to offset the attractions Rossetti had for her, he escorted Mrs. Leyland to the theatre and went on tours with her to the dressmakers and milliners. Mrs. Leyland was apparently enjoying herself—she afterwards confessed that she liked Whistler because she liked cats—and she probably thought of Rossetti as her tame lion. In spite of being the mother of four children, she seemed amazingly young, pretty and very slender; her blue eyes held a look of innocence and her hair when the sun struck it had a hint of fire in its coils.

In this situation there was little chance of art for art's sake prevailing in the design of Frederick Leyland's dining room. There was every chance that Whistler would not approve of Jaeckyll's attempts to please the lavish purse and eye of Leyland. In painting the portraits of the Leylands he had met with partial failure and injured pride; Mrs. Leyland's sister held his proposal at greater than arm's length and then slipped away. Whistler did not approve of the dining room at all; he did not approve of Jaeckyll, he did not approve of his Spanish leather, nor the rug with its red design upon the floor, nor the red Spanish flowers—all these would ruin his *Princesse*. He informed Leyland of his disapproval; he begged permission to stay at Speke Hall through the summer and to delay the opening of his town house until the dining room was fit to meet the critical eyes of his guests.

Whistler thought of Rossetti's garden and its peacocks, and he was certain that Mrs. Leyland also remembered them. Even before this occasion, the idea of peacocks as a motif in decoration had come to mind. Why not the blue-green of peacocks' tails to counterbalance the reds in the room? Leyland agreed that Whistler should have a hand in remaking the room. Whistler wrote a cheerful, extremely boyish letter to his mother announcing his victory; he was to prove to her that he was the best of all interior decorators. The youthfulness of the letter showed how earnestly he valued her

opinion; it was as if he were reassuring her that his difficulties in his relationship with the Leylands would be solved by the creation of a Peacock Room.

Perhaps no one of the company who gave well-paid advice to Leyland was less fitted to redesign any room of his intended palace in Princes Gate than Whistler. The charm of Whistler's house in Lindsey Row depended upon its austerities. The little money spent upon the rooms gave them their qualities of light, air and pastel simplicity. The lack of money called upon the resources of Whistler's ingenuity and wit. The only person within Leyland's reach who might have conveyed an impression of richness and a cluttered harmony out of the chaos of his dining-room was Rossetti. As it was, the only virtues of the fantastic decor had a distorted origin in ideas derived from Rossetti himself—which may have convinced Mrs. Leyland that Whistler had found the occasion to parade the pea-cocks.

Whistler had plans for going to Venice that summer. He dismissed them. The city was empty; he moved from Lindsey Row, an hour's brisk walk, into Princes Gate. With him came the helpful, shabbily genteel Greaves brothers, his assistants, his pupils in arms, humorless, docile, active. They marched into the dining room and set up ladders and scaffolding; their position at Princes Gate was a serious matter to them. They came to a world beyond Bloomsbury and Chelsea, the world of fashion where pocket money was always to be found where it should be: in one's pocket, and not to be sought for painfully through small loans from booksellers or with a ticket received from the pawnbroker.

As for Whistler he assumed military command of a garrison— the Peacock Room—in the same spirit that animated his grand-father's command at Fort Dearborn. His soldiers were the Greaves and Frederick Leyland's caretaker, and with this spirit he combined the air of Michael Angelo painting the *Creation* on the inner roof of the Sistine Chapel. Actually, however hard he worked, it was a parody of labor, quite unlike the concentration of his painting in Lindsey Row. He invited friends to watch his labors, and one remarked that on the high scaffolding he looked like an imp stepping footsure upon a tightrope. He gracefully tripped down the ladders to serve tea. Faced with that hopelessly ill-proportioned rectangular

room with its yellowed leather walls, painted flowers and shelves which were in fact perverse versions of the Victorian whatnot, Whistler's problem was difficult enough. He attempted the dangerous expedient of trial and error; he gilded the red flowers, and the yellow leather merely looked dead; he then began to paint the leather peacock blue. The color did not take well; yet it was out of character for Whistler to give up a bad situation easily—a stroke here, a stroke there might save the room. He began to treat the walls and ceiling and floor of the room as though all six sides of the room were a canvas, decorated with peacocks and his *Princesse*. He almost deceived his own eyes; he became less and less professional and more amateurish. His air of optimism which had so often brought further indulgences from his mother was transformed into slightly hysterical levity—and true inspiration was at further distance than ever. He could be neither Baroque nor Victorian Quarto Cento; that was beyond his skill. He had misjudged himself almost as completely as Leyland had misread his character and abilities; Whistler was forced to bluff, to carry off the performance as an act of showmanship to save whatever remained of his defeated vanity and pride.

He had cards printed announcing his temporary residence at Princes Gate and the progress of the Peacock Room; these were distributed at Liberty's department store as invitations to the public to visit him at Princes Gate. Leyland was not as shocked by Whistler's effrontery in making another man's house his garrison as he might have been. Since Leyland was in his own way a pirate and a successful one, he understood Whistler's tendencies in the same direction, nor was he overtly critical of Whistler's sudden arrogance—that too was something he could understand. He enjoyed the role of the generous, tolerant patron. He loved the transparent flattery of artists—and if artists gave his reconstruction of a large house in Princes Gate publicity, he could well afford to enjoy that too; at the very least, it showed the world how much money he was willing to spend.

If the presence of Leyland's wealth and the Peacock Room did not corrupt Whistler's aesthetic integrity, it showed its limitations. It displayed the contrasts of Whistler's aesthetic to Victorian art. In a professional sense his Peacock Room could not be taken seri-

ously; in a moral sense Whistler was at fault in not being able to confess his failure. To make the room a work of art, it would have to have been redone completely, its leather and shelves ripped down —it would have to have been a room in Lindsey Row. In spite of Leyland's tolerance the situation was riding to a quarrel. Jaeckyll stepped in to look at what was once his dining-room; legend has it that he went home and quite out of his mind gilded the floor of his room. Some said he painted the floor black, but whatever colors he poured across his floor he was discovered truly to be raving mad. He was taken at once to an insane asylum where shortly afterwards he died.

Poor Jaeckyll. The loss of his sanity did no more than add a footnote to the legend of the Peacock Room, and if the incident of his going mad has any meaning beyond the pathetic scene itself, it shows the kind of unstable creatures that Leyland's wealth attracted and Leyland's inability to judge the men he hired to rebuild his house. Leyland's generous lack of discrimination was earning very nearly what it deserved.

During that summer Whistler initiated the unusual practice (for him) of rising at six, of snatching a breakfast and waking the Greaves brothers. An hour and a half later they were at Princes Gate, daubed with gold paint, gold on their faces, literally in their eyes, in their hair. A symbolic farce of golden and blue peacocks was in the making. Each day the drama began at eight, ran till four with its interlude for tea, then on until it grew too dark to see anything at all. On some days Whistler hired a cab, and like the devil concealed in a coach, rode for a hurried lunch in Lindsey Row from and to Princes Gate. Prospect of Leyland's gold brought with it the excitement and flurry of brief luxuries—among them, the hansom cab.

At tea time Whistler invited his women guests to dance with him across the floor of the Peacock Room. Freshly applied with gold and greenish blue paint, the room had its attraction for impressionable young ladies, who, of course, had seen nothing like it before. Whistler referred to the work at Princes Gate as "the show's afire" and if anyone accidentally dropped into London during that dull summer, Whistler's "show" was the show to see. Visitors saw him on his back, high on scaffolding, delicately stroking with

a brush the pendant lamps hung from the ceiling. At one time he threatened to cut them all off, to shave the ceiling clean of pendants that looked not unlike inverted mountains of the moon, but he changed his mind and went on painting. The Marquis of Westminster dropped in and so did Victoria's artistic daughter, the sculptress, Princess Louise; it was she who did a seated portrait of her mother in stone, which even now gazes east with youthful authority across Kensington Gardens toward Knightsbridge. They marveled at Whistler's labors, which pleased him so much that he wrote to his mother about his royal visitors.

Scarcely less welcome than the Princess Louise at Princes Gate was Lord Redesdale.* Redesdale was in the diplomatic services; he had been to Russia, Japan and the United States, and these various places vastly entertained him. He had a fondness for Tsars and a liking for Americans, almost a weakness for learning more about their curious habits, and he developed, like a taste for olives, particular admiration for Brigham Young and Whistler. He had finely modeled features and was always smartly dressed, his top hat worn at a sharply tilted angle over his right eye. In London he loved to disconcert people by asking direct and leading questions; his rapport with Whistler which began in the early Seventies was instantaneous and lasting.

When he saw Whistler perched on a ladder in the Peacock Room, he asked him flatly, "What are you doing?"

"The loveliest thing you ever saw," said Whistler.

Redesdale was both charmed and curious.

"But what of the beautiful leather—and Leyland? Have you consulted him?"

"Why should I? I am doing the most beautiful thing that ever has been done, you know, the most beautiful room."

Young Redesdale, noting the confusion in the room, was impressed; he believed, as he wrote later, that Whistler was as confident of the value of his work as Thucydides was of his history.

Through late summer and fall the quarrel with Leyland still hung fire. Leyland continued to be patient, and yielded to Whistler's demands that he stay on at Princes Gate for another three months.

* Lord Redesdale was the grandfather of Nancy Mitford. The bright and chatty character of her prose is a direct heritage from his.

Leyland had agreed to give Whistler five hundred guineas for re-touching the room, and then he agreed on the figure of one thousand. Meanwhile, Whistler still found himself unable to leave worse enough alone at Princes Gate. The hope of perfection still glimmered before him; he received praise from the newspapers for creating a sensation, and he then demanded two thousand guineas. Another spring had arrived, the spring of 1877—and Leyland seemed ill-disposed toward the new demand. It was then that Whistler painted the cartoon of the two peacocks, the rich peacock and poor at war on the wall of Leyland's dining room. This was the closest approach that Whistler ever made to vulgarity, and even here his ill-temper vented itself in almost abstract design. It was intended as an insult and Leyland faced it. At last Leyland's temper broke and he wrote a cheque to Whistler for two thousand pounds; the exchange of insults was complete—the change from guineas to pounds put Whistler on a footing with the commercial classes, tradesmen and lower craftsmen, who dealt in and were paid in pounds, not guineas.

The gossip following the break with Leyland had serious consequences for Whistler. One story was that Mrs. Leyland had walked into the house unnoted by Whistler as he stood entertaining guests in the Peacock Room and she overheard him say of Leyland, "Well, you know, what can you expect from a parvenu?" Mrs. Leyland then ordered him out of the house. Another story ran that Leyland had spoken to Rossetti about Whistler's demand for two thousand guineas and Rossetti replied that Whistler's work in the Peacock Room was scarcely worth a thousand. Both stories had a grain of truth within them. The first contained Whistler's attitude toward Leyland, who, after all, had shown a kind of sportsmanship in allowing him to follow through his conception of design in the Peacock Room. Leyland also had the courage to permit the fighting peacocks to remain where he could face them as he sat at dinner. The second showed Rossetti's public view of the case; after all, he had sold Whistler's *Princesse* to the Leylands and he had no wish to lose the friendship of a rich patron.

The harm done to Whistler's reputation ran below the surface of immediate events at Princes Gate. Whistler had become a public character. In that respect he was no longer the artist to be appreci-

ated by the few, but a notorious figure whose services commanded a high price. He was established in London, and talk of what he did and said was dinner-table conversation. These were the immediate results of his quarrel with Leyland. Beneath the quarrel which had been hinted at by Rossetti's remarks to Leyland, was the rumor that Whistler overcharged his patrons and transformed them into victims, that his showmanship at Princes Gate proved how un-serious his painting was, that he was "unprofessional" to the last degree. This was harmful, and only half-true; like most charges of its kind, the half-truth within it caused the greater damage.

It was at this time that Henry Irving's career on the London stage reached its first great wave of popularity. Whistler's association with E. W. Godwin, the brilliant and controversial architect, and through Godwin with Ellen Terry, Godwin's mistress, brought Irving within hailing distance of Whistler's circle.* Irving had the gift of

* The relationship between Edward William Godwin (1833–1886), George Frederick Watts (1817–1904), and Ellen Terry (1848–1928) provides an interesting chapter in Victoriana. Of the three, Godwin the architect was the most highly gifted. His unconventional, romantic temperament was not un-like that of the American architect Frank Lloyd Wright (1869–1959). Like Wright's his published statements aroused controversy. Like Whistler, he re-garded his art as a "calling," a vocation—not a profession, or a trade. His influence inspired his son by Ellen Terry, Gordon Craig.

Watts was a precocious "genius" among British painters; his origins were of the lower middle-class. At an early age his facility in drawing, his effemi-nate good looks, his "ethereal" manner readily attracted art critics and pa-tronesses. At 28 (1843) he won a prize in competition for designing a huge mural to be placed (which it was not) in the newly built Houses of Parlia-ment. The prize made him famous, and also enabled him to study in Italy for four years. Watts's imagination was that of a didactic illustrator of "ideas." As he said to Ruskin, "My instincts cause me to strive after things that are hardly within the province of art, things rather felt than seen." In Italy he met Lord and Lady Holland, who after his return to England became his generous protectors; in their household he was called "Signor" and shielded from the hardships of earning a living. In the United States the best-known of his illustrated ideas was a painting called "Hope" which showed a female figure blindfolded, head bent to a string instrument and seated on top of a globe representing the world. The figure was that of a freshly bathed Eng-lish girl lightly draped in blue-green voile. In colored reproductions, neatly mounted and glazed, it hung in many suburban homes. Watts's paintings became models for "moral" cartoons illustrating ideas on the editorial pages of pre-World War I Hearst newspapers. There is little doubt that his soft

turning stray words and phrases to his own advantage. In the London of that hour Rossetti's peacocks were well known. Whistler had tried to convince Cicely Alexander's father that what his house needed more than all else was a Peacock Room. Talk of peacocks was in the air, and the image of them was as fashionable as the sight of a Japanese kimono or a display of blue and white china. In Irving's Hamlet (surely a Hamlet that would not be tolerated today) Ophelia in the "dumb-show" scene, the play within a play, carried a fan of peacock feathers, which gave Irving the chance to shout "Peacock" at her and the fan—a moment which brought roars of delight from the audience, and gave Irving many curtain calls at the end of the play.

The effects that Irving sought for and placed behind the footlights of the Victorian stage were nothing if not an exploitation of a personality, his own. Seeing Irving act became an object lesson to Whistler. Aside from being a painter he was rapidly learning something of which he had had glimpses in the early public suc-

pastel colors and "compositions" also influenced the popular American commercial artist Maxwell Parrish (1870–1938).

Ellen Terry's relationship to Watts was no less curious than that of Effie Gray's to her first husband John Ruskin. Ellen and her elder sister Kate Terry, both handsome "child actresses" on the London stage sat as models for Watts's picture, The Sisters. Innocently enough, Ellen, who was under 16, was lured into marriage with Watts (1861) who was then 48. The marriage was never consummated. Aside from her services as a docile and graceful model, Watts and his friends found Ellen Terry restless and troublesome. The painter and the girl agreed to annul the marriage. During their brief marriage and for many years before and after it, Watts lived in Little Holland House, nursed, guarded and cared for by Mrs. Princep, who served as sub-patroness of Watts with Lady Holland's approval. Godwin on his visits to the Princeps, attracted girlish and beautiful Ellen Terry-Watts, who after she was sent home to her mother, cheerfully eloped with Godwin to a country cottage at Gustard Wood and lived with him as his mistress. Prolonged stays in the country did not suit Ellen Terry's temperament; she was an actress, fond of the stage and urban life. She was rescued from domesticity a second time, by the intervention of Charles Reade, novelist and playwright, who convinced her that it was better for her to be a leading lady in one of his plays than to waste her talents as a bored housewife in a cottage. In tribute to Ellen Terry's personality and histrionic gifts Victorian domestic morality accepted her irregularities without disapproval—and she became Dame Ellen Terry. Further details of her and Godwin's careers may be read in The Story of My Life by Ellen Terry and in Dudley HarBron's life of Godwin, The Conscious Stone.

cesses of Courbet in Paris. In contrast to the fact that his canvases were painted in low tones, the colors of his personality became florid and high. He liked Irving, and more than that, admired him in much the same fashion that he liked Rossetti and tolerated Howell. The art that he admired in all three was one concerned with the projection of personality, whether it brought cheers from crowds at the Lyceum Theatre, or circulated around the dining room of Rossetti's house in Cheyne Walk, or in the case of Howell, held spellbound unscrupulous art dealers, who for the moment, were caught off guard.

In his paintings of Carlyle and of Pablo Sarasate, the violinist, Whistler had learned the advantage, however abstract his titles for portraits were, of selecting celebrated men that the public welcomed, even on the walls of his studio. With the same persistence he had shown in Paris in seeking out Henry Murger and Courbet, he sought out Irving. Irving whose long hours of work equalled those of Whistler's at Princes Gate was not at home to artists, particularly Chelsea artists whose reputations were not established in conservative circles. Whistler had made several attempts to see him and each failed. He was forced to write a letter:

"It is hopeless calling for I *never* find you—I have tried before now. Meanwhile *do* look in some afternoon directly at the 'Society of British Artists,' Suffolk Street—and see my picture of Sarasate—and let that show you what I meant your portrait to be and then arrange with me for a day or two at my new studio."

Irving had been playing the part of Philip II in *Queen Mary*, Tennyson's first play. The run of the play was short, scarcely more than a month, but it had attracted an intellectual as well as a fashionable audience—and Whistler, through his love of Velasquez—found his chance to do a portrait of Irving as Philip II.

Irving came to Lindsey Row, and though the season of the year was spring, Whistler's studio was filled with drafts and very cold; bill collectors interrupted the sittings, yet Whistler worked and the actor stood for him as though discomforts and lack of money were furthest from their thoughts. Both acted well; Whistler cheerful and confident, Irving friendly, but making his point clear that he had little time to pose, and Whistler finished the picture, an arrangement in black and silver, with incredible speed. He re-

fused to allow Irving to buy it, nor was he prepared to give it to him. Meanwhile the picture became part of Whistler's growing collection of distinguished portraits. Bill collectors and cheerful disregard of health, money and unpaid bills were warnings that Irving read meanings into that Whistler ignored. Far from cutting down expenses and moving to cheaper quarters, he was plotting with Godwin to build a house in Tite Street.

THE threat of disaster that cast a cloud over Whistler's affairs after the collapse of his intentions to improve the Peacock Room was withheld. For a short moment it seemed that his quarrel with Leyland would be turned to his advantage. Sir Coutts Lindsay became the new patron of the arts; he had greater wisdom than Leyland and less eagerness to involve himself in erratic friendships of artists. From the Duke of Westminster he leased a plot of land near Grosvenor Square and built the Grosvenor Gallery upon it and for the first showing held there he invited the more exotic, unconventional painters to contribute; he invited Burne-Jones, Rossetti, Whistler, and a few others. Rossetti declined to show, which marks the beginning of Rossetti's coolness toward Whistler and stressed the point that their association was social rather than professional. The difference of their attitudes toward art in general and painting in particular had always been clear, and by this time Whistler's remark that Rossetti should frame his sonnets and paint his poems had probably reached his ears. Whistler loaned the Gallery his nocturnes, and Burne-Jones his water colors, six panels of his *Angels of Creation,* his *Beguiling of Merlin* and *The Mirror of Venus.* On the occasion of opening the show a new Mrs. Godwin, daughter of a painter and an artist in her own small right, appeared along with other young women—all with their hair dressed in the fashion of Burne-Jones's ladies. Even on state occasions such as this they affected the Pre-Raphaelite costume of no corsets, flat heeled slippers, and long skirts which revealed the natural lines of the figure. If the paintings themselves failed to shock the smartly gowned and more conventional faction of fashionable society, the costumes of those who were most enthusiastic over the paintings did.

A new Mrs. Godwin was evidence that the Ellen Terry-Godwin household was broken up beyond repair. Even in London Godwin could not be kept at home; his children missed their charming father, and Ellen Terry used the resources of her art to answer their questions as to why he was away. She put on a widow's gown and a long crepe veil, put their children (the young Gordon Craig among them) in a carriage, drove them to a cemetery and pointed out a new-made grave. She wept aloud:

"O my poor children, there lies your dear, dear father. You will never see him again."

The children wept with her and the entire cast of this small play, worn out with an hour's weeping, drove home and went to bed. Very late that night Godwin returned, but Ellen Terry was still in full command of her part:

"You are dead," she told him, "and dead you remain. Those children would think me a fool or a liar if they saw you resurrected at the breakfast table, and it is as well for their happiness as for mine that I keep their respect. If they knew you better they would despise you, and now you will be a romantic memory. Get out, stay out."

From that time onward, so this story of Ellen Terry's liberation from Godwin went, Godwin not only sought the company of women elsewhere but gave in cheerfully to Ellen Terry's preference for the company of Henry Irving. Soon an officially married Mrs. Godwin took her place, a very young, plump, pretty little girl, whose hands and feet were small and finely molded—and who accepted Godwin's erratic behavior with easy and reassuring smiles. Whistler gave her lessons in painting. The presence of Beatrix Godwin strengthened rather than diminished the friendship between the two men.

Godwin with his usual felicity set about to design what was soon to be called the White House in Tite Street, Chelsea, not too far from Lindsey Row. In the making of the White House Godwin and Whistler effected a collaboration that was unique.

In passing through several phases of the Gothic revival and in his consideration of Oriental art, Godwin's mutations carried him to reconsiderations of Greek design. He dismissed the monotonous regularities and balances of the Queen Anne house as lifeless in-

interpretations of classicism. "Queen Anne led to Harley Street," said Godwin, yet he saw the need of simplifying Gothic excesses, and the path he took led him unwillingly into the road once traveled by Adam; at this point Whistler and he joined hands. The memory of the Chinese Room in the Catherine Palace outside of St. Petersburg came to life again in Whistler's mind and with it the work of Catherine's Scottish architect, Charles Cameron, who had fused the teachings of Adam with conceptions of Eastern art and Cameron's conception had inspired Whistler's drawing room in Lindsey Row, which was almost empty; a large sofa, two or three chairs, a Chippendale table and thin straw matting on the floor, all placed in slight unbalance about the room, served as an example to Godwin's eye. In designing the compact little White House, Godwin showed the touch of genius that had its deepest affinity with Whistler's genius. Even today the White House whose exterior of white brick is now an "arrangement" in black and white, the white bricks of its street floor painted black to the foot of the second floor windows, has retained its quality of being a work of art. The admirable proportions of the interior of its street floor are as they once were; the windows of the rectangular dining room still look out to the garden Whistler and Godwin had in mind, and light, though the day may be cold and cloudy, still fills the dining-room. No tenant, however unsympathetic to its designers, has been able to destroy their intention and identities. It is even today a memorial to the combined genius of Whistler and Godwin.

When the house was finished, its top floor held a studio; its second floor, rooms for a vaguely possible school of painting. The house was attacked by critics for the varied sizes of doors and windows facing the street. "Tite Street was not Baker Street," Whistler replied; there was to be no sign of commercial dullness and flat imitation of Queen Anne houses fronting the visitors when they walked into the White House. As for the placing of doors and windows, Godwin had undoubtedly seen sketches of that side of the Doges Palace which faced San Marco Square in Venice, and had achieved a harmony in counterbalancing with Adam-like restraint in ornament of unequally sized rectangular forms.

Pastel colors reflecting light dominated the interiors of the White House and to the Paris Universal Exposition of 1878 Whistler sent

a design of a room, Harmony in Yellow and Gold, a precise rendi-
tion of what he had failed to accomplish in Leyland's dining-room.
His drawing was guided by the austerities of Adam—which was
proved by his entirely successful suggestions to Mr. and Mrs. D'Oyly
Carte when they restored the rooms of their house in Adelphi Ter-
race and retained Adam ceilings and mantelpieces. Whistler's gift
to London interiors was a rebirth of sunlight in hitherto cluttered
and crowded rooms where the sun seldom entered and from which
the gray light of fog and rain had been excluded by heavy drapes
of deep browns and greens with their colors endlessly repeated on
walls and within the upholstery of sofas and chairs. In London's
climate of damp and cold it is easy to understand why the display
of Victorian wealth and domestic comfort took on the aspect of
overstuffed weight and sunless "cozyness". Deep reds and browns
stressed the illusion of warmth; a fire in the gate, a hot teapot with
its padded tea caddy—these reassured the guests of rapidly rising
lower-middleclass families that comfort, though dark as the interior
of a bear's cave, welcomed them and made them "feel at home" in
a glow of maternal Victorian protection and warmth. The crowded,
jewel-like colors of early Pre-Raphaelite painting stressed the same
cave-like qualities. In contrast to them Whistler's nocturnes with
their slate-blue, green-blue tones and surfaces were cold. Empty
spaces in Whistlerian rooms looked cold and abstract and in his
paintings (since he actually use liberal quantities of turpentine) the
surfaces were thin; even black tones looked thinly applied. A
Whistler room had the appearance of brightness, of utility (al-
though he had no use for anything "useful"), of being contrived at
minimum expense. This last quality was a shock to the demands
of Victorian wealth, was a threat to Victorian ideals of comfort
and domestic security.

The withheld storm threatening Whistler's future was gathering
force, and the signs of coming financial disaster were already
glanced at by Henry Irving as he stood manfully indifferent to cold
in Whistler's studio as Philip II. Irving's Philip was a calm, sneer-
ing, graceful Tennysonian villain, romantic enough to charm the
readers of David Copperfield who remembered Steerforth (as Irving

did), and prophetic enough (since in the play he predicted the rise of Elizabeth to Queen of England) to please the historically minded members of the audience.

Irving's romantic temperament was never unmixed with shrewdness; he saw and noted things that others overlooked; he never forgot how narrowly, when he was merely John Brodribb from Somerset, he had escaped from eternal poverty and eternal junior clerkship in the counting room of Thacker, Spink & Co., East India Merchants in Newgate Street, far from the fashionable West End. He could read the meaning of Whistler's bill collectors and the lack of fuel in Whistler's studio without much further speculation.

The meaning became clear when Whistler attempted to move from Lindsey Row to Tite Street. Whistler's lawyer, Anderson Rose (who had also become one of his patrons), did what he could to stave off creditors, and another man of business, a money lender to whom Whistler appealed, a Mr. Blott, reluctantly took the portrait of Carlyle as hostage as well as promises of other pictures to be painted as security for a loan of one hundred and fifty pounds. Whistler's portrait of his mother was in pawn to a Strand printseller, and Charles Augustus Howell was called in to raise smaller sums of money for the possession of art objects in the White House. If the White House was not built on sand, it certainly resembled a house of cards whose faces were scrawled with promissory notes of pounds, shillings and pence—and at the moment, orders for Whistler's work were in a falling market. His mother had been ill and was sent to the country, out to Hastings for recovery. Whistler himself was threatened with ill health; in the past five years during which he had worked beyond the resources of his fragile body, his brain and even the earlier promises of his talent were sustained by something which could be called "nervous energy." What had been wilfullness in youth had now transformed itself to will, and his will contained an odd mixture of egotisms of "character" and all-too-easily ruffled vanity. His doctrine of daily living which was that of levity, of eating and drinking and smoking sparingly (such as his autograph and butterfly signified), also had in practice something very like Carlyle's doctrine of *work*. Whistler could not relax; his forays into society were conducted with deliberately poised gallantries and insults. He was often gay, but his gaiety was urban, complex, and at

this turn of his life, shrill rather than boyish. His strength of character, or "will," saved him from what today would be a nervous breakdown. As he moved into the White House his affairs had taken a serious turn; he was ocean-deep in small and large debts.

The failure of his relationship with the Leylands, both husband and wife, and the notoriety that Whistler had enjoyed at Princes Gate left him peculiarly naked to his adverse critics. The Grosvenor Gallery opening of 1875 had been the event of the season in London. Everyone who was anyone in London from the Prince of Wales to the merest of newspaper critics had attended it. Out-of-town critics appeared. Two critics came down from Oxford. One was young, eager, generous, unknown; he was Oscar Wilde who had dropped down from Magdalen College to write a report on the show for the *Dublin University Magazine*. The other was John Ruskin himself who held the Slade Professorship at Oxford, the most romantic and eloquent of Oxford's lecturers. He had drifted into madness, but he retained his genius for talking and writing. During his moments of lucidity, his writing had greater force, deeper insight, and sharper clarity than ever before. That he had become a victim of autoeroticism and a violent one, that his particular judgments were more often unsound than not, were facts unknown to the general public. The undergraduates at Oxford delighted in the sight of the tall fantastic figure who shouted sermons disguised as lectures at them; he did not speak, he exhorted; they could feel the heat of his moral agony long after they had forgotten the words that phrased it. At Oxford a student could run from Pater to Ruskin, from Pusey to Jowett, the Master of Balliol, without loss of excitement at each forensic turn. There was more dramatic art in full play at Oxford than on the stage of the Lyceum where Henry Irving held the center of the stage.

Oscar Wilde stepped into the Grosvenor Gallery fresh from the rooms of Magdalen and the lectures of Walter Pater and John Ruskin. Before coming to Oxford, he had been groomed at Trinity College Dublin by John Pentland Mahaffy, Professor of Ancient History, whose submerged gifts of irony, wit, and social fantasy found their release in teaching the brilliant boy who became his favored pupil. As he instructed Wilde, Mahaffy became the *beau ideal* of the gentleman *manqué*; he could cast a fly or shoot a bird

or keep a dinner-table conversation in the air by vaulting references
to Greek art, literature, history. All that the embittered Anglo-Irish
Mahaffy lacked was enthusiasm for the fantastic game he had taught
himself to play—the very quality that his young pupil possessed in
abundance. The younger Wilde could affect boredom; he could simu-
late its outward appearance with a fair degree of accuracy, he could
do everything but feel it. Like many another Anglo-Irishman, par-
ticularly one who had been awarded a "demyship" at Magdalen Col-
lege Oxford, worth ninety-five pounds a year, his sense of social
inferiority was deep enough to unseat whatever tendencies to bore-
dom he had acquired. He could never quite master the cold arts of
prolonged *ennui*. He had walked too closely to the edges of a social
abyss to indulge in anything but the most transparent of insinceri-
ties; whenever he was most insincere, the ardour of his wit betrayed
him, and with unguarded enthusiasm, he promptly sat at the feet of
Godwin and Whistler.

Pater was Wilde's god of the hour, and for diversion, and with a
youthful lack of discrimination, he embraced the Pre-Raphaelites,
Whistler and Godwin with equal warmth.

As the new Mrs. Godwin heralded in her dress and in the way
she bound her hair, Burne-Jones had captured the attention of
Ruskin at the Grosvenor Show. Ruskin was not to be diverted from
the cause of the Pre-Raphaelites, yet in his attack on Whistler, he
must be given credit for seeing at a glance how widely Whistler's
Nocturnes deviated from the Pre-Raphaelite standards as they had
been painfully, painstakingly recorded in the paintings of Holman
Hunt. Each picture of Holman Hunt contained enough literal detail
to tell a story twice as long as *Derby Day* by Frith. To make certain
of the correctness of his Biblical canvases, Hunt traveled to Palestine;
his painting was honest, industriously produced, and as soon as its
story had been conveyed to the eye, remarkably dull. Yet all of it
contained virtues of a moral order that Ruskin could and did ad-
mire; Hunt was absent from the Grosvenor Show, but the spirit of
his painting through the medium of Burne-Jones prevailed and
Ruskin was prepared to praise it.

Of all the Pre-Raphaelites Ruskin committed himself to praise,
Holman Hunt was an outstanding example of aesthetic and moral

virtue. The literal details of his pictures were proof to those who saw them of his laborious craftsmanship, were evidence of the many hours, weeks, months he spent in painting them. No camera portrait or landscape was half as literal in detail as his completed canvases. In writing of his painting, he stressed the importance of his "ideas," the faithfulness of the sermons that he preached. To a few critics as well as the majority of the gallery-visitors Hunt's *The Awakened Conscience,* painted in the mid-eighteen-fifties, was a sermon by a master. The picture showed the interior of a heavily furnished music-room with an upright piano at the right, and at the room's center a young woman rising from the lap of a richly dressed, bearded, leering Victorian gentleman. She had obviously resisted temptation to disrobe completely, and though her hair had come undone and one of her gloves had fallen to the carpeted floor, the rapt expression on her face showed spiritual renunciation of fleshly desires. She was not to be had that night. She was mistress of herself. The essential, stripteasing vulgarity of the picture, since both figures were draped, was unfelt by Hunt; he felt he had preached a warning to young women in the company of rich young men. His professed intentions were high-minded, even "socially-minded." Thomas Carlyle, Hunt was happy to note, admired the way he painted the moonlight shining through a garden window behind the figures of his man and woman, yet the philosophic Carlyle had failed to appreciate, Hunt thought, the reflected light of green foliage on the furnishings of the room.

Ruskin came to the show in the guise of a reporter for his monthly periodical, *Fors Clavigera.* This extraordinary paper written by, edited by and published by John Ruskin from January First 1871 to December 1884 was in the form of letters to the Workmen and Laborers of Great Britain and was read (as such papers often are) by club men and intellectuals—not by workers. In his old age Bernard Shaw wrote of *Fors Clavigera* (which translated means Fate carrying a Key, or a Club—the ambiguity was probably deliberate): "Ruskin in particular left all professed socialists—even Karl Marx, miles behind in force of invective. Lenin's criticisms of modern society seem like the platitudes of a rural Dean in comparison."

Ruskin's letters to Workmen and Laborers were in actuality notations on everything that drifted through his increasingly disordered

James McNeill Whistler in his Paris Studio circa 1890

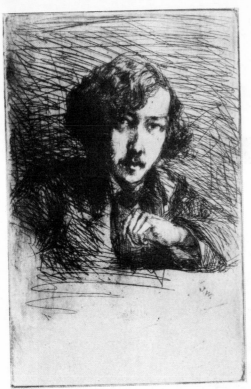

Very Early Self-Portrait of Whistler

Fantin-Latour's Portrait of Whistler

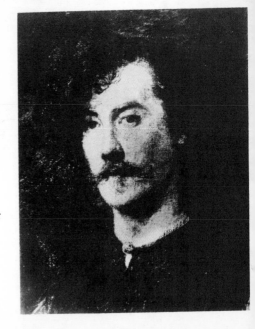

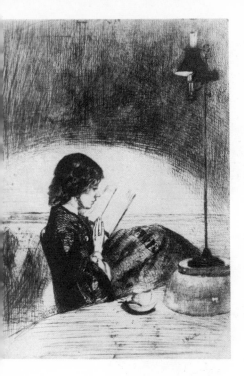

Whistler's Half-sister Deborah
(Mrs. Francis Seymour Haden)

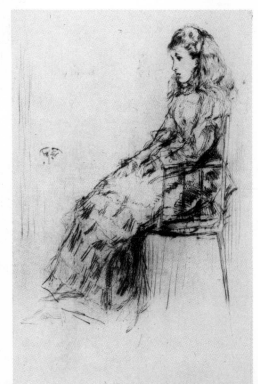

Miss Leyland

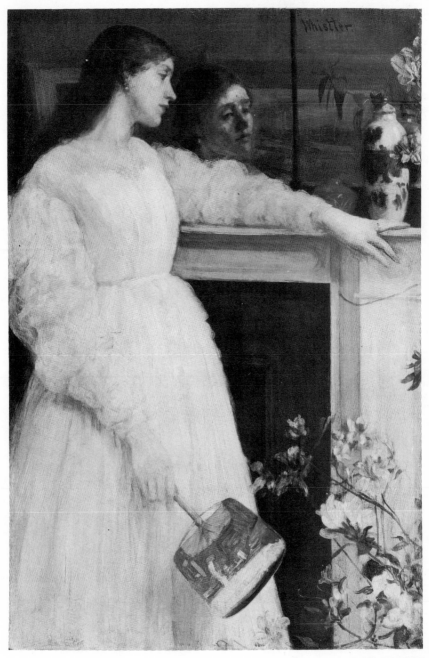

Jo in *Before the Mirror*

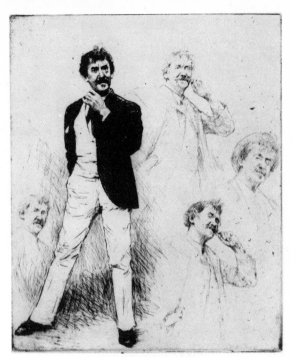

Whistler in the 1870's
By Mortimer Menpes

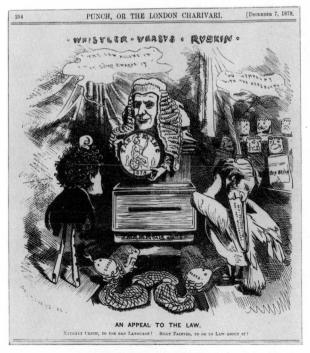

Punch on the Ruskin Trial

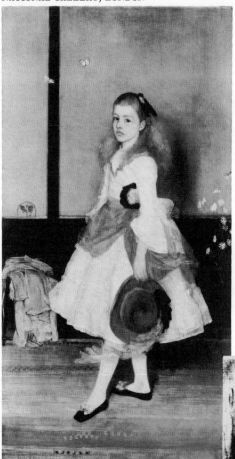

Miss Cicely Alexander:

Harmony in Grey and Green

Beatrix Godwin Whistler

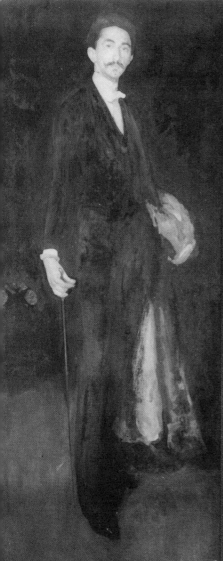

Comte Robert de Montesquiou-Fezensac
By James McNeill Whistler

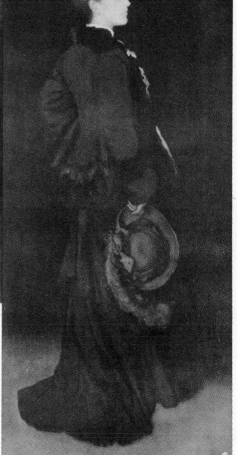

Rosa Corder
By James McNeill Whistler

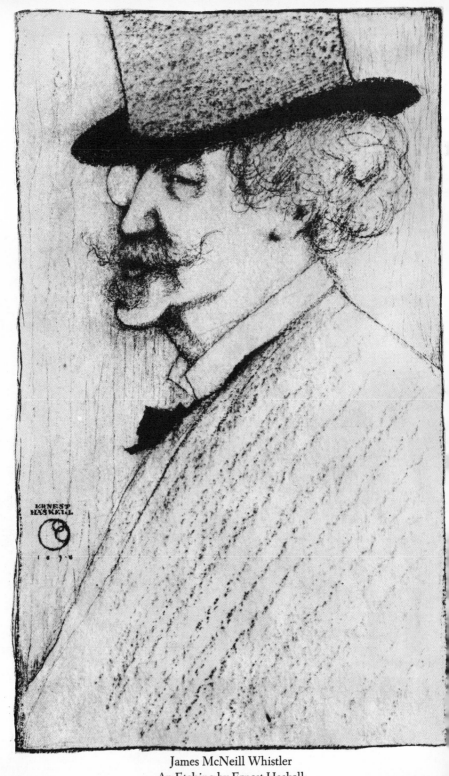

James McNeill Whistler
An Etching by Ernest Haskell

mind: discussions of politics and art, morality and work as well as fragments of autobiography. In these papers his opinions were set forth impulsively, directly, with all the effect created in writing a letter to a friend. He saw Utopia as through an Olympian mist that shrouded his suburban estate at Denmark Hill, and through that dimmed vista anonymous clouds of friends, the workmen of Great Britain. He called himself, aptly enough, "the Don Quixote of Denmark Hill." His occasional flashes of lucidity were proof that genius perceived the nature of his mental disorder. It is little wonder that Marcel Proust, three generations later, so deeply admired him, for *Fors Clavigera,* and Ruskin's autobiography, *Praeterita,* can be re-read as early models for *Remembrance of Things Past.*

When Ruskin walked into the Grosvenor Gallery his emotional life had passed through a crisis in the failure of his attempt to marry Rose Là Touche who was scarcely more than a child. His marriage with Effie Gray had ended in annulment since the marriage was never consummated: the deaths, first of his father, then his mother, left Ruskin in an empty universe, all too easily stirred to anger or to despair. His writings had been pirated in America which did little to improve his temper, nor did he view Americans in general with a kindly eye; and because of his recent experience in respect to his publications in the United States he had just cause for distrust of everything that had American origin.

The Grosvenor Gallery was like a room in a Venetian palace. Its pictures were hung against walls of faded red brocade and between them stood fine examples of antique furnishings. Among them Whistler's Nocturnes were an anachronism projected into the future. Only the portraits of Irving and Carlyle seemed to fall into place at all, and the critic of the London *Times* dismissed the entire lot, including the portraits, by complaining of "an entire absence of details, even details generally considered so important to a full length portrait as arms and legs." Whistler's work, he went on, "suggests to us a choice between materialised spirits and figures in a London fog."

Ruskin was both less suave and less naïve than the *Times* critic. He had never liked anything he had seen from Whistler's hand; Swinburne had tried to introduce him to Whistler and he had refused to see him; he associated Whistler with the less respectable

members of the Rossetti circle, including Howell * whom he had in-
troduced to Swinburne. Ruskin's irrational fits of snobbery were also
active in refusing to see merit in Whistler's work; Ruskin's earlier
defense of the Pre-Raphaelites had the air of being a concession

* During the years 1864–66 Howell had served as Ruskin's secretary, and it
was rumoured that Ruskin, then in difficulties with his young wife, Effie,
had tried to get her to commit adultery, and had bribed Howell to seduce
her. He failed; she was both beautiful and intelligent.

She had no fancy for Howell and was in love with the thoroughly mas-
culine Millais, who married her after her marriage to Ruskin was annulled.
Her instincts and her will were stronger than the combined wills of the auto-
erotic Ruskin and the adventurous Howell.

In 1954 Helen Rossetti Angeli, daughter of William Michael Rossetti, pub-
lished an honestly intentioned effort, Pre-Raphaelite Twilight: The Story of
Charles Augustus Howell, to whitewash the character of Howell, and to
clarify obscurely understood rumours emanating from gossip which sur-
rounded the Rossetti circle. Although it is impossible to refashion Howell
into a latter-day Pre-Raphaelite saint, he was not as vicious as Victorian gos-
sips thought he was. He was the youngest son in a large Anglo-Portuguese
family; his mother held claims to being of royal Portuguese heritage. Howell
was forced to fend for himself in London, and with a few social connections,
made the best of a Bohemian-celebrity-worshipping temperament. He was
handsome and was easily accepted by and attracted to women. With his wife
and several other good-looking women he lived in the house that Ruskin had
given him in Fulham Road. The house was also filled with children of whom
it was said: "All were sure who their father was, but no one was certain
as to who made claim to being their mothers."

It is certain that Rosa Corder was Howell's mistress, and nearly certain that,
for a short time, she was also Whistler's. Mrs. Angeli proves that the dis-
graceful story attending Howell's death—that he was found in a gutter, his
throat cut, and with a coin thrust between his teeth—is false. He died of
pneumonia, aged 50 years, in the Home Hospital, 16 Fitzroy Square, St.
Pancras, April 25, 1890, an unsuccessful adventurer in the renting of sea-
coast real estate (summer cottages) and nearly forgotten by those who knew
him when he was young. He was a romantic, not-too-scrupulous dealer in
works of art, and much too unbusiness-like to be a true rival of Murray Marks.
He was not much more dishonest than the majority of antique dealers today.
In his early friendships he had a fatal gift of intimacy, and since he was a
Bohemian by temperament, he had no use at all for respectable, mediocre,
middleclass company. He ran to the best company he could find—or the low-
est, and thereby relieved himself of boredom. This last was a trait that he
shared with Dante Gabriel Rossetti and Whistler, who forgave him for his
habit of telling wild lies because his lies were half-poetic, fantastic, brilliant.
When young, his personality was that of a skilled actor; he was a gentleman-
artist manqué, quick to serve his friends or to make love to a pretty girl. The
best marks in his favor may be found in the loyalty he inspired in his mis-
tresses (who knew him better than his male acquaintances), and these in-
cluded Rosa Corder, who was not promiscuous, but quite the contrary.

downward in the social scale. He was a champion of the drawings made by Dante Gabriel Rossetti's wife, "Lizzie" Siddal, weak, feeble drawings that showed scarcely more than a sensibility that yearned toward "art." Yet Ruskin knew that her origins were proletarian, and she herself had been a milliner's assistant (which was in those days a euphuism for "whore," a euphuism not earned by poor "Lizzie's" conduct); she was literally employed in a milliner's shop. Ruskin was then able to patronize her without restraint. Like many well-to-do Communists of the twentieth century whose impulse is to *patronise* the poor, to rule them by doctrinal force disguised as universal benevolence, so Ruskin embraced Socialism. He openly patronised the Pre-Raphaelite movement. The Pre-Raphaelites had nothing in common with his favorite painter, Turner—except, and this by vaguest association, they, too, were romantic painters.

Ruskin's instincts told him that he could never patronise Whistler or his work—and by 1875 he had transformed his patronage of the Pre-Raphaelites into something that resembled his crusade for Socialism. At Oxford he had dismissed Whistler's painting as absolute "rubbish." At the Grosvenor Gallery show he had found an opportunity, spurred by his madness, to reiterate his opinion of it.

He looked at the *Nocturne in Black and Gold*—the falling rocket, a blaze of color at night in Cremorne Gardens. Or was that blaze of color the memory of what in childhood Whistler saw on the Neva from a window in St. Petersburg? One will never know; in all probability the *Nocturne in Black and Gold* represented the fusion of things remembered—and the place was neither Cremorne Gardens nor night on the Neva, but the essential explosion of fireworks at night held with authority within Whistler's memory. These are speculations that Ruskin did not know of, and had he known, would have cared little for them. The painter who controlled Ruskin's imaginative life was Turner; for Turner's paintings Ruskin's intuitions were unfailingly alive; placed before one of Turner's seascapes he could see everything that was there and much that was not. Turner filled completely the place reserved by Ruskin for contradictions of his theories, for his flights of speculation beyond the rational limits of taste and aesthetic dogma.

The sight of *Nocturne in Black and Gold* infuriated Ruskin; he had just cause to think of Americans as charlatans and here was

proof of it; he had expected to see "absolute rubbish" and here it was. If he saw the Carlyle portrait he saw it with his mind made up that that too was not a painting. In respect to Whistler's painting a glance would suffice, would tell him all he needed to know, and he knew enough to know of Howell's household in Fulham Road, and had probably heard through Rossetti more than enough of Whistler's friendship with Howell and Rosa Corder. If he had overheard gossip arising out of Chelsea (and it is difficult to think that he had not), Whistler's pictures represented an immorality—he sought out the price asked by Whistler for the *Nocturne,* and saw that it was two hundred and fifty guineas—an enormous price to ask for a piece of what he thought was no more than a scrawling of paint across the canvas. There was no *work* in it at all.

Ruskin felt it his duty to tell the workmen of Great Britain the enormity of the crime that he had witnessed; his imaginary friends, the laborers, should hear of it; Sir Coutts Lindsay the banker should know in what contempt Ruskin and his friends held his choice of Whistler as an artist.

In *Fors Clavigera* of July 2, 1877, Ruskin voiced his charges against Whistler which were:

> For Mr. Whistler's own sake, no less than for the protection of the purchaser, Sir Coutts Lindsay ought not to have admitted works into the gallery in which the ill-educated conceit of the artist so nearly approached the aspect of wilful imposture. I have seen, and heard, much of cockney impudence before now; but never expected to hear a coxcomb ask two hundred guineas for flinging a pot of paint in the public's face.

A few weeks later George Boughton whom Whistler had met in Paris in the Fifties saw him at The Arts Club, told him he wished to talk quietly with him in a corner, and showed him *Fors Clavigera* of July 2. Whistler said: "It is the most debased style of criticism I have had thrown at me yet." Boughton, like so many friends of artists in similar situations, half enjoyed the prospect of a fight and replied, "Sounds rather like a libel."

"Well—that I shall try to find out!" said Whistler; yet he did not act. On the surface his financial disorder did not seem hopeless. His

brother had married a cousin of his wealthy friend, Luke Ionides. Whistler did not see that Ruskin's attack would cause further distrust of his abilities among those who had witnessed the failure of his attempts to make the Peacock Room a work of art. The Grosvenor Gallery had been such a fashionable affair—that gallery had been opened to rival the Royal Academy and as far as a glittering attendance to an opening show went, the rivalry was established.

Up to this time Whistler's quarrels with the critics were for the most part an exchange of words without benefit of print, but in 1867 he did reply to P. G. Hamerton's notice of his *Symphony in White No. III* in the *Saturday Review*. It was the best of all his earlier remarks on critical irrelevance, and it proved that the butterfly signature contained the sting of a scorpion. In that reply he advanced his skill in quoting the critic to the critic's greatest possible disadvantage, and with a military flourish created a field of battle in which no quarter was asked or given:

> How pleasing that such profound prattle should inevitably find its place in print! "Not precisely a symphony in white . . . for there is a yellowish dress . . . brown hair, etc. . . . another with reddish hair . . . and of course there is the flesh color of the complexions."
>
> *Bon Dieu!* did this wise person expect white hair and chalked faces? And does he then, in his astounding consequence, believe that a symphony in F contains no other note, but shall be a continued repetition of F, F, F? . . . Fool!

The letter was an exact rendition of Whistler's speaking voice and the way his mind worked. Readers of the letter had a direct view of the little black-haired man with a white forelock, and they caught the reflected beam of the eyeglass screwed into his right eye. The letter also disheartened all thought of pity for either artist or critic. To sentimental readers of his reply, Whistler fought a shade too well; his appeal was to abstract justice and to the brain— if any sympathy was required it was for the critic who had made a foolish mistake, not for the artist. The artist, so many thought, was one who had creative powers, not brains or wit; the real artist was more like Watts, a creature in delicate health and protected by the

ladies of Little Holland House, or like Millais, who was robustly kind to everyone, or like Rossetti, a queer person who kept strange animals as pets. The Whistler legend that Whistler had begun to create for himself ran counter to middleclass—a prosperous, comfort-loving middleclass—morality. That public would enjoy finding the artist himself in error; then, perhaps, they could pity him and at the same time assert the superiority of their own ability to make mistakes, to forgive themselves, to forgive the world, and yet be successful.

Whistler did not foresee that Ruskin's attack would affect even the two Miss Alexanders, that their friends would ridicule even the *Harmony in Grey and Green* and make Miss Cicely who resented his not restoring the face of her doll, who hated to think of the hours wasted in his studio when she might better have been out of doors, ashamed of the picture that showed her standing impatiently behind his back. In the present emergency, like the scorpion encircled by fire (a fire represented by restive creditors), Whistler was trapped. He was without pocket-money; he hired cabs to drive about London, and at the end of a drive wound up at the doors of friends asking for cab fare, plus the loan of a shilling. However much experience he had gained during his student days in Paris of Vie de Bohème, there was a keener edge to his lack of money in 1878. He now dressed far better and more expensively. He made much of having his hair dressed well and instructed each barber who served him in the particular art of arranging his hair, scolding and cheering the man alternately. His model Jo had left him, and in her place he had installed Maud, a smaller English version of Jo who had Jo's coloring, the same flash of reddish hair, but was less violent in temper, had fewer brains and was of less help in saving household money. Godwin, the most intimate of his recent friends, had dissolved partnership with Norman Shaw, one of Leyland's architects of the remodeled house in Princes Gate, and was too deeply enmeshed in debts and legal troubles of his own to offer help. Godwin was also in ill health. Beatrix Godwin, his new wife, complained that her husband, despite his continual round of gallantries, had chills at night and nearly suffocated her with blankets when they went to bed.

The charges against Whistler in *Fors Clavigera* meant that his

money-granting patrons had become increasingly elusive. They ap-
peared regularly enough at his Sunday breakfasts in the new White
House to accept his service of pancakes with maple syrup, to see him
refuse to sit at one place at the table, but instead to carry a chair
with him and talk to each guest, laughing as he did so. If bill
collectors stepped in, he pressed them into action as waiters. Under
the spell of Whistler's commands, they removed plates and returned
with tea and coffee cups; this was all very gay, but the guests did not
buy the pictures in his studio. If they had, many of his debts would
have been cleared in six months' time; they preferred to listen to
his talk, his invectives against critics, against Leyland. They ac-
cepted Whistler as they accepted a performance by Henry Irving.
The scene was one of high and impolite comedy.

Whistler traveled out to Hughenden—the day was fine, it was
September—to see Lord Beaconsfield, Disraeli. Surely, he thought,
they would have something in common, and Disraeli's portrait could
be painted. He walked into the park of the estate; the elderly states-
man was leaning on the arm of a companion; Whistler introduced
himself; the old man was distantly polite in the manner of elder
statesmen. Yes, he recognized Whistler, or pretended that he did,
and then slowly walked away on the arm of his companion, talking
blandly of other things. Whistler had been smoothly cut; there was
nothing for him to do but to go back to Chelsea. A few months
later Disraeli's portrait was painted by Millais.

Far-fetched attempts of this kind to check his falling market did
not bring expected results, which in a great emergency is all-too-
usual. Whistler was not to be saved by intervention of the demigods
of state. A little help came by way of Howell; Howell had intro-
duced Whistler to a Pall Mall engraver, Henry Graves; Graves
agreed to make mezzotints of the Carlyle, and the venture brought
Whistler eighty pounds; this was very well, but it was not enough.
Nor was Howell's payment of a hundred guineas to Whistler for
Rosa Corder enough; nor were the continued friendships of the
Ionides enough, nor the friendship of Lady Colin Campbell enough.
The well of disorder, which had become a whirlpool of Whistler's
debts with the White House at their center, was too deep. There
was nothing to do but to open counterattack upon Ruskin in court—
to sue Ruskin for libel and a thousand pounds damages.

Anderson Rose, Whistler's solicitor, agreed to act; he believed that Whistler had a case and Ruskin no case at all. He saw Ruskin's lawyers, they agreed with him and attempted to dissuade their client from taking the stand in court against Whistler. Ruskin was ill; more than that, one of his deeper cycles of mental illness had arrived; he could not appear in court—that was understood; but he would not allow the case to be settled out of court. Ruskin had heard that Whistler had called one of Turner's paintings of the sun, "a red wafer"; that was an indignity he would not allow. He convinced himself that it was he who was persecuted, that he needed the support of all his friends, everyone and in particular, Burne-Jones, Whistler's successful rival for attention at Grosvenor Gallery. He felt he could prove in court what he had written about Whistler, that the man was an amateur in art and shopkeeping. It was useless for Ruskin's lawyers to argue with him at all; reluctantly they reported failure of settlement out of court to Anderson Rose. Ruskin was far more eager to quarrel in court than Whistler; Whistler knew that the verdict might well turn against him; he was not a popular artist and Ruskin was an influential critic, the only critic of art in England whose word carried weight, enough weight to destroy him, as it seemed to be doing now.

The coming trial demanded the most of Whistler's histrionic gifts, gifts that had been tested in private theatricals during his early days in London, gifts that had reached a dubious eminence in the Peacock Room at Princes Gate. He could not depend on his friends among fellow artists. Among popular artists he knew Charles Keene well, the cartoonist for *Punch,* but Keene did not wish to commit himself, and *Punch,* of course, was against all forms of the "new" in art, even the Pre-Raphaelites were a shade too "new" for them as George du Maurier's drawings showed. Whistler could not hope for help from that quarter. Keene saw the case as any journalist would see it—as a "lark." George du Maurier would see it in the same light; beneath the surface of their neutrality lay the half-envious jealousy of the cartoonist for the studio painter. This has always existed and always will. The only witness that Whistler could depend upon was himself.

Whistler's general situation was so bad, so completely unstable, that the suit for libel against Ruskin was in actuality Whistler's

trial for life. If he lost, the dark present would forecast an increasingly darker future. He would lose face in London which had become his choice of place for the working out of his destiny. He enjoyed fighting, but here the stage was large enough to inspire stage fright; a misstep on his part could lead only to further disaster.

XII

HE was assured of publicity. That he knew, and when the case opened on a dark day, November 26, 1878, in the Exchequer Division at Westminster, in a gloomy, ill-lit courtroom, the press was there, even Henry James, the young American novelist, on an assignment from the New York weekly, *The Nation*. Across the street from the building, Whistler had hired a room which held a collection of his paintings for the purpose of showing them to the jury. The courtroom was not the place to exhibit paintings of any kind; even a well-trained judge of art would have been discouraged by lack of light and the natural confusions which arise in a legal discussion of art.

Baron Huddleson who sat on the bench had chosen a special jury. Representing the case for Whistler were Mr. Serjeant Parry and Mr. Petherham; a Mr. Bowen represented the defendant, Ruskin. Mr. Parry spoke respectfully of Ruskin's high reputation as a critic of art in England and America and quoted the passage from *Fors Clavigera* that had caused offense. He also had a few words of modest praise for his client, speaking strangely enough of Whistler's reputation in the United States, which was not as great then as it was later. He mentioned his work as a painter, but stressed his activities as an etcher, and stressed most of all Whistler's industry, "an unwearied worker in his profession," he called him. Mr. Parry's opening was better than it seemed. It was truthful, sober, and a little bit dull; we know now that he was clearing the stage for his client who was dressed in a double-breasted suit of navy-blue serge.

Whistler was the first witness. After he had asserted that he was born in St. Petersburg of a military family, his effort was to prove his education in art, a delicate point. Ruskin's charge of "ill-edu-

cated" had struck home. Whistler said to the court: "I studied in
Paris with Du Maurier, Poynter, Armstrong." He knew their names
would be familiar names in court, and the statement was disarm-
ingly truthful. He spoke of a gold medal he had received at The
Hague; he named the eight pictures hung at the Grosvenor Gallery
and was careful to name certain people who had bought them—
the Hon. Mrs. Percy Windham, wife of a Tory statesman, and Mrs.
Leyland. He mentioned his portrait of Thomas Carlyle; he men-
tioned that his price for Nocturnes was two hundred guineas, that
he had received as much from the Hon. Percy Windham; that most
of his pictures were sold before they had appeared on the walls of
the Grosvenor Gallery. Whistler had picked up where Parry had
left off; he was sparring for time; his opening was nearly as dull as
Parry's; he had scarcely caught the attention of the court; he was sur-
prisingly modest.

A few of his pictures were shown to the court, the portraits of
Irving and Carlyle—*The Falling Rocket* was presented to the court
upside down. There was a moment of confusion, yet those who had
come to the court for excitement were in danger of disappointment.
Uneasiness filled the room as well as first signs of boredom. The
reporters looked bored; how could one judge art in a courtroom;
someone would have to talk with more enlightenment. The attorney-
general began to cross-examine Whistler who had remarked that
The Falling Rocket was a night-piece that represented the fireworks
at Cremorne.

"Not a view of Cremorne?" asked the attorney.

"If it were called a view of Cremorne, it would certainly bring
about nothing but disappointment on the part of the beholders—"
with these words Whistler drew a laugh; he was beginning to feel
his way into his part. "It is an artistic arrangement," he went on.
"It was marked two hundred guineas."

The attorney-general then took the plain man's attitude, some-
thing that the jury could understand: "Is not that what we, who are
not artists, would call a stiffish price?"

"I think it very likely that that may be so."

"But artists always give good value for their money, don't they?"

"I am glad to hear that so well-established." A single laugh was
heard; Whistler was talking over the heads of his audience. He was

still cautious, and his use of irony was of a character not likely to be clear to those who heard him. "I do not know Mr. Ruskin, or that he holds the view that a picture should only be exhibited when it is finished, when nothing can be done to improve it, but that is the correct view; the arrangement in black and gold was a finished picture, I did not intend to do anything more to it."

"Now, Mr. Whistler. Can you tell me how long it took you to knock off that nocturne?" The attorney-general's contempt was obvious; he had slightly overstepped the line of formality.

Whistler leaned forward in the witness box: "I beg your pardon?"

This was a real exchange. The attorney-general retreated half a step:

"Oh! I am afraid that I am using a term that applies rather to my own work. I should have said, 'How long did you take to paint that picture?' "

The plain man's attitude was being slowly turned to Whistler's advantage, not the attorney-general's. The exchange of ironies began to show that Whistler was not ill-educated and not quite a cockney.

Whistler resorted to further politeness.

"Oh, no! permit me, I am too greatly flattered to think that you apply to work of mine any term that you are in the habit of using with reference to your own. Let us say then how long did I take to—'knock off,' I think that is it—to knock off that nocturne; well, as well as I remember, about a day."

Unknowingly the attorney-general had opened a breach for Whistler; the conversation was still over the heads of the listeners. It was a play of words, rather than true action, but an opportunity was in the air.

"Only a day?" said the attorney-general.

"Well, I won't be quite positive; I may still have put a few more touches to it the next day if the painting were not dry. I had better say then that I was two days at work on it."

"Oh, two days!" The attorney-general had probably heard of the time spent by Millais and Hunt on their pictures. It seemed safe to drive his point home. "The labor of two days, then, is that for which you ask two hundred guineas!"

For the past five minutes Whistler had had time to think. A breach had opened wide—the attorney-general had sprung his own trap;

the conversation was no longer intellectual; it had to do with time, human effort, and money—not with art. It had to do with work that prepared a man for excellence in any profession.

"No; I ask it for the knowledge of a lifetime."

There was applause. To Henry James the case looked like a farce, but whatever remained of it was under Whistler's control; the public character that he had been building up in his own name had matured. At the center of his being was an artist, but his creation in the courtroom was one that used arts other than those of paint, brush, and the etcher's tools. The creation was as histrionic as one of Ruskin's ironic angry dances, his gown flapping, before undergraduates at Oxford. It was also literary; it was appropriate to the situation in which Whistler's antagonist was a writer of the first order. Ruskin was undeniably mad, but he had genius and the gifts of a great romantic poet. For him, a mistake in judgment could not be fatal; the trial could do little harm to him; yet the trial was to change the course of Whistler's life.

After the applause, the attorney-general changed the subject: "You have been told that your pictures exhibit some eccentricities?"

"Yes; often."

"You send them to the galleries to incite the admiration of the public?"

"That would be such a vast absurdity on my part that I don't think I could."

"You know that many critics entirely disagree with your views as to these pictures?"

"It would be beyond me to agree with the critics."

"You don't approve of criticism then?"

The attorney-general had opened the way for another point to be made. The point was intellectual, and would probably be lost, but by this time Whistler had the concentrated attention of the courtroom:

"I should not disapprove in any way of the technical criticism by a man whose whole life is passed in the practice of the science which he criticizes; but for the opinion of a man whose life is not so passed I would have as little regard as you would, if he expressed an opinion on law." The statement had nothing to do with Ruskin;

Ruskin was something of an artist himself; his drawings, largely architectural, had distinction. Whistler's point was to rule out the aesthetic opinions held in the courtroom, and later to establish the artist as the highest possible authority on art. The stroke was a bold one, and later in the trial, it was to lead to general confusion on the part of the jury.

He was then asked why he called Mr. Irving an arrangement in black, and Baron Huddleston, who was not without wit, broke in with: "It is the picture, and not Mr. Irving, that is the arrangement"; and he also said, so as to keep balance between Ruskin and Whistler, that a critic must be competent to form an opinion and bold enough to express that opinion in strong terms.

The court adjourned to permit the jury to visit the Probate Court where Whistler's pictures (which had been stored across the street in the Westminster Palace Hotel) were put on view. After that interval the duel between the attorney-general and the plaintiff-witness was resumed. . . .

"You mean, Mr. Whistler, that the initiated in technical matters might have no difficulty in understanding your work. But do you think now that you could make *me* see the beauty of that picture, *The Falling Rocket?*"

Whistler then showed how much he had learned from watching Henry Irving; he paused, he gazed at the attorney-general's face as if to measure it—it was a long look; his eye glass shone. Then he turned to the picture held up for inspection of the court. Another long grave look, then back to the attorney-general's face; the court was silent, it waited; then there was an explosive, "No! Do you know I fear it would be as hopeless as for a musician to pour his notes into the ear of deaf man."

The court roared; it had expected entertainment, and it was now getting it. The proceedings were turning into mock melodrama. Whistler's each word, each gesture, was well calculated for maximum effect; he could now well afford to step down and allow Albert Moore, a minor artist, but one whose friendship he could trust, speak in his favor, but William Michael Rossetti, Dante Gabriel's brother and art critic, was the next witness.

It was a surprise to see W. M. Rossetti take the stand in Whistler's favor. This particular Rossetti was the least gifted member of

the family which had three poets, Christina and Dante Gabriel and their romantic father; but it was William Michael who supported the family in their darkest days by his critical journalism, by a vast variety of deadly hack work; he had an earnest, sober mind and great honesty. Burne-Jones circulated a story about him which ran as follows. One day William Morris tried to interest Dante Gabriel in Sigurd the Volsung and in Fafnar, figures out of Norse mythology which were of particular moment to Morris; Dante Gabriel grew impatient and protested: "I don't care for that stuff; it's too unnatural. How can one take a real interest in a man who has a dragon for a brother?" Morris gravely thought the matter over, then, staring straight at Dante Gabriel for a full minute, shouted back, "I'd much rather have a dragon for a brother than a bloody fool."

There was nothing in common between Whistler and William Michael; yet William Michael knew that at this trial Burne-Jones was Ruskin's man. William Michael did not like Burne-Jones, nor did he like the artist's big, dark, pretentious house in Kensington, nor his air of flattery to the great, nor the kind of stories he told when their backs were turned. Burne-Jones delighted in telling how crazy old Ruskin mistook a half-dozen of his water colors for oils. That was one reason for William Michael's sympathy for Whistler; another was the fact that Whistler's levity cheered the moments of Dante Gabriel's deepest melancholy; and another was an abstract love of justice that existed in the back of William Michael's honest mind. He could not praise Whistler highly, but he could and did insist that The Falling Rocket was worth two hundred guineas; he was glad to do something to counter-balance whatever Burne-Jones would have to say in defense of Ruskin's obvious mistake.

In Ruskin's absence at court, Burne-Jones stood for him. He was the British ideal of how an artist should look, a little shaggy around the head, bearded, gray-blue-eyed, and with a relaxed and easy manner. He attacked unfinished pictures and he believed all of Whistler's Nocturnes to be unfinished, not works of art. It was clear that he agreed with Ruskin that his own work was superior to Whistler's, but despite his ease of manner, his talk was a dull recital of how artists failed to paint night pieces. The shadow of boredom fell across the courtroom.

Nor did the boredom lift when the elderly Frith appeared to say

his few words against Whistler, nor did it lift when Tom Taylor, critic of the London *Times* read aloud his review of the Grosvenor Show in which he had attacked Whistler's Nocturnes.

A Titian portrait was presented to the jury, and the jury protesting that it was tired of looking at Mr. Whistler's pictures refused to look. The jury was worn out. Yet the jury's mistake of a Titian for a Whistler brought a last flourish of excitement to those who reported the trial, and the incident was in keeping with the air of fantasy the trial created.

Baron Huddleston summed up the case by standing at the center between Ruskin and Whistler. "There are certain words by Mr. Ruskin about which I should think no one would entertain a doubt: those words amount to a libel." He then brought up the question of substantial damages or of "contemptuous damages to the extent of a farthing," and the weary jury took the hint. The jury had had enough talk of art; it could understand that a man of middle age had painted a picture that contained the knowledge of a lifetime, and its rough sense of justice found Ruskin guilty of libel with damages to the extent of a farthing to Whistler—as a gesture of contempt.

The costs of the trial were to be equally shared by Ruskin and Whistler. Ruskin's friends raised Ruskin's share, but Whistler was forced into bankruptcy. He was put to the effort of turning the trial into a moral victory for himself, of telling the story of it over and over again, of acting out the parts of the attorney-general, the judge, and Burne-Jones, and, of course, of writing pamphlets on the trial, and of reading Ruskin and annotating him. At last, twelve years later, he gathered all his papers together and published them under the title of *The Gentle Art of Making Enemies*. Twelve years later, he met Miss Harriet Monroe, an eager young woman from Chicago who was then visiting London, and for her he re-enacted Burne-Jones's being cross-examined by Ruskin's attorney with the question, "Do you see any art quality in that Nocturne?" For a split second, Burne-Jones lost his poise and stuttered, "Yes" in contradiction to what he had said before, then saying, "I must speak the truth you know." He then showed Miss Monroe a watch chain on his vest and the famous farthing he had won at the Ruskin trial, dangling from it, but no one ever saw Whistler consulting a watch.

Talk of the trial diverted Whistler from the melodrama of bank-

ruptcy in Tite Street. Many paintings were slashed, cut into rib-
bons to prevent their falling into the hands of creditors. Others van-
ished as if by sleight of hand (which was an art possessed by Howell)
into Howell's house on Fulham Road. In Chelsea a young man
walked up to Whistler, introduced himself, and said, "Oh, Mr.
Whistler, I'm so sorry about the White House and your losses."
Whistler replied, "Don't pity me—think of those poor devils, my
creditors," turned on his heel and walked away.

The White House was immediately leased by Harry Quilter.
Quilter was a stocky, brash little man, a free-lance journalist—free
lance because of his aggressively short temper which cut short his
jobs on various newspapers. Like many Victorians, his hobby was
drawing and he turned out an occasional painting. Quilter followed
Tom Taylor (who originally was a drama critic) as art critic on the
London *Times*. He had his eye on the White House. Quilter had
very nearly all the qualities that Ruskin assigned to Whistler in
Fors Clavigera; he swaggered, bluffed and shouted his way into and
out of newspaper offices; he had a large fund of journalistic informa-
tion and the power to recite it with unqualified assurance.

Meanwhile Whistler's grocer turned up with a bill for tomatoes
and fruit, which had been running for years at Lindsey Row—a bill
amounting to six hundred pounds. In Tite Street Whistler offered
him two *Nocturnes* and his *Valparaiso,* but the grocer, who had
read of the Ruskin trial feared to take them. He wanted money.
Whistler replied, "I think the best thing is not to refer to the past—
I'll let it go, and in the future we'll have a weekly account—wiser,
you know."

As guests entered the White House for Whistler's Sunday-morn-
ing breakfast in the spring of 1879, furniture was being numbered
for sale at auction by bailiffs who served breakfast, and as Whistler
motioned the guests to their seats, he said, looking the men over with
marked approval, "They are wonderful fellows. You will see how ex-
cellently they wait on table, and tomorrow, you know, if you want,
you can see them sell the chairs you sit on. Amazing!"

The bailiffs were in attendance and possession: one evening
Whistler's guests for dinner saw seven bailiffs drinking beer in the
garden, beer that had been treated with something stronger in it,
so as to keep the men quiet while Whistler's small party was in

progress. It began to rain, to thunder, to hail, but the men in the garden had fallen asleep.

"Look," said Whistler, "at the seven sleepers of Ephesus: stick pins in them, shout in their ears—see—you can't wake them—look at them, it's amazing."

Auction bills, bills of sale, covered the front of the house and one night a storm tore the bills into shreds and tatters. Whistler woke up the bailiffs who were sleeping inside, told them to tidy things up, paste up fresh bills so the house would be neatly up for sale the following morning. His mother was still ill at Hastings; he was in the house alone with the bailiffs, drawing up plans for further economies. His liabilities were four thousand six hundred and forty-one pounds, nine shillings and three pence; his assets were one thousand nine hundred and twenty-four pounds and four pence; he was far under the weather.

He could not work in his studio, yet restlessly he sketched three paintings in caricatures of which the central figure was Leyland, a lobster with a shirt frill: "Whom the gods wish to make ridiculous, they furnish with frill," said Whistler. This was called *The Loves of the Lobsters—An Arrangement in Rats;* another showed Noah's Ark on a hill with frilled creatures dancing around it; another was *The Gold Scab—Eruption in Frilthy Lucre* with a creature wearing frills, seated on the White House and playing the piano with scales of gold in sovereigns dropping from it. Whistler in anger was not unlike Poe; in his fury his imagination turned to the grotesque; his gifts of irony and of paradox were purely literary. He lost those gifts whenever he attempted to translate them into the arts of caricature in drawing or in painting.

In the bankruptcy court, Whistler, dressed in a long black frock coat, stormed against the rich. The poise, the authority he had won and sustained in the Ruskin trial, were gone. His voice shrilled and the court had to silence him.

The examiners appointed for the sale of Whistler's effects Leyland, Howell and Thomas Way; of the three, Way, the engraver and print publisher, was the most sympathetic. In a thoroughly cool, level-headed manner he continued to help Whistler. He knew Whistler's gifts as an etcher and trusted them.

Irving visited the rapidly emptying house in Tite Street and from

a mass of half-destroyed canvases rescued his portrait for thirty pounds. He had recognized his legs beneath the rubbish. Augustus Hare walked in with a large party to see Whistler among his ruins. He glanced at the caricatures, but was more deeply shocked to see the little man, his white forelock waving in the air, skipping in fury around the room. The exhibition was not a pretty one. Whistler sent a small show to the Grosvenor Gallery; it received direct and conclusive critical attack. Whistler was spoken of as an artist who once had high promise; it was admitted that he was an etcher; at the moment it seemed that if Whistler had won a moral victory, the aesthetic laurels went to Ruskin; attempts to raise a subscription for Whistler failed.

By September 1879 there was nothing for Whistler to do but to leave London. He had heard that Ruskin's share of the trial's cost, three hundred fifty-two pounds, twelve shillings, six pence, had been paid. He learned that the little paper *L'Art* which hoped to raise funds for him, had collected almost nothing at all, that Harry Quilter had actually bought the White House with the purpose of remodeling it for two thousand seven hundred pounds. He held his last reception, a very small one, and among the guests was Godwin. They placed a ladder at the door and Whistler climbed it to write on Portland Stone above it: "Except the Lord build the house, they labor in vain that build it. E.W. Godwin F.S.A. built this one." Whistler's early readings in the Bible had served him well, but never better than in this farewell to Tite Street. The next day he left for Venice.

 XIII

FOR the past three years Whistler had made provisional plans to go to Venice each summer—and now the opportunity arrived in the form of urgent necessity. He could try to live cheaply in Venice; the change of scene would certainly force economies upon him that were difficult to learn in London. He had received a small advance and a commission from the Arts Society to do twelve Venetian etchings. The Arts Society had a young man as its new manager; he was willing to take risks. Though Whistler's Nocturnes were now selling at auction for twelve pounds ten shillings, perhaps the falling market would not materially affect the prices of his etchings. Venice was familiar to the well-to-do Englishman on holiday; the vogue for buying etchings had begun its ascendency. Prospects for the combination of Whistler, the buyer of etchings, and Venice were not too bad; the investment had the possibility of profit.

Whistler came to Venice at one of the two seasons of the year— the other was spring—when the sunfilled city was at its best. The streets, squares, Baroque gardens and facades shone with light from both sky and waters of the canals. Though the city showed its greatest beauty, Whistler's spirit was at its worst. He did not care for historical remains or ruins; the southern Renaissance and Baroque spirit had no charms for him with the single exception of Velasquez' paintings. The deep red brocades on the walls of the Ca' Rezzonico, now transformed by the sun into a red unknown to any other place on earth, was not to his liking. He took rooms in that beautifully proportioned late Renaissance Palazzo which looks out over the Grand Canal and attempted to paint the sunset from a window. He swore at the sun's brightness and at its glow as it disappeared from an evening sky. Nor did the darkness of the courtyard please him; likewise

the clumsy weighted remains of late Renaissance carvings in imitation of late Roman decor did not please him. The courtyard, filled with these remains, depressed and annoyed him.

He escaped to Florian's in San Marco square, the café frequented by Americans from Whistler's day to Hemingway's, and then remembered that he lacked the money to live there in the style he best enjoyed. Florian's with its orchestras playing into the small hours of the morning is close enough to the American dream of Venice to hold its charm. From its tables to the right there is a view of the gold-tinted archways of San Marco itself with gilded horses riding above them, and across the way are the clock and bell tower.

Whistler's discomfort at Ca' Rezzonico sent him to other quarters, quarters on the edges of Venice's slums, and there Maud Franklin joined him. He would have none of the interiors of Palladio's churches. He avoided the Venice that Ruskin had known so vividly and described so memorably in *The Stones of Venice*. He disliked Italian food, which he said was nothing but *fowl,* and brought bits of chicken fat home to his room to fry into something he hoped would resemble bacon. The chill of a Venetian winter was setting in and he moved into the worst possible place in Venice, Riva degli Schiavoni, bleakly exposed to winds and hail.

His reverses of fortune in London had temporarily dulled his instincts. His medium was changing; he painted less and tossed off a number of pastels. He haunted the English Club and the American consulate. To him Venice was a foreign city: he tried experiments (probably suggested by Tiepolo) of filling his sketches with impressions of light and air. In these his fine taste and sensibility remained as it always was, but they were, somehow, less effective. They lacked authority. At first his commissioned etchings came slowly. He could and did catch details of movement in the courtyards and in the golden tops of towers and spires, but the spirit of Venice was ill-fitted to his temperament; he could not find peace within the churches. He could not, like Henry James two years later, grope his way to an understanding of Venice through its people.

The truth was that he was painfully homesick for London, for the half-lights of London fog and rain, for the elegantly dressed press of crowds on an autumn evening in Mayfair. He had been spoiled by notoriety; he had grown used to ordering servants about, his valet,

his maid, his models, the Greaves brothers. A hired gondolier was poor substitute for the small retinue that followed his steps in Chelsea. His spirits were not broken but slightly twisted askew; everywhere he went in Venice, whether to cafés or clubs, he advanced his habit of borrowing small change from British tourists. Love for the English and their late Victorian glitter led him into their company; hatred of them forced him to indulge in the petty revenges of borrowing change that he did not intend to pay back. Stories of him that traveled back to London were not flattering and reached the ears of the Arts Society. The Arts Society began to worry about the commission of twelve Venetian etchings.

His adjustment was slow. After rain, with water still dripping from vines creeping over walls of high banked gardens, he began to modify his dislike of Venice; slowly he began to discover Tintoretto, Titian, Veronese, Canaletto, Guardi, but he could find no way to apply them to his own work. At Christmas mass at San Marco he decided that the ceiling of the Peacock Room was better than its dome; he said frankly enough: "Venice is an impossible place to sit down and sketch, there is always something far better still just around the corner."

He reassured his mother in his letters that he was actually working hard, that he rose early in the morning and worked till nightfall. Because he disliked sketching with an Italian crowd around him or in a gondola, he sat or stood restlessly at a window and sketched the views from it. He sought out small canals, doorways darkened by overhanging shadows, and beggars to look at. It was what he had done at Wapping in London, and he thought he had found a way to look at Venice; but shipping was the essential quality of the London he first saw, and Venice was both a city of churches and of tourists. He had to find a new style of etching to catch even a fleeting impression of what he saw.

The Arts Society in London need not have worried; Whistler's new style of etching was something that would please the public. The etchings were quick, glancing, subtle tourist-eye views of places that had been overlooked. Even the crudest buyer of etchings could discern the presence of style and an expert sense of design. Of the more familiar scenes in Venice the buyer could easily find a print or a photograph, but the Whistler etching was unique. Whistler may

have been conscious of a commercial rightness, of doing precisely what would sell, as he sketched his plates for his Venetian etchings. Perhaps not, but if his instincts failed him in seeking out quarters to live well in Venice, they were very much alive in guiding his hand toward pleasing the eyes of British and American tourists.

In his costume, he dropped the frock coat and looked more like the artist on holiday. His curls and the white forelock were set against a very broadbrimmed brown hat, tilted far back on his head. He wore a dark jacket and light trousers and a very low collar with a long thin black tie loosely knotted in a bow. At night and usually at Florian's his white duck suits reflected lights from gas jets and candles, and as he stepped from its shadows to cross San Marco Square his figure reflected the soft light of the moon. He found a room in the Casa Jankovitz to which he brought a mixed company of Americans, Russians, Poles, and Dutch. The company was by no means of the brilliance of what he had known in London, and among them was a Russian, whose name is now forgotten, who claimed to do better pastels than Whistler.

One night Whistler hired a barge and a band to play "Yankee Doodle" on it; the barge was flooded with lights that showed several of his pictures and it sailed the length of the Grand Canal until it met Whistler's gondola near the Riva where Whistler laughed aloud from the darkness. When he saw one of Ruskin's friends high on a scaffolding at San Marco sketching a detail, he pinned a sign on which was written "I am totally blind" to his coat tail. Stories of these adventures, however true or false they were, diverted tourists passing through Venice and revived the legends of Whistler's student life in Paris. Among them appeared the story of a quarrel with an Italian landlady who lived on a floor below him. One hot day Whistler noticed that she had set her goldfish bowl out on her window sill; it was said that he let down a fishing line, caught the fish, fried them and returned them to the bowl, so that the woman would think that her fish had been killed by the rays of the sun. There is little possibility that the story has literal truth in it; it is a schoolboy's story—but it does add to the general atmosphere of Whistler's discontent in Venice; it adds to the air of forced levity that he did not feel, to the loss of poise that his ego had suffered, to his hatred of the position in which he found himself.

Even less fortunate was the story of his accidental meeting with Harry Quilter who had so recently bought the White House. Both men had selected within a narrow canal the same doorway to sketch and their gondolas collided. Whistler shouted "Hi, hi, you've taken *my* doorway" and Quilter insisted that he had been working there a week; Whistler still claimed his priority, that he had had an iron grating put up to improve the design; at last Quilter offered Whistler the use of his gondola to sketch in and Whistler's gondola backed out of the canal. As Whistler sketched, he talked to Quilter as though he did not know it was he, and told him about 'Arry Quilter of *The Times,* what a stupid critic he was, and gave him a particularly unflattering account of all of 'Arry Quilter's activities. The interview delighted Quilter; he had a Whistler story to tell in London, and he could also tell how superior his drawing of the doorway was compared to Whistler's and how generous he had been in offering Whistler his gondola. Quilter, with all his blunted sensibilities alert, was, as he told the story, a *gentleman,* and kind to an inferior artist.

In Venice Whistler attempted to revive his Sunday morning breakfasts in the rooms he shared with Maud Franklin. Maud was pert, pretty and cheerfully helpful; she made excellent coffee but Whistler could never learn to set the table correctly. He hovered over a spirit lamp, laughed with melodramatic hollowness because the Italians had no maple syrup and the making of good pancakes was unsuitable to Venetian climates. The scene was a half deliberate parody of earlier scenes in Lindsey Row and Tite Street. He shifted the hour of his receptions to the high-tea hour of six o'clock in the afternoon and the fare was a combination of Maud's coffee, hard-boiled eggs, sardines, cigarettes and fruits, very like an American summer outdoor lunch. Whistler showed his pastels and groups of his new etchings and then gave burlesque reviews of them by London critics. The showing closed with Whistler acting out the part of a London business man, how he is waked up always at 8:30 each morning, then a pantomime of his being closely shaved at a quarter of 9 and arriving in the City at 10; Whistler waved his left arm in the direction of the pastels: "What will he make of *this?*" His obsession was clear; he was thinking of Leyland. The guests seldom returned a second time.

To younger men whom he met in cafés over a plate of fish and a bottle of the cheapest of Italian red wines, he would talk for hours on the beauties of Vermeer and the small Dutch masters. In Venice he was often possessed by memories of his extremely brief visits to Holland; to him, the Dutch masters were always right; "their work was covered with a single skin," and as he talked, he closed his eyes to the sights and sounds of Venice.

XIV

SUDDENLY and without announcement in November, 1880, Whistler was back in London. He dropped into his brother's house in Wimpole Street and a few days later, he stepped from a cab into the Fine Arts Society at a moment when it was holding a show of Twelve Great Etchers. As he described the event later, "In one hand I held my long cane; with the other I led by a ribbon a beautiful little white Pomeranian dog; I spoke to no one, but putting up my glass I looked at the prints on the wall. 'Dear me! dear me!' I said, 'still the same sad old work! Dear me!' And Haden was there talking hard to Brown, and laying down the law, and as he said, 'Rembrandt,' I said, 'Ha, ha!' and he vanished."

As he told the story the spirit of his arrival in London also returned; the dark, soft, chill air was tonic to him—he was out of the wings and back on the stage again. He had kept his promise to the Arts Society. He had only to make prints of his etchings; he had a collection of pastels; he was unlooked for in London and generally unwanted, but he was back in a homeless (for him) milieu that had become and would remain his home.

The start was to be made all over again; the absence of slightly more than a year had refreshed him. The retreat to Venice was hardly a stay in a desert or wilderness; his work had changed; if anything it was more selective, more certain of its refinements in design, but less intense; there would be no more Miss Alexanders, no more Battersea Bridges, no more Carlyles; there would be more letter-writing to the papers—there would be the same, and yet a different Whistler, a Whistler who was more completely a public figure, more of an art critic, more of a conversationalist on the subject of art than a painter. The new Whistler was one who etched,

sketched pastels, talked, moved about London, met more people than ever. He was there to preserve the best of the painting he had already done. As for new work, there were the etchings; even among unfriendly critics, a company which included Henry James (and James represented the opinion of a younger generation), the etchings were considered of established excellence. That was a reality that Whistler faced. Whether people liked him or not, whether they liked his theories about art or briskly dismissed them, they would concede that he was an able craftsman in the art of etching.

This new position was not by any means a happy one but it could be made secure. He could talk and hold the attention of those he wished to hear him; he could insist that Ruskin had made a mistake.

Ruskin had discontinued the publication of *Fors Clavigera* for fourteen months; he had resigned the Slade Professorship at Oxford, but was re-elected to it. Through sleepless nights he fought against his own particular devil, "The Evil One," he called it; it had transformed him into an old man.

As Ruskin retired into the shadows, Whistler's figure slowly and with some few reverses at first reemerged, and indeed, the new generation with more enthusiasm than the preceding one accepted him, not as a startling young artist, but as a singularly prodigal godfather.

The 1880's ushered in a distinct variation of the Victorian age; it was a slight, yet perceptible change in atmosphere that was to prepare London for the turn of the century. On the second day of 1880 Ruskin wrote in his diary, "Utterly jaded and feverish with nearly sleepless night and crowding thoughts." On this occasion the self-named "Don Quixote of Denmark Hill" with no thought of uttering a prophecy defined (by setting down in words the condition of his own distracted mind) the temper of the next two decades.

The changing mores of the British nineteenth century which included a popularization of Darwinism, a revival of Roman Catholicism, headed by Newman's Oxford Movement earlier in the century, William Morris's and Ruskin's crusade for Socialism shook the foundations of Anglican complacencies, causing as they did so, many a "sleepless night and crowding thoughts." In the arts an

"utterly jaded" atmosphere prevailed; a something "new" was sought, which found one answer in the poems of Swinburne, another in the pages of Henry Harland's *The Yellow Book,* the plays of Oscar Wilde and Bernard Shaw, and still another in the presence of Whistler as a public figure. In these the artist emerged as the "enemy" of middle-class society.

The London of the 1890's was not the same London that Whistler had hoped to conquer in the 60's. It had conquered him in 1879. A sharp indication of a change in spirit came with the success of the Gilbert and Sullivan operas. The Pre-Raphaelites and the Gothic revivals were waning slowly. The Romantic seriousness of an earlier moment had begun to fade, was visibly "jaded." The aesthetic atmosphere was changing from deep reds and purples into violet blues and lavenders. Melodrama, never to be entirely absent from the stage from that day to the midtwentieth century, permitted topical comedy and burlesque to flourish side by side with scenes of untarnished vice and virtue. Broad strokes of humor were less frequent, had almost died with Dickens in 1870, was in a grave with memories of Fielding and *Tom Jones.* Signs of wit appeared; the age was becoming far more critical.

The new London was prepared, if not to welcome, to tolerate a resurrected Whistler. He had contributed his share to the changing temper of the times in the Ruskin trial. In the rush of events preceding and following that trial, lawsuits came and went like a succession of thunderbolts and rainbows within the Whistler circle. A week after the Ruskin trial Charles Augustus Howell's case against the Metropolitan District Railway came up in Sheriff's Court, Red Lion Square. Chaldon House in Fulham that had been given to him by Ruskin stood in the path of the railway's development; it was a Queen Anne house on which Howell claimed to have spent seventeen hundred pounds so as to make it fit for his selling of art objects as well as a home for his wife and children. In private conversation he also claimed to have written a number of Ruskin's books.

Visitors who had attended the Ruskin trial strolled into Sheriff's Court, Red Lion Square. Howell, the plaintiff, took his cue from Whistler and strode bravely into the witness box. He said that Chaldon House at the time he entered it was the wreck of a very

fine Queen Anne house, that he immediately agreed to spend (he did not tell the source of the money which probably came from Ruskin) five hundred pounds for repairs, that the costs of repairs mounted to two thousand pounds of which he had receipts for seventeen hundred, that he had converted the house into an artists' paradise with walls covered by William Morris's wallpaper, so that he could fill a room with Rossetti's drawings one day and Titian's paintings the next.

"My connection in the art world," Howell said, "is very considerable. I am known as a collector of works of art. If people are in a collecting humor they will buy, and if they are not in that humor I soon put them in it." He waited for the laugh that he received, then went on, "I know the collections of most connoisseurs. People come to the house because they like me, and because I make them comfortable." Another laugh followed this; among the visitors were some who knew of the handsome young women Howell also collected and whose presence in the house materially added to its beauty. "I buy Whistler's pictures at his house. I take them home and hang them up and I never laugh, I never even smile. A man comes who appreciates a Nocturne, and he goes mad till he gets that particular one. I cannot allow a friend to remain in that critical state and then he gets it."

At that moment Whistler walked into the courtroom; Howell waved a hand in his direction and said, "An arrangement in black and white."

The cross-examining attorney asked Howell questions winding up with a few remarks about arrangements of color, and then concluded with: "I suppose the green is the customer and the gold is the money they bring?"

Howell, cool as ever, replied, "No. The gold is thrown in to show there is no ill-feeling."

Judgment was awarded to Howell for the sum of three thousand six hundred and fifty pounds. Howell had talked of art to his own advantage, and during the proceedings the presence of Whistler gave the general atmosphere of the trial the quality of being in view behind the footlights, a comedy acted out for the entertainment of the public.

On Whistler's return to London it was less the painter than the

actor that the public was willing to read about and to see. And there was also Whistler, the pamphleteer who was read by the few, a few young men who were about to enter the arts; his brown paper-covered pamphlet, *Whistler vs Ruskin,* was being read, especially its closing paragraphs:

> "Taste" has long been confounded with capacity, and accepted as sufficient qualification for the utterance of judgment in music, poetry, and painting. Art is joyously received as a matter of opinion; and that it should be based upon laws as rigid and defined as those of the known sciences, is a supposition no longer to be tolerated by modern cultivation . . . The whole scheme is simple: the galleries are to be thrown open on Sundays, and the public, dragged from their beer to the British Museum, are to delight in the Elgin Marbles, and appreciate what the early Italians have done to elevate their thirsty souls! An inroad into the laboratory would be looked upon as an intrusion; but before the triumphs of Art, the expounder is at ease, and points out the doctrine that Raphael's results are within reach of any beholder, provided he enroll himself with Ruskin or hearken to Colvin in the provinces . . . Eloquence alone shall guide them—and the readiest writer or the wordiest talker is perforce their professor . . . The Observatory at Greenwich under the direction of an Apothecary! The College of Physicians with Tennyson as President! and we know that madness is about. But a school of art, with an accomplished *litterateur* at its head disturbs no one! . . . Still, quite alone stands Ruskin, whose writing is art, and whose art is unworthy of his writing . . . Let him resign his present professorship to fill the chair of Ethics at the university. As master of English literature he has a right to his laurels, while as the populariser of pictures he remains the Peter Parley of painting.

As Whistler assumed his role of controversalist, young men in London began to disregard the weightier aspects of Victorian morality, like the Prince of Wales himself—Prince Edward Albert—who in middle-age was to become Edward VII. An emotional as well as an

intellectual revolt against domestic morality was taking place. Seeds of that revolt had existed in an earlier generation, but the present signs of it were vocal and consciously so. The scene was now prepared for the arrivals of Oscar Wilde and Bernard Shaw at the end of the decade. Whistler's style of wit in print and in conversation (he remarked that Henry James had been waiting for a custom-made face but had not yet found one) was beginning to set the fashion.

Whistler was correct enough in pointing out that the aging Ruskin's first concern was in the field of Ethics and Morality, that his teaching of art was not likely to produce painters. (Ruskin's teaching of drawing classes in the Working Men's College during the 50's was an experiment in social reform rather than an actual teaching of art; this was freely admitted by Ruskin who said, "They" —his working-class students—"are taught drawing primarily in order to direct their attention accurately to the beauty of God's work in the material universe," which thirty years later was the very conception of teaching art *against* which the younger generation was in arms.)

Ruskin's later concerns with art were not only moral but distinctly literary; Whistler's later concern with art was to keep alive what he had learned from his observation of Oriental art. But to do so he was forced to use literary means of making his message clear; paradoxically, he became a man of letters (as well as an actor) by *tour de force*.

When Whistler returned to London he lived in rooms near Oxford Circus and later in Belgravia. He remained within walking distance of Regent Street where the Fine Arts Society gave him two rooms in Air Street in which to work. In a very real sense he was living on the town: Piccadilly Circus flowed beneath him, and when he stepped out, the street flowed around him; he wore a long fawn-colored frock coat and pink or yellow ribbons as shoe laces in highly polished black slippers; as he walked from Regent Street to Bond Street, he was more than visible; it was impossible not to see him, not to be aware of his presence, not to know he was back in town. The Fine Arts Society in preparation for an exhibition of

his Venetian etchings gave him the use of a press above their show rooms and it was there that he received his visitors, several of them young men who had read his *Whistler vs Ruskin* pamphlet and from then onwards, treated him as their "Master"; they watched him pull proofs from the press and helped him, and in December, 1880, the Venetian set of twelve etchings was shown. The show met with a flurry of adverse criticism from the press; the etchings which some five years later were to attract general approval gave Whistler the chance to further his attacks on the critics. His notoriety had again increased, but his income was largely non-existent; one of his young admirers, Mortimer Menpes, loaned him a room in his house.

No matter what the critics said of the Venetian etchings (Whistler saved press cuttings of the reviews and his replies to them in the papers to publish later in *The Gentle Art of Making Enemies*) the Fine Arts Society had received attention. It was publicity for the Gallery as well as for Whistler, and the Gallery supported him by a showing of his Venetian pastels early in 1881. The Gallery was soon rewarded by a sale of the pastels that brought in eighteen hundred pounds—and Whistler moved out of his furnished room back into a house in Tite Street, near the White House.

As the show prospered Whistler was suddenly called by his brother, the doctor, down to Hastings. His mother who had been ill since 1877 was dying and was dead before his arrival. Looking out over the bleak January countryside where the Saxons fought the Norman invaders hundreds of years ago, Whistler turned to his brother and said, half in grief and half in irony, "It would have been better if I had been the parson she had first wanted me to be." The brothers buried her at Hastings; whatever restraint she had over Whistler's movements and domestic behavior had melted away.

The year brought another important event in Whistler's life; the portrait of his mother was shown at the Pennsylvania Academy of Fine Arts in Philadelphia. Aside from an article by W. C. Brownell in *Scribner's*, Whistler had received very little notice in the United States. Following the Philadelphia showing of his mother's portrait, the picture was shown (through the enthusiastic offices of the American painter, Alden Weir) at the Society of American Artists in New York. This was the beginning of a growing appreciation of Whistler's

painting in the United States, the beginning of his legend in this country, which in the last years of his life was to save him from the extremes of poverty in London. From this time onward visiting Americans in London and Paris made efforts to meet him, and in London in particular, groups of Americans divided their hero-worship of their countrymen who lived abroad between Henry James and Whistler. The two groups did not often mix; they formed two temperamentally antagonistic camps with no love lost between them; those who could listen to and talk to Whistler, found James stolid, silent, unfeeling; those who admired James found Whistler's vanity, wit, levity overtly spectacular and wearying. The followers of James were genuinely annoyed by Whistler's shrill "Ha ha's" of simulated laughter; they were inclined to think that Ruskin's judgment of Whistler's character was not far wrong.

In his new quarters in Tite Street where walls were painted a brilliant yellow and where Whistler's friends felt they were standing at the center of an egg, Whistler expected crowds of carriages to line the walks in front of his door. A few people came; but fashionable ladies did not care to risk sharing his notoriety. The exception was Lady Meux and as she stood for him would not permit his usual dictation to and criticism of his models. She talked back to him softly but pointedly.

"Jimmy Whistler," she said, "either you keep quiet or I'll call in someone to *finish* the portraits you've been trying to do of me."

Whistler flushed and danced with anger.

"How dare you, how dare you, how dare you," he shouted back, but could say no more. Lady Meux did not sit again. A few of the portraits of this period were successful, but the greater number were either unfinished or destroyed. Whistler could not recreate the fortunate moments that produced, even at great labor, his Miss Alexander, or his Carlyle, or even the felicities of his Battersea Bridge. To those who visited him he began reciting Poe:

> Ah, broken is the golden bowl!
> The Spirit flown forever!
>
> * * *
>
> The sweet Lenore
> Hath 'gone before'

With young Hope at her side,
And thou art wild
For the dear child
That should have been thy bride—
For her the fair
And debonair,
That now so lowly lies—
The life still there
Upon her hair,
The death upon her eyes.

"Of all poems," he said, "this was the best." He was no longer singing usual music-hall refrains. He rubbed out portions of his canvases with greater frequency, and began to confess openly to those who sat for him his discontent with what he painted. Comments by newspaper critics fretted him, and on days when he felt progress on a canvas impossible, he rushed from his studio to his writing desk and jotted down his replies. His great consolation at that moment was the spoken admiration of Theodore Duret who wrote an article on him in the *Gazette des Beaux-Arts*. Duret was a French business man of considerable means and of scarcely less appreciation of subtle painting; as he stood for Whistler to have his portrait done, he renewed Whistler's confidence in his own work. So far as his painting was concerned, Duret's understanding was a prop he needed. To balance his self-criticism he needed French approval from someone he respected. Duret was both intelligent and worldly—and in return for Duret's friendship, the portrait of Duret was done with a rightness of touch that showed Whistler at his best. "The Spirit" had not quite "flown forever."

Two local quarrels interrupted the further growth of Whistler's confidence: the first was over the White House and the alterations made by Harry Quilter:

Shall 'Arry, whom I have hewn down, still live among us by outrage of this kind, and impose his memory upon our pavement by the public perpetration of his posthumous philistinism?

* * *

Shall the birthplace of art become the tomb of its parasite in Tite Street?

The second was a record of an amusing if trivial complication of the sale of a cabinet, in which Howell figured as the chief cause of complication. A Mr. Morse bought Whistler's Chinese cabinet, of which the top had been stolen by Howell. Whistler, at last fearing that Howell's dubious financial dealings would add deeper stains to his own recent fall into bankruptcy, wrote his story of the sale of the furniture under the title of *The Paddon Papers: The Owl and the Cabinet*. Rossetti and Whistler had nicknamed Howell "the Owl" partly because of Howell's nocturnal activities and his decidedly shady business transactions; what had once had the nature of a family joke now became a public one.

In 1883 there was a second showing of the Venetian etchings at the Fine Arts Society. Yellow was the dominant color of floors and hangings; the walls were white; there were buttercups in yellow pots. Whistler wore yellow socks and gave his friends white and yellow paper butterflies. The color anticipated by several years "the yellow '90's" and *The Yellow Book*. "As I was hanging the prints," said Whistler, "I could hear whispers that I was hanging them too high, that no one could see the etchings. I laughed. 'Dear me, of course not—that's all right. In an exhibition of etchings the etchings are the last things people come to see.'"

The activity of planning the showing, decorating the room, dressing up for the part he had to play in presenting it, restored the poise that he had too frequently lost as he stood before a canvas. He was delighted to welcome the Prince and Princess of Wales and escort them around the room at his private showing. It no longer mattered what critics thought or wrote. Not every bankrupt in London could play host to Royalty and turn a semi-public Gallery into an afternoon as intimate as a garden party. It was precisely as intimate as that—and no more. Actually London society patronized Whistler; he amused it, and he seemed to be amused. His signature, the butterfly, had become very like a trademark or a reiterated slogan; it had become too easy for people to remember the butterfly and to forget everything else associated with the painter.

Without knowing it, Whistler stood in great danger of becoming a bore, but it was clear that however successful his raids upon public attention were, the results were unsubstantial. A warning came in the ascendancy of Oscar Wilde. At one of Whistler's last Sunday breakfasts in the White House, Theodore Watts-Dunton warned

him that the tall, "smock-faced," young Irishman who strode into the room would soon know ten people in London society to Whistler's knowing one. Theodore Watts (when he assumed the hyphenated "Dunton" to commemorate a legacy left him by someone of that name, Whistler had telegraphed him: "Theodore, what's Dunton?") was in appearance both plump and flabby, looking a little like the Walrus in Sir John Tenniel's illustrations for *Alice's Adventures in Wonderland,* but he was immensely shrewd. There was nothing walrus-like or sleepy in his understanding of slightly off-color relationships between human beings. As a lawyer, which was his profession (he was a poet by desire and a novelist through industry), his movements were slow, but his mind was quick. Later when Swinburne had suffered a mental collapse and physical debility through heavy drinking, the poet's mother appointed Watts as her son's guardian or caretaker. And Watts saw to it that Swinburne did not escape his clutches nor did Swinburne dare to leave the ugly attached villa he shared with Watts in the depressing middle-class suburb of Putney where they lived.

After a successful tour of the United States Wilde had returned to London. Wherever Whistler went, Wilde was there: he was large, pale, moon-faced, heavy lipped, as easy in manner as Whistler was nervous. He had the art of picking up a few of Whistler's epigrams, and then, with a touch of his own style, improving upon them. He had begun to patronize Whistler, and overhearing the elder man speak, said calmly, "I wish I had said that." Then came Whistler's famous reply, "You will, Oscar, you will." Wilde and Whistler were soon engaged in a game of sending telegrams to each other, and then showing copies of them to friends. *Punch* had published an imaginary conversation between them. Wilde telegraphed Whistler: "Punch too ridiculous—when you and I are together we never talk of anything except ourselves"; to which Whistler wired back, "No, no, Oscar, you forget—when you and I are together we never talk about anything except me."

The contest between the two men was a thinly draped, almost obscene, struggle for superiority at dinings-out and at receptions, and Whistler, the elder man, who had created the fashion of verbal exchange that Wilde graced with ease and brilliance, was not always at advantage. Beneath the surface, the strain was all too evident;

Whistler's laugh was far too shrill, too loud; he was too fond of alliterative phrases to compete with full success against Wilde's neatly balanced paradoxes. Concealed within Whistler's contest was a fundamentally serious argument concerning graphic art. Wilde's wit was social and in the dialogue of his plays. That kind of wit was Wilde's true art. Whistler's art was either on paper or on canvas. Whistler was tortured by a play of intellectual problems within his mind, especially those concerned with abstract design. Wilde, less abstract, was more humane, more generous to an adversary, more erratic in temperament, less embittered—and always half-willing to forgive an insult, which Whistler never was.

The contest was an unequal one. Wilde, even at the start, had the greater chance of winning popularity. As Whistler's foil he gained sympathy with those who took sides; he was younger, was "new," and not likely to disrupt a gathering by a show of ill-temper.

One of Whistler's efforts was to dissociate his name from Oscar Wilde. Gilbert and Sullivan's *Patience,* performed in 1881, adroitly written as it was—for it did not offend Victorian moralities, domestic or otherwise—dimly conveyed the idea that its principal character, Bunthorne, who certainly did not care for ladies, was homosexual. And Bunthorne, as far as he could be identified with anyone, was Oscar Wilde. This meant that gossip, involving the names of those who represented the newer arts of the Grosvenor Gallery, whispered shreds of scandal behind Regent Street crescent. Gilbert in writing his lyrics cleverly fused the Pre-Raphaelites with the aesthetes of the younger generation—all were sketched in, retouched, smeared, gilded with the same brush. In the play a triangular satire came to life: a contest between Ouida's heroic Guardsmen, the Heavy Dragoons, virile but foolish, the Aesthetes, and the Philistines, the bouncing young men who were certain to be the "City men" of tomorrow. Gilbert had never been so skillful, nor was he to be more effective in his later satires.

After the performance of *Patience* shreds of gossip concerning Wilde were swiftly woven together. It was impossible for Whistler to be ignorant of it, and also impossible for him not to grow more uneasy at its implications. He, for one, could not afford scandals other than the public humiliation of bankruptcy, association with Charles Augustus Howell, and stories of his two mistresses, Jo and

Maud Franklin. Any further drop into the darker shadows of gossip might well be fatal.

To disassociate his name from Wilde's was by no means easy. Wilde had married Constance Lloyd, a beautiful, helpless, brainless little Dublin heiress, whom Wilde dressed in Greek, early Venetian and Dutch costumes, and then leased a house for her and himself in Tite Street. John Singer Sargent, the portrait painter from America who had done a spectacular portrait of Ellen Terry as Lady Macbeth, had a studio nearby. (Sargent never allowed his sitters to speak ill of Whistler; he combined the virtues of a gentleman, a patriot, and one who respected himself and other members of his profession.) The street had been touched with the fame of Godwin and Whistler, which even today it still has, and the house that Wilde leased, though red-bricked and turreted in Gothic Victorian fashion, still retains its charm. Wilde called in Godwin and Whistler to redesign its interior. Colors of blue, white and yellow were on its walls, reproducing many of the same effects that prevailed in Whistler's new Tite Street house; and Whistler gave Wilde a few of his Venetian etchings. Wilde celebrated his marriage with the remark, "The proper basis for marriage is a mutual misunderstanding," and when a small boy in Tite Street, who noted the extraordinary dress of bride and bridegroom, shouted after them " 'Amlet and Ophelia out for a walk I s'pose," Wilde answered, "My little fellow, you are quite right. We are."

As for Whistler, Wilde said, "Ah, Whistler! Yes, wonderful, of course, but how he fears beauty! He puts a blot, a mere stain like a petal, a butterfly upon a sheet of paper and dares not touch it, lest its charm be lost. His portraits remind me of the painter in Balzac's *Chef-d'oeuvre inconnu,* laboring his canvas for years and when he draws the curtain to show the masterpiece, lo, there is nothing. Then Jimmy explains things in the newspapers. Art should always remain mysterious. Artists, like gods, must never leave their pedestals."

Proximity to Wilde of Tite Street had become slightly dangerous. There was enough truth in what he said to cause Whistler a bad night, to make him rush from canvas to writing desk. On Wilde's return from the United States, Whistler had already written to *The*

World: "Oscar—We, of Tite Street and Beaufort Gardens, joy in your triumphs and delight in your success; but we are of the opinion that, with the exception of your epigrams, you talk like S——C—— [Sidney Colvin] who lectured at Cambridge in the provinces; and that, with the exception of your knee-breeches, you dress like 'Arry Quilter."

The World supplied the dashes after "S" and "C" to which Whistler replied, "My dear Atlas, if I may not always call a spade a spade, may I not call a Slade Professor Sidney Colvin?"

It is almost an understatement to say that Whistler felt himself under fire from both Oxford and Cambridge; Colvin had been scarcely less critical than Ruskin—and in Whistler's eyes, Wilde, aside from his presence in Tite Street, had come down to London from Oxford; there was a fusion of the two universities in Whistler's mind, and the image of them had become a hostile one. Later Wilde appeared in Tite Street wearing a Polish cap and a furred, frogged, green greatcoat. Whistler wrote, "Oscar. . . . Restore those things to Nathan's, and never again let me find you masquerading the streets of my Chelsea in the combined costumes of Kossuth and Mr. Mantalini." His break with Wilde was clear enough for anyone who could read to understand.

Yet the quarrel with Wilde was not without positive as well as negative results. Whistler had gained the friendship of Mrs. D'Oyley Carte, wife of the producer of Gilbert and Sullivan's *Patience,* and she, an ex-actress, enjoyed Whistler's flair for histrionics. She was sure that he had few if any true affinities with Wilde; she was entertained by him, yet had glimpses into his theories of art; she and her husband agreed to stage a lecture to be given by him at Prince's Hall at ten o'clock on the evening of February 20, 1885. The event was preceded by a long period of rehearsal, of writing and rewriting a lecture called *Ten O'clock,* the hour safely beyond the dinner hour to insure the seating of everyone before the lecturer began his talk; it was to outshine the performance in the witness box at the Ruskin trial; it was to attract a fashionable audience; it was to show London that it held an actor as gifted as Wilde, an apostle of aesthetics who had moved above and beyond popular taste—a Whistler in evening clothes who discarded the unnecessary white tie because the starched low-cut collar and starched shirt front were white. On this occasion

the accent struck would be an exaggerated simplicity so as to contrast
with the more elaborate dress of Wilde; at the very best it would
correct misconceptions of the aesthetic movement and separate Whis-
tler from the fusion of aesthetes who danced and sang to Sullivan's
melodies in *Patience*. The occasion made public Whistler's telegram
to the church where Wilde held his wedding. "Fear I may not be
able to reach you in time for the ceremony. Don't wait" and Whis-
tler's famous aside, "Oscar, *bourgeois malgré lui.*"

Whistler had recited the lecture to fog and wind, mist and rain
above the waters of the Thames on the Embankment; he recited it
to Menpes, and the night before his engagement at Prince's Hall,
he rehearsed it for the last time in Prince's Hall itself before Mrs.
D'Oyley Carte. On February 20th crowds streamed from Piccadilly
into the hall; Whistler was on the platform and not quite at ease;
he placed his stick against the wall, and on the table before him,
his opera hat; his nervousness was obvious, but it was appropriate
to his opening paragraph: "Ladies and gentlemen, it is with great
hesitation and much misgiving that I appear before you in the char-
acter of The Preacher." Subjectively, and of course not known to the
audience, the last phrase recalled his mother's fondness for her
pastors and her early wish that he become one. The public meaning
of the phrase was the deliberate irony of taking Ruskin's place as
preacher on a public platform.

He opened his lecture with the same air of modesty that preceded
his brilliance in the witness box at the Ruskin trial. He said that art
was upon the town to be coaxed into company as a proof of culture
and refinement, that art had been brought to its lowest stage of
intimacy. He remarked that artists were not reformers, and then sud-
denly, "Beauty is confounded with virtue, and, before a work of Art
it is asked: 'What good shall it do'?". Then remembering *Patience*
and the Pre-Raphaelites, he directed satire against the desire to imi-
tate literally the past; "Useless! quite hopeless and false is the effort!
—built upon fable, and all because a wise man has uttered a vain
thing and filled his belly with the East wind!

"Listen! There never was an artistic period.

"There never was an Art-loving nation."

The talk began to strike fire, and Whistler deftly separated the
artist from all other men, one who perceived in Nature about him

curious curvings, as faces are seen in the fire . . . "was the first artist."

The lecture was seriousness itself; and then came his plea for the particular art of his best work and his view of Nature:

> The sun blares, the wind blows from the east, the sky is bereft of cloud, and without, all is of iron. The windows of the Crystal Palace are seen from all points of London. The holiday maker rejoices in the glorious day, and the painter turns aside to shut his eyes.
>
> How little this is understood and how dutifully the casual in Nature is accepted as sublime, may be gathered from the unlimited admiration daily produced by a very foolish sunset.
>
> The dignity of the snow-capped mountain is lost in distinctness, but the joy of the tourist is to recognise the traveler on the top. The desire to see, for the sake of seeing is with the mass alone the one to be gratified, hence the delight in detail.
>
> And when the evening mist clothes the riverside . . . as with a veil and the poor buildings lose themselves in the dim sky . . . and the whole city hangs in the heavens . . . —then the wayfarer hastens home; the working man and the cultured one, the wise man and the one of pleasure cease to understand as they have ceased to see, and Nature, who, for once has sung in tune, sings her exquisite song to the artist alone, her son and her master.

Whistler was, of course, speaking for the validity of his Nocturnes, but he had also advanced a principle of aesthetic rightness in the artist being of his own time. As for the future, he stated with admirable clearness the standards he had in view:

> We have then but to wait—until, with the mark of the gods upon him—there come among us again the chosen—who shall continue what has gone before. Satisfied that, even were he never to appear, the story of the beautiful is already complete—hewn in the marbles of the Parthenon —and broidered with the birds upon the fan of Hokusai— at the foot of Fujiyama.

Whistler's prose was of *le grand homme manqué*. But what took his audience by surprise and justly so was the air of seriousness, of conviction behind the rhetoric and between the words. The man was not a professional lecturer; for the moment, he was an amateur actor who had dramatized the position of a maligned and widely misinterpreted, misunderstood artist. Those who came to laugh at or with Whistler were shocked into being moved by the excellence of the performance as well as by the evidence of its sincerity. He was suddenly heroic, a little man with a dark face above a gleaming white shirt front, stepping out of the darkness behind him toward the audience. The lecture was very nearly stripped bare of invective and the expected epigram. It made no attempt to compete with Wilde's conversational style, and by this thoroughly unexpected action on Whistler's part, he stepped out of Wilde's reach. The field was his own, and his winning it in the fashion that he did, had the appearance of victory in a hard-fought battle.

The lecture could not of course bring the Wilde-Whistler controversy to a close that evening, nor could the lecture change the minds of Whistler's adverse critics. But he had made a long stride in the direction away from Wilde and away from other figures in the aesthetic movement. He had succeeded in making clear to those who heard him that he stood in a singular position.

Wilde's reply to Whistler's *Ten O'clock* was in his review of the lecture for the *Pall Mall Gazette* and he said, "I differ entirely from Mr. Whistler. An artist is not an isolated fact; he is the resultant of a certain milieu and a certain entourage and can no more be born of a nation that is devoid of any sense of beauty than a fig can grow from a thorn or a rose blossom from a thistle . . . The poet is the supreme Artist, for he is the master of color and of form, and the real musician besides, and is lord over all life and all arts; and so to the poet beyond all others are these mysteries known; to Edgar Allan Poe and Baudelaire, not to Benjamin West and Paul Delaroche."

Whistler's answer to that was: "Nothing is more delicate, in the flattery of 'the Poet' to 'the Painter' than the naïveté of 'the Poet' in the choice of his painters—Benjamin West and Paul Delaroche!"

It was clear that Wilde had stepped out on to very uncertain aesthetic grounds, nor was his reply one that gave him better footing.

It was also clear that his knowledge of painting and of painters was superficial. He confessed that his information about West and Delaroche was picked up from a biographical dictionary, that it was there he learned they had lectured on art and that since he knew nothing more of them he concluded "they explained themselves away."

This led Whistler, at a later date, to the remark: "Oscar had the courage of the opinions . . . of others."

The quarrel was in the open and it was to remain a public one beyond the deaths of the two antagonists.

Meanwhile Whistler had joined the Society of British Artists in 1884; his reasons for doing so were not obscure: he had been snubbed by the Royal Academy and his showings at the Grosvenor Gallery had fallen off. The Society of British Artists, a moribund group of elderly minor painters, met at their rooms and showed their work in a rundown building in Suffolk Street. The institution was barely alive but it was better to go there than to go no place at all; its members scarcely approved of Whistler, but they thought, rightly enough, that his name would bring attention to their Society, and he saw hopes of galvanizing the group into a semblance of life.

The *Ten O'clock Lecture* was impressive enough to convince the Society's membership that the election of Whistler into its fold had not been a mistake, and Whistler found the walls of the Society an excellent place to hang his portrait of Sarasate; the picture was conservative enough to please conservative taste. He also hung a portrait of Mrs. Cassatt on its walls; she protested, saying it did not look like her, and Whistler admitted that it did not, but he assured her that anyway it looked like a Whistler and the picture continued to be shown.

The British Artists were five hundred pounds in debt and to cut expenses Whistler told its president to do away with entertainment, an annual luncheon to newspaper critics—"The press ye have always with ye, feed my lambs"—and to that showing Whistler sent an empty frame. Of course, the president had ignored Whistler's advice and the critics arrived; remarking the empty frame, one critic turned to Whistler and said, "Your picture is not up to your best, it's not so good this time." Whistler replied, "You should not say it isn't good, you should say you don't like it, and then, you know,

you're perfectly safe; now come and have something you *do* like—
a drink of whiskey."

The British Artists went further into debt. Whistler had given
them more than enough publicity, but no extended and wealthy
membership. Instead he packed the membership with young men
who admired him, but had their own reputations to make, whose
work did not sell and whose support of British art for its own sake
was extremely uncertain. To the horror of the elder members of the
Society, Whistler was elected president of the institution by its new
members, and they were willing to adopt the "propositions" that
Whistler had written as standards for work done by members of the
Society. Among the "propositions" were:

> A picture is finished when all trace of the means used to
> bring about the end has disappeared.
>
> To say of a picture, as is often said in its praise, that it
> shows great and earnest labor, is to say that it is incomplete
> and unfit for view.
>
> The masterpiece should appear as the flower to the
> painter—perfect in its bud as in its bloom—with no reason
> to explain its presence—no mission to fulfil—a joy to the
> artist—a delusion to the philanthropist—a puzzle to the
> botanist—an accident of sentiment and alliteration to the
> literary man.

No artist in London at that moment, especially among the British
artists, was prepared to take these maxims lying down. Millais was
still in high favor, Sir Frederick Leighton, president of the Royal
Academy, afterwards Lord Leighton, had considerable weight, and
he with Burne-Jones was in full authority. Watts was still enshrined
at Little Holland House and the wealthy family of the Princeps were
still guides of well-to-do patronage of all the arts. It was extremely
likely that Whistler's presidency of the British Artists would lead
that dying institution to financial ruin and its grave. His election
was on June 1, 1886; he had planned to visit the United States, but
the honor (if it was one) of being President of the British Artists
changed his plans. At the very least it offered a new battlefield on
which he could gain another semblance of victory.

The *Ten O'clock Lecture* had brought about a final rift with Swinburne. In 1884 Dante Gabriel Rossetti had died at Birchington-on-the-Sea away from London; his health was gone; he had wandered among the clutter of the rooms at Cheyne Walk refusing to see visitors, sinking deeper than ever into the melancholia that had clouded his mind; he did not like country air, nor did he have any fondness for the sea. Its noise disturbed him; the trip to Birchington was a last hopeless effort to change the fantasies that haunted his mind; the change of scene was literally a last resort. Rossetti's ill health and death also closed the period of association between Whistler and Swinburne. Swinburne, passing under the domination of Watts-Dunton in Putney, was adroitly separated from all the friends of his more dissolute years. Watts-Dunton slowly, softly, as one might shrewdly nurse a spoiled child, had worked a miracle. The drunken poet had all the outward attribute of a frightened and excessively well-trained household pet. His drink had been changed from wine and stronger waters to ale. From the attached villa in Putney he made a few "escapes" to a public house on the rise of a hill over which Putney High Street ran, but these ventures were sporadic. The drink was ale and Watts-Dunton without loss of dignity would seek Swinburne out at a table near the bar, speak to him quietly and guide him home.

One reason for Watts-Dunton's extraordinary care of Swinburne was Swinburne's fascination for and later horror of the company of Charles Augustus Howell. Whistler had said of Howell that he was of the greatest service to his friends: "He had the gift of intimacy. He introduced everybody with everybody, and it was easier to get involved with Howell than to get rid of him." Howell enjoyed the sport of getting Swinburne drunk, obscene, pliant. On such occasions, opportunities arose for blackmail, and Howell saw in Swinburne an ever greater source of income than payment for the lease of a house that he had already received from Ruskin. However deeply Swinburne enmeshed himself in what he fondly regarded his "vices," his instincts, not his brain, became singularly active. He began to fear Howell, and rushed to Watts-Dunton for consolation (since Watts-Dunton was a lawyer) and protection. Watts-Dunton distrusted artists, particularly new artists, who advanced what he considered dangerous theories concerning Japanese art. Whistler was

one of these; and Whistler had gone through bankruptcy. Swinburne had become his charge, his care. The sum of money Swinburne inherited was large. Watts-Dunton would not permit any chance of Howell's associates, including Whistler, having any claims whatever on Swinburne's time, money or affections; these were risks that he did not care to take.

Led by the opinions of Watts-Dunton, Swinburne reviewed the published version of Whistler's *Ten O'clock Lecture* in the *Fortnightly Review,* June 1888. His action was as deliberate in its intention to disassociate his name from Whistler's as had been Whistler's effort to break all associations of his name with Oscar Wilde's. Swinburne's desire was to undo his poem, "Before the Mirror," with its inscription to "J. A. Whistler" and its tribute to Whistler's painting of Jo, *Symphony in White. No. II, The Little White Girl.* The incident and the poem belonged to a past that Watts-Dunton encouraged Swinburne to reject. How Swinburne actually felt concerning that earlier moment in his career (1865) is uncertain, but there can be no doubt that in the spring of 1888 he wished to quarrel with Whistler, to open Whistler's praise of Japanese art to ridicule. His attack on Whistler was a tedious argument to prove Greek art superior to Japanese. To say the least, Swinburne's prose lacked wit and ease. On this occasion it was heavy and prolix. He implied that Whistler was "thick-witted, tasteless, senseless" and an "impenetrable blockhead." He objected to Whistler's statement that "Art and Joy go together" and interpreted it as denying the existence of Greek tragedy.

In his attack on Whistler, Swinburne committed the crime of being dull. His only success in the writing of his review was increasing Whistler's sense of persecution—which of course was part of Swinburne's intention and desire. If Whistler's quarrels in print released his own sadistic impulses, Swinburne was no less sadistic in his efforts to break with Whistler.

Yet to Whistler, the Swinburne attack was quite unlike the injury to his vanity that was suffered in the quarrels with Ruskin, Wilde, Howell and Harry Quilter. He was not merely injured, but hurt; he had admired Swinburne and valued the poem that had accompanied *The White Girl with a Fan;* it was true that Watts-Dunton had not permitted him to visit Swinburne at Putney, that

the green gate at number ten the Pines was closed to him, yet he had not thought of Swinburne going out of his way (as he did) to join other critics in general assault upon his *Ten O'clock Lecture.* In *The Gentle Art of Making Enemies,* his reply to Swinburne was both florid and rhetorical—and what was rare in Whistler's controversial pieces—sentimental: "Do we not speak the same language?" Whistler wrote. "Are we strangers, then, or, in our Father's house are there so many mansions that you lose your way, my brother, and can not recognize your kin?"

In the last paragraph of his reply, Whistler added, "You have been misled"; it is probable that he knew Watts-Dunton had inspired the article. Whistler knew Putney well; he had gone up the river to Putney on all-night journeys at the time he was painting his early Nocturnes, and before six in the morning he had gone swimming with Howell there in the broad curve of the river. He knew its suburban fastnesses, its stolid remoteness from Chelsea and Regent Street, its distance from Paris where he had first met Swinburne.

In his attempt to quote *Ten O'clock* against Whistler, Swinburne had referred to himself as an "outsider." In a brief reply to Swinburne's *Fortnightly* article that he sent off to *The World* Whistler thought of Putney and the attached villa, which even today has a legend of a ghost visiting those who are left alone in the house on Sunday afternoons, and he wrote: "Thank you, my dear! I have lost a confrere; but, then, I have gained an acquaintance—one Algernon Swinburne—'outsider'—Putney."

THE death of this friendship was soon to be followed by Whistler's marriage to E. W. Godwin's widow. Since the break with Jo, Whistler's relationships with women had been of gallant but brief duration. The exception to the general rule, one that included semi-platonic relationships with Lady Colin Campbell and Rosa Corder, was Maud Franklin, who for the most part was content to remain in the sub-official position as Whistler's model. Not until the early 1880's did Maud begin to think of herself as "Mrs. Whistler" and then the thought of her being so came too late. Beatrix Godwin had already appeared on the scene. She was the daughter of John Birnie Philip, the sculptor whose designs are represented at Burlington House and in the details of the Albert Memorial. Beatrix Godwin had grown up with artists; she had a talent for book illustration, but this was the least of her abilities, her knowledge, her understanding. She knew how to take care of men who possessed, or rather were possessed by, "artistic temperaments." She also knew her way about in semi-fashionable, semi-artistic society; her hair was dark; she looked un-English; she was slightly taller than Whistler and inclined to plumpness; her social ease permitted her to be both absentminded and a good hostess, but her greatest asset was a cheerful disposition. As Whistler held the center of the floor, either in his studio or at an afternoon tea in a drawing-room Beatrix Godwin was content to sit in a corner of the room and join in the general laughter that followed his telling the story of the Ruskin trial.

She spoke of herself as one of Whistler's pupils; it was both serious in its implications and yet had a cheerful irony. She had a small income, quite her own, which had relieved the immediate anxieties of living with Godwin; but her financial independence did not free

her of strain in taking care of him. He was ill, and taking care of a sick man imposed a burden on a cheerful temperament.

Godwin who had long been interested in the experimental and amateur stage turned from architecture to the management of the Pastoral Players whose efforts were staged in the open air and whose patronage was derived from the Prince of Wales and Lady Archibald Campbell. From this example it is not extraordinary that his son, Gordon Craig, by Ellen Terry conceived radical ideas of stage craft. In the pursuit of these interests, it was also not surprising that with his drifting back and forth between city and country, Beatrix Godwin solved her domestic problem by being with Whistler in London when Godwin took the Pastoral Players to the countryside and then living in Oxford whenever Godwin stayed in London. This resulted in a friendly separation. Between the management of theatricals, Godwin made plans of a new house for Whistler and a house for Mrs. Louise Jopling, and in August of 1886 he wrote to her, "The next move I make is to St. Peter's Hospital where I have bespoken a ward all to myself; then the next ward may be 6x4x2." He went to the hospital and his friends called Beatrix Godwin home from Paris. Dr. Whistler, Whistler's brother, was put in charge of Godwin's case, and Whistler called on him every day. On the night of Godwin's death Whistler was at his bedside and so were Lady Archibald Campbell and Beatrix Godwin. Early the following morning, October 7th, Whistler walked from his brother's house to Mrs. Jopling's; his errand was to tell her to go to Ellen Terry's house with news of Godwin's death; he wished to spare her the shock of reading of it in the papers.

Within a day or two, the three friends of Godwin who had sat at his deathbed lifted the coffin containing his body onto a farm wagon, and as they were driven to Northleigh in Oxfordshire, they spread a cloth over the coffin's top and ate the lunch they had brought with them in baskets. Godwin was buried in the corner of a field at Northleigh. This, to say the least, was a strange tribute to the builder of the White House, and a markedly grotesque one; but it was probably a better one than the kind that Ellen Terry held in mind. Among her papers she saved a few mawkish lines of verse written in memory of Godwin by a poet who preferred not to sign them and remained anonymous.

From this time onward Beatrix Godwin devoted most of her attention to Whistler's affairs. Judging from her relationship to Godwin, Whistler had small cause to think her relationship to him would be either sentimental or indulgently maternal; but her social tact, both in managing him and those who met him, began to soften the edges of his more violent hostilities toward the world. "If I died before Jimmy," Beatrix Godwin said, "he would not have a friend left in a week." In becoming his wife she was both aware and confident of the part she had to play.

Maud Franklin still presented a difficulty; it was Maud, the English version of Jo, who shared with Whistler the distresses of unpaid debts at the White House, though she had done little to reduce them. It was she who shared the discomforts of the places he lived in Venice, and when they returned to London, the uneasy lodgings before they came back to Chelsea. It was she, who, like Jo, vanished to Paris, soon after her child, this time, a daughter, was born to Whistler. One sees sketches of her as the little nude in Whistler's chalk drawings, lightly draped, with a face that is a trifle oversweet, but also with certain elegance in the turn of the head or shoulder. After the brief stay in Tite Street (the period that Maud spent in Paris), Whistler moved with her into a studio in Fulham, a neighborhood which today faintly resembles New York's Greenwich Village; a little theatre group now flourishes there, houses are of mixed eighteenth-century and early nineteenth-century designs, a number of back gardens are kept in irregular order, and people dress as they choose.

Maud's life with Whistler was a day-to-day battle with ill-paid servants, grocers, butchers. From Fulham, Maud and Whistler moved to a cottage in the Vale,* Chelsea, with its wrought-iron railing before the door and with a tree, struggling to life, its branches climbing upward to throw green-tinted shadows through its front windows. Maud did not accompany Whistler as he rushed off to dinner parties in more fashionable quarters of the West End, yet she had cards

* The Vale was a cul-de-sac along King's Road, a strangely countrified setting-in-a-city, of which A.M.W. Stirling wrote: "On one side stretched a former deer-park and opposite to it was a lovely spot where Whistler grew his larkspurs." It was undoubtedly too countrified for Whistler during the restless months he spent there, too much of a "come-down" from the more fashionable quarters in Tite Street.

engraved with the name "Mrs. Whistler" on them, which were use-
ful enough to show to her few friends and to shopkeepers who were
doubtful when she demanded extended credit. In West End com-
pany she was seldom seen. She attended the openings at the Society
of British Artists, where Whistler introduced her as Madame Whis-
tler; the other ladies at such assemblies merely nodded at her, slipped
by her quickly, and referred to her as Whistler's pupil. She was
docile enough but lacked ease; she talked brightly but without wit or
color; in entering a dining-room, unless Whistler took her arm,
she was in danger of trailing the company.

When Duret called at the Vale, he was careful to bring with him
bottles of wine, fruit and pastry for Maud; he knew something of
the strain she suffered, knew that she and Whistler did not eat well
at home.

Maud was powerless against the rivalry of Beatrix Godwin. Mrs.
Godwin, Whistler's other "pupil," felt she had the right to walk in
on Whistler at any hour, whether he was at work in his studio or
not. The fact was that Whistler did almost no work; the energy that
he had expended during the '70's could not be revived; larger can-
vases seemed to frighten him; as he left the White House he de-
stroyed almost everything he began, and the habit had grown on him
to destroy more. During moments of self-distrust, portaits of Maud
and Lady Archibald Campbell were destroyed. His quarrel with
critics had reawakened a critical faculty (which had always existed)
in the back of his mind, and the results of his present efforts in
painting fell far short of what he wished to see on canvas and he
lacked both the patience and the energy to practice the theories that
he preached. He could too easily content himself with the thought
that his earlier work contained sufficient proof of what he had to
say in print.

He did a number of minor pieces, things that required only the
slightest effort; they displayed, as always, the characteristics of his
style, but did little to raise his ego or heal the wounds that his
vanity had received. He received more attention, more invitations
to dinners through publication of a letter in *The World* or the de-
livery of his *Ten O'clock Lecture* than any showing of a new canvas
to a sitter in his studio. Nor was the Fulham house or the Vale quite
the right place to bring visitors, who would see too clearly that the

middle-aged Whistler did not prosper, that the faithful Maud man-
aged well but not brilliantly, that the household lacked chic, that
however sincerely young men called him the Master, his affairs were
not handled in a masterly manner.

Too late Maud lost her temper. She had been, so far as the world
was concerned, correct enough. Since Whistler chose to be absent
from the Vale and in the company of Mrs. Godwin, she decided to
find another painter who could and did find her an admirable model.
Through visits to the British Artists she discovered William Stott
who had small talent but an appreciative eye; his portrait of Venus,
becomingly unclothed, was shown at the British Artists in 1887.
Those who saw it were amused because the goddess sweetly resem-
bled Maud. Another portrait of Maud by Whistler at the same show-
ing received less attention, but one reviewer remarked that Whis-
tler's painting showed Venus in clothes that were now fashionable
to wear. The ladies who saw the show concluded that they had been
right about Maud, and Maud left London to live in the country with
Mr. and Mrs. Stott.

Whistler also left the Vale and did not return to the cottage.
Throughout his life Whistler did his best to avoid unpleasant scenes
with women; if he failed to dominate them, he did his best to charm
them in the fashion he had charmed his mother. If both efforts failed,
he walked away. He would say nothing against them; he pointed out
their charms in the sketches he had done of them; he would indulge
in light gallantries when he spoke of them, or if he had quarreled
with them, cut them distantly with the room between them.

He moved into lodgings and hotel rooms with Mrs. Godwin.
There was enough dining-out to be done to keep both in circulation
and Whistler was planning to resettle in Tite Street. They drifted
cheerfully enough from London to Paris, but their affairs were not
in order. They put off the actual ceremony of getting married; out-
wardly they knew how to take care of themselves; they were middle-
aged; they did not care to be thought of as romantic children.

Labouchere, a genial Tory politician, whose hobby it was to move
among artists, was one of the guests at a dinner party where Whis-
tler and Mrs. Godwin were present. Labouchere was brisk, practical,
witty, the kind of man who could make a personal gesture at a semi-
public occasion without offense to anyone in the company.

At the dinner table he turned jauntily to Whistler, his voice slightly raised: "Jemmy, will you marry Mrs. Godwin?" "Certainly," said Whistler lightly. The scene was a parody of a marriage service and within an atmosphere that Labouchere delighted to create; he turned to Mrs. Godwin, "Mrs. Godwin, will you marry Jemmy?" "Certainly," she said in imitation of Whistler's light manner. "When?" Labouchere said. "Oh, some day," said Whistler. "That won't do," Labouchere replied, "we must have a date."

Whereupon Whistler turned the entire matter over to Labouchere, date, church, minister. A few days later on August 11, 1888, Whistler married Beatrix Godwin.

The day before the wedding Labouchere met Beatrix Godwin to remind her of the coming event; she told him she was going out to buy her trousseau. "I am going to buy a new toothbrush and a new sponge, because one should have new ones when one gets married." Her manner had the coolness of the Shavian heroine, who a decade later was to make an appearance on the London stage.

London and August are not the best of possible combinations for a wedding, but Labouchere with his usual felicity found an eminently respectable church for the ceremony. It was St. Mary's Abbot, Kensington, a few steps behind Kensington Palace, fronting Kensington Road, as it turns slightly into the High Road. The church was large and cool, and the wedding party an extremely selective one: Labouchere, Dr. Whistler and his wife, the Jopling-Rowes, and Mrs. Charles Whibley, a sister of Mrs. Godwin, were there. After the ceremony the party went south into Chelsea where Whistler had recently moved into the Tower House; he was back again on Tite Street; the wedding breakfast was ordered from the Café Royal, Whistler's favorite restaurant, in Regent Street.

It was characteristic of Whistler to like the Café Royal, which at that time in London had an atmosphere not unlike Florian's in Venice, and its decor was a British version of the more lavish restaurants in Paris. The place was famous for the number of well-known political and literary figures who lunched and had midnight dinners there; its English decor was of the Regency, its French was of the Second Empire; red plush and gilt predominated; cut-glass chandeliers, mirrors, small murals, heavy white damask table cloths

gleamed. To step into the Café Royal was like attending the first night at the theatre.

The Café Royal was certainly one of the places where the new Mrs. Whistler would be thoroughly at ease and so would Whistler. Ascending its red carpeted marble stairway they would be instantly recognized by those whom Whistler regarded as his enemies (including Oscar Wilde) and by a few of his friends.

The wedding at St. Mary's Abbot, the church where Rudyard Kipling's parents had been married, where the more respectable Pre-Raphaelites (including Burne-Jones) had been married, was an omen of a change that had entered Whistler's social life, and his wife, Beatrix, was largely responsible for it. Her circle, through her sister, the wife of Charles Whibley, was to lead him into another world.

The newly married Whistlers went to France for a brief holiday; they wandered into Touraine and visited Chartres; Whistler made a new set of etchings which cost him little effort; they loafed. In London Maud still insisted that she was the "real Mrs. Whistler," but the relationship between them was at an end and she knew it. She had not lost her figure; she sat for several painters, and at last married a well-to-do South American who provided for her and for Whistler's daughter.

The year of Whistler's marriage also brought him a little notice from Germany; largely because he had been elected president of the Society of British Artists, he was invited to hang a picture at the International Exhibition held at Munich. He was happy to receive the invitation; his picture, *The Yellow Buskin,* was given second prize, a medal, and to the committee of awards Whistler wrote that he accepted it with "sentiments of tempered joy" and with complete appreciation of "a second-hand compliment."

The other event of the year was Whistler's removal, by vote of the membership, from the presidency of the Society of British Artists, and the event caused a little explosion in the press. By 1888 Whistler had become the subject of good newspaper "copy"; that is, he had become regarded as a well-established figure who could be relied upon by reporters to give them a "story." The Ruskin trial had insured that kind of reputation for him, and he knew how to make reporters ask him questions that he could answer. He turned

his interviews into "press-conferences"; he had learned how to please young men sent out on an assignment.

The British Artists had admitted him to membership with the obvious purpose of drawing attention to itself, but within a few years, it became equally clear that Whistler had gained more through the connection than had the institution. The sales of pictures from the walls of the Society had continued to drop. When Whistler joined it in 1885, the total sum of sales was under four thousand pounds; in 1888 it was under one thousand. At one time, Whistler had raised a loan of five hundred pounds for it, but its losses had increased so rapidly that the Society had the sensation of hearing clods of earth falling on its coffin as it was being lowered into the ground.

What Whistler gained from the connection was shown by the invitation to send a picture to Munich, a piece of news that did not delight the elder members of the Society; they had never cared greatly for Whistler's painting, and what was natural, elements of envy and jealousy (since their own work was neglected) entered into their mistrust of Whistler. In matters of publicity for the Society, it was Whistler who was talked about, not the Society. They elected in Whistler's stead, a Mr. Wyke Bayliss, whom the *Pall Mall Gazette* described as "a strong man." He was a Board-School Chairman, champion chess-player of Surrey, a Fellow of the Society of Antiquarians, a Shakespearean student, and an ardent, skillful bicycle rider. Whistler never failed to refer to "the mad machine" he rode and his speed in driving. The situation had all the elements of farce and Whistler made the most of them.

The Pall Mall Gazette sent a young man to the Vale in Chelsea (this was shortly before Whistler's marriage) to interview the ex-president. Whistler was at his best; when the young man asked him about the state of affairs at the Society, Whistler raised his eyebrows and sparkled: "Why, my dear sir, there's positively *no* state of affairs at all . . . everything is in order, and just as it should be. The survival of the fittest as regards the presidency, don't you see, and well—Suffolk Street is itself again . . . as I told the members the other night, I congratulate the Society on the result of their vote, for no longer can it be said that the right man is in the wrong place. Eh, what? Ha, ha?"

"Then how do you explain the bitterness of the opposition?"

"A question of 'pull devil, pull baker,' and the devil has gone and the bakers remain in Suffolk Street."

"And the moral of it all?"

The way was open for Whistler's last remark that was certain to be heard and quoted many times: "The organization of this Royal Society of British Artists could not remain together, and so, you see, the artists have come out, and the British remain—and peace and sweet obscurity are restored to Suffolk Street! Eh, what? Ha, ha!"

Of the twenty-five artists who resigned from the Society with Whistler, only one had lasting merit; he was Alfred Stevens, the sculptor; of the "British" who remained, all are mercifully forgotten. As far as posterity is concerned, Whistler's victory was won by an extremely narrow margin, but it was a victory.

If Beatrix Godwin was a Shavian heroine who had arrived in London ahead of Shaw's reputation, her new husband had some of the attributes of a devil's disciple before Shaw had written his *Three Plays for Puritans*. Beatrix Whistler could not refashion Whistler's character, but she did succeed in making him seem less strained, less violent in casual conversation, and among a few friends, more friendly. Her presence also modified his social life in a way that Maud Franklin, and, earlier, Jo, had failed to do. She herself was acceptable in any social gathering to which Whistler would be invited and where Maud Franklin was merely tolerated. In the past Whistler had drifted into many light but dubious relationships with women, and these brief, half-gallant, half-uneasy affairs kept him on the nether side of London's caste-ridden society. It was true that through Lady Colin Campbell and Lady Archibald Campbell he moved on the fringes of a set that included a notoriously reckless Prince of Wales. The Prince was not a model of virtue nor did he wish to be, but because he was the Prince, he avoided ugly consequences that were shouldered proudly by those who followed in his wake; they entertained the Prince, amused him and paid the bills.

Among those who followed the Prince was Lord Colin Campbell, son of the Duke of Argyle. His wife was Vera, a handsome Irish girl, who was six feet tall, dark-haired and dark-eyed; she painted her lips in the newly arrived fashion of Parisian night clubs. Her marriage to Lord Colin had been one of convenience; Lord Colin

had thought vaguely of marriage, and Vera's mother had chosen him as the object of ambition for the improvement of Vera's position in society. She rented a house near the Duke's estate in Scotland, and in spite of the Duke's warning that his son would not make the most virtuous of husbands, Vera's mother had had her ambition gratified. The girl seemed willing, and Lord Colin was, for the moment, pleased, but a few years later he brought suit for divorce against his young wife and named six co-respondents. Vera brought counter-suit against Lord Colin and he lost his case. The lower-middle-class jury who had been brought up on the novels of Ouida believed readily enough that a lady could have a lover, but they did not grasp the possibility that a real lady might have six; that disillusionment was too great to bear.

Whistler's name did not appear among the co-respondents, but had his letters to Lady Colin Campbell been read aloud in court, further questioning of her conduct would have followed. They were extremely gallant, yet vague enough in naming places of appointment to be dismissed as inconclusive evidence. But he did enjoy her company; she was intelligent and had a fancy for the attentions of Whistler as well as those of a younger American, Henry James. Within her own set of bright young people who followed the Prince of Wales, and preceded the brighter set of the Edwardian era, Lord Colin's suit against her had left her hopelessly *déclassée*. She then turned to journalism and the writing of art reviews. Of this latter period Gertrude Atherton told a story of calling on her one afternoon. As Mrs. Atherton walked into her drawing room, she saw Vera reclining on a sofa with an expectant face turned toward the door, but when she saw who her visitor was, her expression froze. Obviously Mrs. Atherton had been admitted by mistake; she was not the expected guest, but before she left, Henry James, smartly dressed and brisk, walked into the room. He had come at the safe hour of four o'clock tea and sat himself in a chair, opposite his hostess with the tea table and silver tea urn between them; he took command of the scene and talked of Whistler, of how he hoped to outlive him, so that he could write a proper and revised tribute to Whistler's art after the artist's death; Lady Colin had the wit to conceal her disappointment at the turn the conversation had taken; Mrs. Atherton left, assured that James would talk more of art than of Lady

Colin's remarkable good looks; he would be flattering but decidedly platonic.

But by this time, Beatrix Whistler had gently guided her husband out of the reaches of the fashionably *déclassée;* the circle into which she led him was perhaps more modest in its pretensions— they had moved from Tite Street to Cheyne Walk, a few doors from the house where Rossetti had once lived—a circle that was smartly literary rather than merely smart.

The direction in which the Whistlers moved was toward Henry Harland, the American, who was soon to edit *The Yellow Book,* W. E. Henley, the vigorous editor of *The National Observer,* and William Heinemann, the publisher, and of these three, Henley was the most spectacular figure. Henley was the son of an impoverished Gloucester second-hand bookseller, and, as if that handicap were not sufficient, he was also a victim of tuberculosis of the bone. He came to London through the aid and patronage of three men, George Wyndham, the Conservative statesman, Leslie Stephen, the editor and critic, and Robert Louis Stevenson. Henley selected as the object of his hero-worship, Disraeli. Within a short time, he became noted as a leader of Conservative opinion in the arts as well as in politics, and he had the gift of attracting young men to his house in Richmond Park and to the offices of the *Observer.*

Henley had a few entirely loyal admirers, and among them were G. S. Street and Charles Whibley. Whibley was one of those rare young men who fitted perfectly into the radical Conservative mold into which Henley tried to force the rest of his contributors. He shared Henley's romantic love of underworld characters, of which Stevenson made such excellent uses by having Henley himself sit as model for "Long John Silver" in *Treasure Island.* He shared Henley's hatred of the Rossettis and of Oscar Wilde; he shared Henley's enthusiasm for the extremes of Conservative political thinking, and was an active, often brilliant political journalist. His mind was better trained, more firmly built than Henley's; he was an eminently "safe" young man.

At Henley's orders, he had written an attack on Whistler as a public figure, but defended his art because Whistler's views ran counter to Holman Hunt's and the credos of the Pre-Raphaelites. In usual circumstances Whistler would have fought against both

Henley and Whibley, but through Beatrix Whistler, whose sister was about to marry Whibley, an open and sustained quarrel with the *Observer* was first deferred, then avoided. Whibley's article on Whistler (which was one of a portrait series run under the title *Modern Man* and was a forecast of what *The New Yorker Profiles* were to become) had its value in increasing Whistler's fame among the younger intellectuals, for the *Observer* was read in club rooms and in university libraries. Since Henley had championed Whistler's cause in an earlier magazine he edited, *The Magazine of Art*, Whistler could afford to overlook unfavorable comment on his *Ten O'clock Lecture*, and the way was clear for Henley and Whistler to dissolve their differences in the intense and narrow stream of their mutual likes and dislikes.

What Whistler had in common with Henley was several convictions. The first was implied in the title of Whibley's series, *Modern Man;* Whistler believed in modernity, which was sharply said on a brief visit to Rome— "It is nothing but ruins." Another belief was the superiority of the individual standing alone against the world. "I am the Master of my fate," wrote Henley. Whistler believed, as Henley did, in the superiority of an informed minority as against the choices made by those who appealed to popular taste, a conviction that he expressed during the Ruskin trial and after it.

Friends of Henley called him a "crippled giant." Their affection held in it the image of a burly, broad-shouldered man who limped like Vulcan and was as coarsely fibered as he, and was innately brutal. He had not quite conquered London, but he had threatened to. Something of the same thing could be said of Whistler, who tripped (quite unlike Henley's weight and limping step) onto the center of London's stage. (Ten years later Henry Adams, who admired the historian Gibbon more than the art critic Ruskin, remarked that Whistler had become more brutalized by the brutalities of his world; this world was of course the same world of London that Henley knew.)

Both Henley and Whistler had cause to think of themselves as self-made men, and as Charles Whibley was drawn closer to Whistler's domestic circle, the friendship, though never intimate, grew cordial; this was the kind of association that Beatrix Whistler encouraged.

One of the fashionable publishers of the '90's was William Heinemann, who like Murray Marks the art dealer might well have been mistaken for the Prince of Wales. His smartly clipped beard, his rotund, somewhat Germanic figure, his fashionable dress made him a welcome guest at dinner parties that the Whistlers frequented. The acquaintance with Heinemann was to lead to the publication of *The Gentle Art of Making Enemies.*

But before Heinemann became Whistler's publisher, the book was to have its moments of publicity and violent dispute. Its title was the invention of an American newspaper man who had arrived in London to do a series of articles for *The New York Herald;* his name was Sheridan Ford. Ford interviewed Whistler, and in doing so came upon the happy idea of making a collection of Whistler's writings. These were to include reports of the Ruskin trial and the *Ten O'clock Lecture* as well as the letters Whistler had written to the papers, to his friend, Yates, who edited *The World,* to Labour-chere, the ex-diplomat who edited *Truth.* Both the Whistlers were delighted with the idea and spent their days in Cheyne Walk going over boxes filled with old newspapers and clippings.

Ford was indigent, enthusiastic and naïve; he had his wife with him and they had been living beyond their means in a London that had already begun to glitter with premonitions of Edwardian "high living." He went to his friends to borrow money against the future publication of Whistler's book. One friend advanced him fifteen pounds but when Ford approached him for the loan of a hundred, promptly said "Good-bye."

Ford was unaware of Whistler's latent brutality that had caught the eye of Henry Adams; Adams had sat at dinner with Whistler and had perceived that much of his wit had become the crystallization of bitterness, that the pearls he cast before those who saw and heard him had been cultured and polished by acid and gall.

Ford worked at the British Museum going through newspaper files to collect Whistler items until one day he received a letter from Whistler with a check for ten pounds enclosed for his labors and instructions to stop work on the book. Ford went to his friend, McLure Hamilton, and showed him Whistler's letter. The friend, reasonably enough, concluded that Mrs. Whistler saw possibilities of making money on the book and had advised her husband to pub-

lish the book without Ford's help. Ford went ahead with the book
and received Hamilton's assistance in reading proof. Then, suddenly,
as the book was in press, Ford told Hamilton that Whistler had
found out who the printer was, had threatened suit against him, and
had effectively stopped the publication of the book. Hamilton who
had never met Whistler received a letter from him accusing him of
helping Ford in furthering an unauthorized book, and Hamilton re-
plied with a letter denying the charges.

At this point Ford's unstable mind and health collapsed. He fell
ill; he had dreamed of making a reputation for himself by use of
Whistler's name, and now he saw too clearly that the end of his
own career was just around the corner. A few weeks later he and
his wife left London for Antwerp where the book was reset and
issued only to be seized by Whistler's lawyer, which was followed by
a suit in a Belgian Court in October, 1891, against Ford. At the
trial Whistler was in the witness box bringing his charges against
Ford in rapid French. The reporters thought of him as the devil in
the box, and probably the Judge did too, for with particular sharpness
he asked Whistler the nature of his religion, and when Whistler
paused in reply, the Judge said dryly, "Protestant, perhaps?" Whis-
tler shrugged his shoulders and then refused to tell his age. If he
was taken for the devil, he played his part well and won his suit
against the unfortunate Ford, who was forced to pay court costs and
damages beyond the total of three thousand five hundred francs.

Later Hamilton attempted to argue with Whistler and to plead
Ford's side of the case; he got nowhere and Whistler spoke of Ford
as one who would steal his host's spoons at a dinner party.

Meanwhile Whistler had made a friend of the brilliant William
Heinemann. Whistler and his wife spent the greater part of their days
and nights polishing the book of letters, notes, and documents that
Heinemann now (since the book had received so much advance
publicity) was eager to publish. The Whistlers had appropriated
with less honor than worldliness the title Ford had suggested, *The
Gentle Art of Making Enemies,* and without credit to the latest of
the "enemies." From its title page to its inscription of "fini" the book
was decorated by drawings of the butterfly in all its graphic varieties
of joy, rage, and triumph—the creature's wings seemed to dance,
trip, point and accuse—and it had acquired a forked tail. The book

was inscribed to "The rare Few, who, early in Life have rid Themselves of the Friendship of the Many," and in this appeal to the rare few Whistler echoed Stendhal's "the happy few." It was the kind of echo, which so often happens in the case of Whistler's conversation and his writings, that "came out of air," out of the dinners he attended, the company he kept—and not from the little reading that he did; he had always been quick to overhear a phrase and then transform it sharply to the character of his own personality.

At the moment of publishing *The Gentle Art,* he had never been more popular; that is, popular in the sense of having his name known. The work that he had done twenty to ten years before was recognized, and though fashionable sitters did not rush in crowds to his studio, he was well in command of his celebrity in Paris as well as in London. In 1891 the Glasgow Corporation decided to buy the portrait of Carlyle. The arrival at that decision had all the weight of Scotch deliberation behind it. The picture had been shown at the Glasgow Institute in 1888, and the showing had coincided with one of the revivals of interest in painting in Scotland. A few young Scottish painters had gone to Paris to study and in 1889 Whistler had received the French Legion of Honor, which in the nineteenth century was a singular distinction for an American painter of Scots descent; it was quickly remembered that Whistler's mother was a McNeill of the McNeills of Barra.

Two other circumstances aided Whistler's fortunes in Scotland. Alexander Reid, a Glasgow art dealer, who had been associated with Vincent Van Gogh and his brother in Paris and who had studied painting as well as the art of dealing with them, was Glasgow's authority on the French Impressionists. To his enthusiasm for the Impressionists he added an appreciation of Whistler. Reid knew Pissarro, and Pissarro highly admired Whistler's etchings, and though he did not care greatly for Whistler's paintings, he defended them against thoughtless criticism and wrote to his son Lucien, "Whistler is very artistic; he is a showman, but nevertheless, an artist," which meant that when Lucien Pissarro went to London in 1890 he made a point of seeing Whistler. Whistler's French connections, however slight they were in actuality, had increased his prestige in Scotland, and particularly so with the alert Alexander Reid. He felt that he could not go wrong in speaking well of Whis-

tler and with proper caution invest in a few of his paintings and etchings. And then he gave his son the middle name of Mc-Neill.

The other turn of good fortune was that before Mary Bacon Martin had become Mrs. Sheridan Ford and had become entangled in the unhappy experience of trying to edit Whistler's letters, she had come to Glasgow from the United States to pick up ideas about art and inspiration for interior decoration. She had been sent to Europe by her employer, a manufacturer of wallpaper in the United States. She made trips down to London and discovered more of Whistler's work and reputation. In Glasgow she spread news of Whistler's need for money and generous patronage. In London her appreciation of Whistler's painting (which in her hands seems to have taken on the character of a crusade and a revolution combined) led to her getting the French firm of Boussod Valadon & Co. (which was then opening offices in London) interested in Whistler. Through Reid she got Boussod, one of the firm's partners, to see Whistler's work in Glasgow. Her scheme was to form a group of art dealers, backed by her employer in America and represented by Reid in Glasgow and by Boussod and Valadon in London and Paris, to sell Whistler's pictures. Her enthusiasms embraced Whistler, all the Glasgow artists and the French Impressionists in one vast transatlantic adventure. As Macaulay Stevenson, who was responsible for telling this story and who was among the lesser Glasgow painters, remarked: she tried to form a syndicate that would run Whistler. How deeply she failed in her intention we already know, for the Sheridan Fords met their defeat when Whistler testified against them in Antwerp. According to Stevenson, Valadon got in touch with her employer in the United States and persuaded him to send passage money to the Fords so that they could return to America. Valadon distrusted bright, energetic young women who had large ideas.

Whistler's immediate gain from the activities of Reid and Mrs. Ford was the purchase of the Carlyle portrait by the Glasgow Corporation at the price of a thousand guineas. A petition had been drawn up which included Millais' name (and since Millais had married Mrs. Ruskin, née Effie Gray, and therefore had small respect for Ruskin's opinion he was glad to sign) and sent a letter

to the Corporation urging it to buy the Carlyle. As Whistler later told the story of the purchase to Joseph Pennell, the American etcher, a group of members of the Corporation called on him and its spokesman said that Whistler's price of a thousand guineas for the picture was too high—"why the figure was not even life-size." "But you know," Whistler replied, "few men are life-size—" and the members left the room to think over the problem of spending a thousand guineas.

The next day they returned and asked Whistler whether he had been thinking of the thousand guineas, to which he replied again, "Why, gentlemen, why—well, you know, how could I think of anything but the pleasure of seeing you again"—and he then received the Corporation's check without further questioning.

A slightly different story of the purchase was told by the spokesman of the Corporation's delegation to Whistler's house in Cheyne Walk. Mr. Robert Crawford, the spokesman, said one member of the delegation had first hoped to get the picture for four hundred guineas, then when he heard that Whistler had asked a thousand, hoped to settle the deal for eight hundred. Mr. Crawford in writing about him called his hard-headed fellow-member of the Corporation a Philistine. To the delegation the house in Cheyne Walk seemed almost bare of furniture. The drawing room was large; a few screens were set up; a few rush-bottomed chairs were scattered about the room, and there was a table; the room was cold—a few sticks of wood smouldered on bricks in a large fireplace. At the sight of the room the Philistine whispered that Whistler would be glad to accept the lower figure.

As if on tiptoe, Whistler stepped into the room. His necktie was loosely knotted; his hair was long and curled; he wore a brown velveteen jacket; he was very much the artist and to Mr. Crawford, his speech and actions were like those of a canary one moment and a doe the next. He served his guests tea that contained less tea than a mixture of rum and lemon; he introduced them to what he called Vienna tea, was very gay, and shied away from talk of money. At last he said: "The picture; yes, of course, the picture is yours. The great Corporation of Glasgow, most enlightened and humane, most liberal in its ideas—certainly into no better hands can I desire to see my Carlyle placed. With great pleasure I see that many artists with

whom I have not the pleasure to see eye to eye have honored me by asking you to take my picture for your city—I honor them for this."

"But," Mr. Crawford replied, "Mr. Whistler, we have not yet decided whether the picture can be ours. My friend the Philistine here and others in Glasgow think that the price now fixed is, perhaps, too high and we think of suggesting—say, eight hundred guineas."

"My dear ruddy-faced Scot," said Whistler, "what is this we are doing? You and I will never condescend to haggle about money. If it was in my power to bestow this picture on the people of Glasgow as a gift I would gladly do so, as proof of my appreciation of their good judgment in desiring to possess it. They do so choose, do they not? Alas, I cannot make it a gift, and I wish you to have it. What need, then, to discuss the question of money? But you have not yet seen the picture. It is not here—tomorrow will you give me the felicity to see you again and I will show you the Carlyle?"

As the group was leaving, the Philistine turned to Whistler with a question: "Is it true, as I have heard, that modern pictures don't stand up as well as the old masters? The colors, they say, fade sooner?"

Whistler's voice suddenly stormed back at him.

"No, it is *not* true—modern pictures do not fade and therein lies their complete damnation!"

The next day, Mr. Crawford again approached the question of the price of the picture; he and his friends were called "most estimable of Scotchmen." They were offered cigarettes and Vienna tea and at last taken upstairs to see the Carlyle resting on an easel. The Philistine, looking at it, said, "Mr. Whistler, do you call this life size?"

"No, I don't," said Whistler. "There is no such thing as life size. If I put you up against that canvas and measured you, you would be a monster."

The Philistine attempted one more question.

"The tones of this portrait are rather dull, are they not? Not very brilliant, are they?"

Whistler was ready for him.

"Not brilliant! No, why should they be? Are you brilliant? No. Am I brilliant? Not at all. We are not highly colored, are we? We

are very, very ordinary looking people. The picture says that and no more."

Mr. Crawford and his delegation left, and on their return to Glasgow sent Whistler a check for a thousand guineas. If the good members of the Glasgow Corporation had been impressed by the preliminary work of Mrs. Ford and Mr. Reid in giving Whistler publicity among their fellow citizens, the actual meeting with the author of *The Gentle Art of Making Enemies,* increased their confidence that they had made a bold choice. They at least could understand why Whistler had said that the Bible was a mine of remarkable invectives—and a book to study well; his conversation had born proof of it. After meeting him the attacks from the Scottish newspapers on the Carlyle came as an anti-climax. When reporters spoke of a "senile Carlyle" in the picture and the picture itself as a "doubtful masterpiece," the Glasgow Corporation remained unmoved.

The buying of the Carlyle shortly preceded the buying of the mother portrait by the French Government for the walls of the Luxembourg (and today the picture is loaned for exhibitions by the director of the Louvre). The picture had had a career of its own: it had been shown at the Royal Academy in 1872, at the Pennsylvania Academy of Fine Arts in 1881–82 (and was responsible for Whistler's growing reputation in the United States; Americans never resist a portrait of a mother, even when this one carried the abstract title of *Arrangement in Grey and Black*). It was shown in Paris in 1883 and in Dublin in 1884 (which was the occasion when a Dublin collector tried to buy it and Whistler wrote, "How can it ever have been supposed that I offered the picture of my mother for sale? I should never dream of disposing of it"). It was shown in Glasgow in 1889, and in Amsterdam the same year. Whistler accepted the French Government's offer as an honor and he received the nominal sum of 4,000 francs for the picture—and by that time the picture held promise of achieving a kind of immortality.

Whistler's opinion of the picture had Whistlerian moments of contradiction; it ran from the fatuous remark, "One must always do best by one's Mummy," to "Art should be independent of all claptrap, should stand alone, and appeal to the artistic sense of eye or ear, without confounding this with emotions entirely foreign to it, as devotion, pity, love, patriotism and the like . . . Take the picture

of my Mother . . . as an Arrangement in Grey and Black. Now that is what it is. To me it is interesting as a picture of my mother: but what can or ought the public to care about this identity of the portrait."

The truth was that many who saw it did care; Carlyle did when the picture convinced him that he should have his portrait done by the same hand. Americans cared, and as recently as 1934 the figure of Whistler's mother, looking like a rather modish Quaker lady staring at a large pot of flowers, was reproduced on a United States three-cent postage stamp, issued "in memory and in honor of the mothers of America." The date of issue was May 2nd, to prepare the public for the annual celebration of Mother's Day on a Sunday in early May, which is a holiday that combines filial sentiment with a hopeful increase of business in the florists' trade.

Nothing could have been happier for the furtherance of Whistler's reputation during the 1890's than these two disposals of his famous portraits. He had become one of those rare figures whose career had been advanced by the extremes of adverse criticism. All Whistler needed were a few tangible expressions of public approval; recognition from Glasgow and Paris had arrived at the right moment, and to celebrate this occasion Whistler and his wife moved from Cheyne Walk to 110 Rue du Bac, near Montparnasse in Paris.

His studio was a few steps away in Rue Notre Dame-des-Champs; his arrival in Paris in 1892 had for him the atmosphere of a well-earned holiday.

It is significant that Whistler's return to Paris brought with it little recognition from contemporary French painters; the French who formed friendships with him were writers; Marcel Proust remembered meeting Whistler at a reception and being charmed, so much so that when Whistler put his gray, lavender-tinted gloves upon a table, Proust quietly slipped them into his own pocket and treasured them as a souvenir.

XVI

WHISTLER'S delightful little pavilion with its garden at 110 Rue du Bac, charming as it was, was not exactly another Eden. Small domestic disasters became enlarged there. He had a large parrot * of whom he had grown fond; he was proud of the bird and had showed him off to visitors. One day the bird flew out into the garden, settled himself high in the branches of a tree and refused either to be caught or to be lured back into captivity. The bird also refused to eat; he died of starvation.

It was generally admitted that as popular as Whistler was among visitors who came to Paris from London and New York, Boston and Philadelphia, he was a less impressive figure at 110 Rue du Bac than in Chelsea. It became part of a visitor's ritual to be introduced to Whistler or to secure an invitation to his house to tea, and some were interested in being invited to look at canvases in his studio. But fewer ladies of fashion cared to sit to him—they had found another American painter whose manner was less intense, less nervous and who stood before them with all the ease of a professional portrait painter—John Singer Sargent. Sargent had something of the social manner of a Harley Street physician; he was handsome, bearded, well-set up, correctly conservative in dress, and robust; his deep voice, his formality without affectation, inspired confidence. Like Whistler he admired Velasquez and his painting showed that he had also looked at Zurbaran and Goya. He frankly confessed his indebtedness to the Spanish school and his liking of it.

To his sturdy knowledge of the Spanish masters, and his application of what he had learned from them, he added lively touches of

* This was probably in memory of Courbet's parrot.

style that he had picked up from Manet and Degas. Sargent had the art of pleasing those who sat to him, and as Sir Osbert Sitwell has remarked, "They loved him, I think, because, with all his merits, he showed them to be rich: looking at his portraits, they understood at last *how* rich they really were."

There were times when the effects that Sargent produced were obviously meretricious, but he was a good craftsman; his eye was clear, his hand was steady, he was almost never dull and frequently brilliant. All his qualities were of a kind that led to his success as a portrait painter: he charged high prices for his portraits (three thousand guineas was a rate he favored and his clients felt that his prices were a compliment to their wealth); he was an excellent guest at dinner; he seldom spoke ill of anyone and his good-humored dignity made it difficult for others to speak ill of him; his appeal was to the younger set of American and British millionaires—those who regarded Watts and Millais *passé* as painters, who, after all, belonged to an elder generation.

If anything, John Singer Sargent, born 1856, in Florence, Italy, of American parents, was far more of a European painter than Whistler. It was not until he was twenty-one, a student in Paris at the Atelier Carolus-Duran where instruction followed the Spanish school of portrait painting, that he paid his first, a four-month, visit to the United States. The trip was a courtesy visit to American relatives, and he was accompanied by his mother and his sister. It is believed, and not without foundation—since Henry James was one of the very few friends of Sargent who had gained his confidence— that James's famous short story, "The Pupil," had one point of origin in Sargent's recollections of his childhood. Sargent's family, drifting about in Europe on a small income, were as hard-pressed for funds as the Moreen family in James's story, and little Morgan Moreen, "the pupil," in his sensitivity and erratic brilliance, does resemble the often inarticulate, yet gifted and precocious young John Singer Sargent.

At twelve young Sargent worked in the studio of a German-American painter, Carl Welsh at Rome, and from Welsh's studio, he attended Domenge's school in Florence and passed from there to the Accademia delle Belle Arti in Florence. His precocity in painting had all the skill, the facile graces of the mid-nineteenth-century

Italian school of landscape and figure painting, and it would seem that he had grasped, instinctively and at second-hand, a few of the disciplines and a touch of the poetic insights of Jean Baptiste Camille Corot. Ten years later these came to light in his *Luxembourg Gardens at Twilight* and his painting, *The Capri Girl*. Meanwhile he had entered the studio of Carolus-Duran in Paris where his early admiration for the seventeenth-century school of Spanish painting strengthened his hand.

His biographer, Charles Merrill Mount, believes that his first meeting with Whistler took place in Venice in the mid-eighteen-seventies, which is, of course, an impossibility of dates and place. Whistler never saw Venice until after the Ruskin trial. It is possible that Whistler first praised young Sargent's drawings and water-colors in London; and the great probability is that young Sargent's cordial, first greetings from Whistler took place in Venice in 1880. At that dark moment for Whistler, he was glad enough to see an American face; and among young artists on holiday in Venice, Sargent was easily the most distinguished and most brilliant.

The personal, invisible, tenuous, almost inarticulate bond between Whistler and Sargent may be interpreted as the attraction of opposites: Whistler was fluent and verbal at moments when Sargent was impelled to hold his tongue. Yet both artists in their paintings had an affinity in producing brilliant effects. Both had an eye for elegance in portrait painting. No rivalry disturbed them. Sargent, a generation younger than Whistler, moved in distinctly different and far more respectable circles than Whistler. Sargent's personality as well as his skilled and rapidly executed craftsmanship caught and held the admiration of Henry James. Sargent was a professional painter in the sense that Whistler was not. His portrait painting was scarcely a matter for introspection, reappraisal, and tortuous repaintings; this was done with the speed that Whistler painted some of his Nocturnes and almost none of his portraits. Whistler never achieved true ease in portrait painting.

The distance between Whistler and Sargent is best illustrated by Sargent's comments on portrait painting to Joseph Pulitzer. The modest seriousness of his tone; his quiet air, his evident sincerity, his very lack of verbal wit point up the contrast of his aesthetic to Whistler's:

I paint what I see. Sometimes it makes a good portrait; so much the better for the sitter. Sometimes it does not; so much the worse for both of us. But I don't dig beneath the surface for things that don't appear before my eyes.

This confession makes Sargent seem far more literal-minded than he was, yet it was true that he had none of Whistler's power to call on the resources of his memory, nor had he Whistler's drive (which was sometimes self-destructive) toward perfection. If the picture failed, he shrugged his massive shoulders at it, locked his lips, and went on painting. Internally as well as in his relationships with his patronesses and women sitters, he could be counted on to keep a secret. It was by this quality of restraint that he kept the respect of British society. He was often painfully silent, yet a few of his terse remarks took on the character of epigrams. Near the end of his long career, and when he became "nervous" in completing his portrait of Woodrow Wilson, he thought of Whistler and wrote to Mrs. "Jack" Gardiner of Boston, the most romantic, exhilarating, and willful of his American patronesses: "It takes a long time for a man to look like his portrait, as Whistler used to say—but he [Wilson] is doing his best." Sargent's nervousness in painting portraits was a rare experience for him, and occurred only near the close of his career.

Seldom if ever was Sargent troubled by problems of design in portrait painting. (Problems of design had been Whistler's bête noire, his digging "beneath the surface," which when he solved them in his Nocturnes and in a dozen of his portraits were the trademarks of his genius.) They did not exist as problems for Sargent, but were rather the mechanics of his well-trained skill, a skill that accepted and reproduced the conventions of Velasquez. Sargent's brilliance was nine-tenths manual, a rapid co-ordination of hand and eye which accounts for the impressions of spontaneity and freshness conveyed in his remarkable watercolors. His success as a portrait painter came to him, not through literal flattery of his sitters, but because his skill recreated in their portraits the courtly conventions of Velasquez which became a display of elegance in late Victorian and Edwardian dress.

Whistler and Sargent enjoyed one another's company. Mrs. "Jack" Gardiner cleverly divided her enthusiasm for the two painters be-

tween them—but it was Sargent who painted the memorable, spec-
tacular, and not flattering portrait of her in a very low-cut black
evening gown. The lady was an exhibitionist—and a candid one; she
was far too arrogant and intelligent to deny the fact. When she came
to Paris Whistler advised Rothenstein to guide her about the city,
which he did, and he also brought her on a visit to Whistler's studio.
Rothenstein wrote of the incident in his memoirs:

> Whistler was in his most genial mood, and showed a
> number of his canvases, among which was a lovely sea
> piece with sailing ships. Mrs. Gardiner nudged me; I could
> see she was eager to have it. "Why don't you put it under
> your arm and carry it off?" I whispered. She was always
> ready for any unusual adventure, and she boldly told
> Whistler that she was going to take the picture with her.
> Whistler laughed and did nothing to stop her.

Later Rothenstein learned that Whistler had given her the pic-
ture for three hundred pounds.

To Rothenstein Whistler confided a few disparaging remarks
about Sargent, and to his friends, Mr. and Mrs. Joseph Pennell,
Whistler made a few uncharitable remarks but quickly checked
himself with "I like Sargent, and I am afraid if these things are
repeated, people will get the idea that I am ill-natured . . . I
may be wicked, but—what?—never ill-natured."

The truth was that in Paris, which was to him "the city of the
sun" Whistler still felt, and in some respects, keener than before,
cold draughts of adversity. Mallarmé translated Whistler's *Ten
O'clock Lecture* and sat for a lithographed portrait by him. The
lithograph was not successful but the friendship was. Degas happen-
ing to see Whistler in a café strolled up to him and said, "My dear
Whistler, you have too much talent to behave the way you do,"
and then calmly strolled away again. It was made clear that French
painters would have little to do with him; even Manet was tolerantly
half-friendly, half-indifferent.

The most complete view of Whistler through French eyes is
not Theodore Duret's well-balanced and appreciative study, but one
obtained through the restless gaze of Comte Robert de Montesquiou-
Fezensac (Proust's Baron de Charlus)—and this by way of Edmond

de Goncourt's journals (1891–1893). The occasion was Montes-
quiou's sittings to Whistler for his portrait. That picture is now in
the Frick Collection in New York, nearly unseeable, looking very like
a glossy sheet of oil-spattered, rain-darkened asphalt paving, still
impervious to the efforts of restoration, its original grace glimpsed
only through faint outlines of a figure with a stick.

A kind of posthumous irony attends this portrait of the highly
affected, wealthy, homosexual, ungifted, would-be poet Montesquiou.
In the Whistler portrait, time has given his vanity the light touch
of ironic defeat that it so painstakingly deserved. As early as 1862
the de Goncourts, excellent critics of eighteenth-century French
painting as they undoubtedly were, had been jealous of Whistler's
discoveries in Japanese art; the brothers, Jules and Edmond, point-
edly ignored him. Thirty years later (Jules had died in 1870), Ed-
mond through the agency of Montesquiou, gave Whistler notice
in his journal. On a visit to Montesquiou's apartment he wrote:

> As I happened to pause in front of an etching by Whis-
> tler, Montesquiou informed me that Whistler was work-
> ing on two portraits of him: one in a black suit with a fur
> coat draped over one arm, the other in a large fur great-
> coat, the collar turned up, a thin border of his cravate
> showing at the neck—this with a certain nuance of—a
> nuance of—which he could not express, but which the
> idealistic glow in his eyes revealed well enough.

> It is fascinating to hear Montesquiou describe Whistler's
> method of painting, for he has had seventeen sittings dur-
> ing his month-long stay in London. For Whistler, the
> first sketch is a "storming of the canvas": one or two hours
> of feverish insanity at the end of which the whole thing
> is slapped into its desired shape . . . Then come the sit-
> tings, the interminable sittings at which for most of the
> time the brush hovers in front of the canvas, the painter
> seldom allowing it to touch his palette, and then this brush
> is thrown aside, and he takes up another one—and some-
> times this goes on for three hours, without more than
> fifty light strokes being applied to the portrait—"each
> stroke," to use his expression, "lifts a veil from the hidden
> form of the sketch." O those sittings at which they seemed

to Montesquiou that Whistler with the intensity of his attention was drawing the very life-force from him!—was
pumping out of him vital strains of his individuality, and
at the end of it all, Montesquiou felt drained so dry that
he experienced something like a shrinking of his whole
being. And it was indeed fortunate that he happened to
discover a certain *coca* wine which helped him to recover
fragments of himself from these terrible sittings!

Later, Wednesday, April 5, 1893, Edmond continued, and not
without his delicate shades of malice, the saga of the Montesquiou-
Whistler relationship:

> Montesquiou dropped by to inquire after me, and to pick
> up his copy of the *Chauves-Souris* so as to have it illustrated
> by a portrait of himself by Whistler.
>
> Montesquiou told me that he had collected a great many
> notes on Whistler and much information concerning him,
> that one day he hoped to write a study of him, and re
> vealed his admiration for that painter who, as he said, had
> managed to arrange his life so as to gain the victories which
> for others in the usual course of events are inevitably
> posthumous victories. And he spoke again about Whistler's
> law suit with an English journalist who had emphasized
> the *impertinence* of asking a thousand guineas for "throw
> ing a pot of paint in the public's face." And Whistler's per
> fectly beautiful reply when asked how much time he had
> taken to paint the picture, a disdainful volley: "One or two
> sittings," and on the "Os" which this provoked, he added:
> "Yes, I worked on it for only one or two mornings, but that
> canvas contains the work of a lifetime."
>
> Whistler lives, at this moment, in Rue du Bac, in a
> hotel that overlooks the garden of the *Missions Etrangères*.
> Montesquiou, recently invited to dinner there, witnessed a
> performance that impressed him immensely. In the gardens
> of the *Missions Etrangères*, at dusk, a male choir was sing
> ing *Laudates*, the men lifting their voices—Montesquiou
> supposes that the singers had before them several dreadful
> paintings representing the terrifying martyrdom of some

of their fellow-missionaries in tropic climes—lifting their voices and exalting before these ghastly portrayals of their comrades' tortures, as though they in the garden were eager to emulate the examples before them.

Anyone who has read Proust's *A la Recherche du temps perdu* will quickly recognize its Baron de Charlus revived for the moment under Edmond de Goncourt's hand—but what a place, overlooking as it did, the garden of the *Mission Etrangères,* for Whistler to have lived! To English readers it may seem strange to see Ruskin referred to as an "English journalist" by Edmond de Goncourt—all the stranger because a few years later Marcel Proust announced himself as an admirer of Ruskin's prose and was engaged in translating fragments of it for French periodicals. Was Whistler pulling Montesquiou's leg? Was he torturing him? Which, of course, Montesquiou, being what he was, would have enjoyed. Perhaps. With Montesquiou as a sitter, Whistler could not have resisted exerting his own powers of showmanship to the limit. If Montesquiou was a dandy—and he was—Whistler could readily out-dandy him, prove himself to be a far more precious aesthete than he; more than that, carry his preciosity with more levity, more wit than Montesquiou could command.

Something of Whistler's attitude toward the Montesquiou portrait may be gleaned from a letter by Logan Pearsall Smith to his mother. Smith, the wealthy Philadelphian exile (afterwards the author of several appropriately titled volumes of *Trivia*), was footloose in Europe. He ran into Whistler—which was during the year, a summer day, Whistler was painting the portrait. Smith was small-boned and short; Montesquiou was tall. The day was hot. Whistler invited Smith to take Montesquiou's place at one of those "terrible sittings." Smith was highly flattered as he wrote to his mother: he had gained the honor of sweltering for several hours in a fur great-coat that actually belonged to Comte Robert de Montesquiou-Fezensac! This was a rare privilege indeed for a Philadelphian. The young man was beginning to make his way in the world!

The Smith incident is characteristic of the grotesque form that Whistler's wit so often assumed. At times its shafts were boomerangs and self-destructive. Certainly ill-luck attended the career of the Montesquiou portrait, which when it was first viewed, outshone the

brilliance of Whistler's contemporaries in portrait painting. In re-
touching it, he had probably worn his canvas thin with too much
scraping of the palette-knife; his surface paint was probably over-
loaded with turpentine; in any event, the portrait began to "spoil"
at an early date. Whistler's habit of "storming the canvas," of too
vigorously scraping it with his palette-knife has created problems in
restoration of his paintings by directors of present-day museums.

Whistler's great love of fame and his contempt of it were of one
piece in bitter conflict within his psyche. As he grew older, and as
his nervous sensibility increased while working before the canvas,
his tendencies toward inward-reaching self-criticism, outpaced his
renewals of creative energy. In painting he had formed the danger-
ous habit of "living on his nerves," which, by the way, is an Amer-
ican disease, and one not often shared by European painters who
have reached maturity. Whistler's French contemporaries were well-
poised and free of American "nerves."

The Whistler apartment, an eighteenth-century pavilion set in the
courtyard of 110 Rue du Bac, became a center for young men from
London and the United States; it was they rather than the French
who knocked at the green and white door, who came and were
admitted to the sitting-room with its few pieces of Empire furniture
and to the dining-room with its blue and white china and rare pieces
of English silver. A Japanese bird-cage was set at the center of the
table; there was a pleasant garden behind the pavilion, and next
door was a convent where nuns chanted morning and evening
prayers.

To these chambers came William Rothenstein, a young artist from
the Slade school in London who had come to Paris to study art at
Julian's. At the Slade he had worked under Legros; he saw in
Whistler (as a number of young men did in London) the leader of
everything shockingly new. Rothenstein was smartly dressed, short,
dark and spectacled. More important than his manner which was
both alert and deferential was his desire to find a hero. Whistler was
affable, toyed with his eyeglass, looked over the young man's draw-
ings and praised them.

Whistler took Rothenstein to a dance at the American Ambas-
sador's apartments, and to keep up the role of being shocking to the

young man from London, he remarked that the Union Jack covered a union of hypocrites. Whistler fell in neatly with the lighter, half-irreverent spirit of the '90's; at the dance a pretty young American girl was draped scantily in the folds of the American flag; Rothenstein delighted Whistler by observing that the Stars and Stripes concealed almost nothing.

For some time after this incident, Whistler accepted Rothenstein as part of his retinue, and with Rothenstein other young men from across the Channel drifted in. Whistler was host to them on Sunday afternoons in his garden; he would sit with an etching plate in his hand, lightly sketching the surface and talking rapidly of many things. He was "in character," dressed in a short black velveteen jacket, dazzling white shirt, white duck trousers, and at intervals he drew from his pocket adverse reviews of his work he had clipped from newspapers and read them aloud.

To this circle came Aubrey Beardsley, a pale thin young man, straight yellow hair falling over his forehead. The patronage of Burne-Jones had released him from a clerkship in an insurance office, and a commission to illustrate a new edition of *Morte d'Arthur* had given him means to visit Paris. Beardsley had scarcely turned twenty and was fatally ill with tuberculosis, but like many who were afflicted with that disease (and the list includes Keats, Robert Louis Stevenson, and D. H. Lawrence) he was remarkably productive. It was as though he knew too well that his gifts, were they to find any expression at all, had to be released and to receive recognition in the shortest possible time. Whistler was as enthusiastic over his drawings as Burne-Jones had been, and in Whistler Beardsley discovered an affinity—the affinity of being one who regarded art as a vocation, rather than a profession. In a traditional and literal sense, Beardsley did not know how to draw; his gift was a gift of perceiving design, of having an "eye" like those who are said to have an "ear" for music, and yet cannot read a note. He had no time to learn because his illness precluded any extended period of training. In Paris he found another kind of affinity in the posters of Lautrec; he quickly if superficially grasped the elements of Oriental design from Whistler's example and combined with them the compositions of space and masses that he had found in Lautrec's posters.

Quite as Whistler would scrape and rub out that which displeased him in painting a canvas, so Beardsley would painfully erase lines

and work over the same surface in his drawings. Whistler saw in the boy's drawings much that reflected his own temperament—and Beardsley's admiration for *The Gentle Art of Making Enemies* was everything that the elder artist wished to hear. Another trait they had in common was the desire to write as well as draw; Beardsley's nervous, delicate hand traced drawings with the same effort toward precision that he sought in words. In going to Whistler, Beardsley went to the source of much that had prepared London for the "Yellow '90's." Young as he was, ill-trained as he was, gifted as he was (and not without a touch of genius) within four years, Beardsley became the most clearly defined example of the Aesthetic Movement in English art. It was said of Beardsley that even his lungs were affected, yet he evolved a manner, and a style (derived from the Pre-Raphaelites, Whistler, Lautrec and probably the erotic drawings of Fuseli—did he see Rosa Corder's imitations of Fuseli?) that was his own.

Certainly through Beardsley's admiration Whistler strengthened his association in London with what the younger generation thought and felt. Beardsley's rooms in Pimlico where he lived with his mother and his sister, Mabel, were painted bright orange, and doors, sills, wainscoatings were painted black—and these were inspired by rumors of the rooms where Whistler lived in Chelsea. Beardsley's sister, Mabel, was several years older than he; in her own right she was known as a woman of wit and of remarkable intelligence; W. B. Yeats was attracted to her and wrote poems in tribute to her. It was probably she who led her brother to the reading of *The Gentle Art.* In the four years of Beardsley's rise to fame (he illustrated Wilde's *Salomé,* and in the process of doing so, William Morris's rosebriar designs became transformed into Whistler's peacock feathers and butterflies) the Beardsleys moved into fashionable literary circles. It was known that Burne-Jones, Wilde and Whistler had influenced him, encouraged him.

Through Rothenstein's admiration (or rather it was short-lived hero-worship) Whistler's name was heralded among young English artists of a more robust school than those of the Aesthetic movement. Rothenstein numbered among his friends Max Beerbohm, who had come down from Oxford to London, and had captured the town.

One of the best of the stories that Rothenstein told of Whistler in

Paris ran as follows. He had dined with Whistler at the Hôtel du Bon Lafontaine. "After dinner Whistler proposed we should go to his studio. We walked to the Rue Notre Dame des Champs. Climbing the stairs we found the studio in darkness. Whistler lighted a single candle. He had been gay enough during dinner, but now he became very quiet and intent, as though he forgot me. Turning a canvas that faced the wall, he examined it carefully up and down, with the candle held near it, and then did the like with some others, peering closely into each. There was something tragic, almost frightening, as I stood and waited, in watching Whistler; he looked suddenly old, as he held the candle with trembling hands, and stared at his work, while our shapes threw restless, fantastic shadows all around us . . . I followed him silently down the stairs."

This picture of Whistler is one that has more conviction in it than the many of those telling of his social ease. It shows, by contrast, something of the strain he labored under as he played the part of a celebrity in Paris. Of French painters, who attained any stature, Toulouse-Lautrec was alone in remarking that Whistler had made a contribution to the painting of his day; other French painters who had anything good to say of him at all were minor figures—and Whistler knew it. Pissarro had already granted his gifts as an etcher, as a graphic artist. Whistler was distressed when he learned that Montesquiou had sold the portrait he had finally completed for him.

Visitors to Whistler's house too closely resembled the tourist trade. This was not enough, and the strain of bitterness that Henry Adams had noted in Whistler's conversation, still streamed beneath the surface of talk that was held in check by a look from Beatrix Whistler. The surface broke when Whistler read an installment of Du Maurier's new novel, *Trilby,* in an issue of *Harper's Magazine* in 1894.

In the intervening forty years between Whistler's student days in Paris and the early years in London, du Maurier and Whistler had seen little enough of each other. Du Maurier had made an excellent place for himself as *Punch's* leading social satirist. He was not a political cartoonist, like Sir John Tenniel, the illustrator of Lewis Carroll's *Alice in Wonderland* and *Through the Looking-Glass.* If Thackeray as a *Punch* "cartoonist" may be described as a Victorian James Thurber, Du Maurier was a Victorian Peter Arno; his wit was

the wit of understatement, and in his drawings he flattered his fashionable London by making it seem far smarter, more glittering, more fashionable than it actually was. He was both industrious and clever.

As Whistler and Du Maurier went their separate ways in the London of the 1860's, du Maurier's road took its turning by becoming an intimate of the Princeps at Little Holland House, at whose center was the portrait painter, G. W. Watts. The Princep fortune was maintained by wealth made in India and as we have seen, when Ellen Terry was Watts' wife, the household (which Thackeray used as a model for a number of details in *The New-comes*) was dominated by Princep's wife and her two sisters, three women of extraordinary character; they had strength of will and remarkably good looks. The women took a fancy to young George du Maurier. He was ambitious, cheerful, an easy-to-look-at, easy-to-talk-to Philistine. He had lost the sight of his left eye, the loss of which warned him that he could not be the painter he had hoped to be; yet the fact that he pursued the career of an illustrator, despite a physical handicap, gave him an heroic air. He was the kind of young man to whom middle-aged women offer maternal advice and aid. In writing to his mother, the daughter of the notorious Mary-Anne Clarke, the mistress of the Duke of York, he professed to be shocked by the low-cut evening gowns worn by the beautiful ladies of Little Holland House; their manners were far more easy than those of the demure young woman who became his wife. He married early, and with the connections he had formed at Little Holland House he had became a member of *Punch's* staff.

When he himself had grown middle-aged, he turned to the writing of two romantic novels, *Peter Ibbetson* and *Trilby*. Whistler called him "the new Thackeray"—and a "new Thackeray" he was, but without the original's touch of cynicism and mastery of a theme in writing *Vanity Fair*. Like Thackeray his drawings enlivened the chapters of his fiction; he was accomplished in both arts—and in both he practiced the same skill and charm.* In *Trilby*, his romantic

* Daphne du Maurier's popular romantic novels, *Rebecca* and *My Cousin Rachel,* are twentieth-century versions of her grandfather's highly successful ventures into popular fiction. She like him has the same skill in making an appeal to the taste of the lending libraries; George du Maurier and his granddaughter were singularly expert in writing "the summer hammock and an apple" kind of romance.

memoirs (in fiction) of his student years in Paris, the drawings were as much a feature of the romance at the text. *Harper's Magazine* (which for many years had reprinted Du Maurier's drawings from *Punch* in their "Editor's Easy Chair" and had extended Du Maurier's influence upon illustrators to the United States) ran *Trilby* serially in monthly installments. It also welcomed the chance to publish Du Maurier's illustrations to the story. The caricatures of Whistler as Joe Sibley were obvious; Joe Sibley wore Whistler's white duck suit, his broad brimmed straw hat—and he was described as "the most irresistible friend in the world as long as the friendship lasted, but that was not forever . . . his enmity would take the simple and straightforward form of trying to punch his ex-friend's head; and when the ex-friend was too big he would get some new friend to help him . . . He is now perched on such a toppling pinnacle (of fame and notoriety combined) that people can stare at him from two hemispheres at once."

There is little evidence of deliberately turned malice in Du Maurier's caricature, but there is much hidden malice floating beneath the surface. The day had long passed when Whistler subrented a London room to him for ten shillings which included the use of Whistler's formal evening jacket. It was natural enough for Du Maurier, who had given up painting for the commercial profession of illustrating *Punch*, to feel a touch of envy at Whistler's fame; that touch of envy had made itself felt early—as early as Du Maurier heard of *At the Piano* being shown at the Royal Academy Exhibition in 1860. Du Maurier, like many a successful illustrator, also had a slight twinge of jealousy toward painting that represented an art more "pure" than his, and the fact that he had known Whistler when both were young and quite unfamous brought a twinge of jealousy home to him with especial sharpness. This was the kind of feeling that so many people have toward the acquaintances of their youth who have moved into circles either above them or into other spheres. Du Maurier was in the position of someone who had "known Whistler when——"

His comment on Whistler's character was not without its thorn of truth. Whistler was hurt, rather than angry, hurt in much the same fashion that Swinburne's attack on his *Ten O'clock Lecture* had left its scar. Whistler had long treasured the friendship of Charles Keene

who was also on the staff of *Punch*. *Punch* represented the world of
fashionable London taste toward which the elder Whistler glanced
in the hope of receiving belated recognition. Du Maurier's *Trilby*
showed him clearly enough that his conquest of London was as in-
complete as ever. Du Maurier's informal patronage of his gifts and
character were of greater hurt to his vanity than open slander.

Whistler threatened *Harper's Magazine* with suit unless the
offending Joe Sibley was removed from its pages and afterwards en-
tirely expunged from the novel. It was then Du Maurier's turn to feel
grieved; he protested that he wished to recall "the good old days" in
Paris. But Whistler stood his ground; Joe Sibley was suppressed and
a figure called Bald Antony took his place. In January 1895, the Du
Maurier farce was over; *Harper's Magazine* published an apology to
Whistler. Whistler afterwards told William Rothenstein that Du
Maurier submitted the manuscript of his book to him before sending
it to press; Whistler deleted what he saw fit, so he said. But the story
has an air of Whistler bragging of his power to silence Du Maurier;
it should not be forgotten that the story was told to an admiring
young man.

As 1894 came to its close, Whistler's domestic life at 110 Rue du
Bac came to an abrupt change. Beatrix Whistler was stricken with
cancer. The pavilion in Rue du Bac had never been the paradise
that the Whistlers hoped it would be, yet it was to Whistler and in
his half-ironic phrase, a "palatial residence." Although he would not
have regretted a return to London, the occasion which forced the
return was filled with anxiety. From now onward 110 Rue du Bac
was not a settled household; like his studio in Rue Notre Dame des
Champs, it was a stopping-off place in Paris. Beatrix Whistler's ill-
ness (he called her "Trixie") was to transform Whistler into elderly
middle-age. Graham Robertson has a sketch of him on one of his
visits to London before his wife's illness which shows very nearly the
last of his spriteliness and the direct influence of Beatrix Whistler
upon his temper. Robertson, a tall, fair-haired young man with a
large income, was a pupil of Albert Moore. (His portrait had been
painted by Sargent, a long, frockcoated portrait, fashionably brilliant,
and he always looked as though he had just stepped out of a

picture.) Robertson was saying good-bye to the Whistlers in Kensing-
ton High Street. The three had just been visiting Albert Moore;
Moore was one of Whistler's constant British admirers and an undis-
tinguished painter. Whistler never hung one of Moore's pictures on
his walls and the single Whistler that Moore owned was not of the
best, so it was hung face to the wall in a dark corner of Moore's
studio. Robertson was turning west as he said good-bye; to the east
were St. Mary's Abbot and the trees of Kensington Gardens—as well
as the Albert Memorial that Mrs. Whistler's father had helped to
design. As Robertson turned west:

"What are you going down there for?" asked Whistler suspi-
ciously.

"I'm going to see Burne-Jones."

"Who?"

"Burne-Jones."

"O—Mister Jones. But what on earth are you going to see him
for?"

"I suppose because I like him."

"*Like* him. But what on earth do you like him *for? Why* do you
like him?"

Whistler circled Robertson and barred his way; by this time they
were standing in the middle of Kensington High Street, forcing
traffic to detour around them, and Whistler's stick rapped the pave-
ment.

"I suppose because he amuses me," said Robertson.

"Amuses you? Good heavens—and you like him because he amuses
you! I suppose—I suppose *I* amuse you!"

"Don't tease him, Jimmy," said Mrs. Whistler. "Surely he may
choose his own friends."

Robertson then told how suddenly and lightly Whistler touched
his hand. "He doesn't mind, do you?" he said with one of his rare
smiles. And in his memoirs Robertson observed, "Though he
laughed much he seldom smiled, the carefully studied sardonic grin
being merely a stage effect and counting for nothing."

Beatrix Whistler's tact had smoothed the surface of Whistler's
sleepless sense of persecution, for he had never forgiven Burne-Jones's
testimony in the Ruskin trial—and Whistler's vanity was also sleep-
less. His wife's illness told him plainly enough that his protection

from the world and from himself was to be short-lived. He worked at water colors, lithographs, paintings fitfully; almost nothing was completed that he wished to keep. He received large commissions and accepted advances, yet almost nothing was done. He and Beatrix Whistler drifted between doctors' offices in Mayfair (and a hotel in Bond Street) and Paris. Living expenses mounted; to his friends Whistler would not admit that his wife was hopelessly ill; everything possible must be done for her.

And what of Whistler's friends in the period in which he rose to fame, in which he did little of his best work, and much that was literally perishable? Of a slightly earlier period, Walter Sickert, a Danish painter who, like Whistler, had adopted London, was the most gifted. In Whistler's latter Chelsea days, Sickert became one of his followers, and was second only to the Greaves brothers in his devotion to Whistler and his theories of art. Sickert's father had been a painter and a friend of Whistler's old friend, Fantin-Latour. Sickert had picked up French, German and Italian with the facility that Whistler had for acquiring languages, and in his boyhood had traveled freely on the European continent. His early worship of Whistler was natural enough. When he came to England Whistler was precisely the person for a young painter of Sickert's background to discover—a decidedly unBritish artist in Chelsea, and upon Whistler's advice, he, too, settled in Chelsea. It was characteristic of Sickert to choose another aspect of Chelsea than that which Whistler saw, and to some degree, created, for Whistler's contributions to Chelsea were river Nocturnes, and pastel-tinted walls of rooms and studios. Sickert welcomed rundown rooming houses, dark, dingy walls, cast-iron bedsteads and rather the worse-for-wear Cockney girls between the sheets. If the subjects of his paintings were of a different world than Whistler's, the smartness of his dress, his verbal wit and the liveliness of his personality showed an affinity with the elder man.

Early in their acquaintance (as William Rothenstein remembered the incident), Sickert shared Whistler's admiration for Ellen Terry's acting. He weighted a bouquet of roses with a piece of lead and tossed it on the stage of the Lyceum on the opening night of an Irving-Terry performance; it was thrown from the gallery and narrowly missed braining Irving. Sickert heard Whistler's loud "Ha,

ha!" from a section of the orchestra, and it was rumoured that after this episode they became close friends. When Whistler dashed into London from Paris on a short visit, his frequent stopping-place was Sickert's gloomy studio in The Vale, Chelsea, and on one occasion he finished a painting Sickert had left sketched in upon his easel.

For Whistler Sickert supplied the last associations of Vie de Bohème, but when Whistler found in Paris that Degas paid more attention to Sickert than to himself, and then praised his work, the friendship cooled. Sickert received early encouragement from the later Impressionists, particularly in Paris, where Whistler was acknowledged and then quickly set aside. At his least Sickert anticipated the American, John Sloan; at his best, his genre painting anticipated the work of another American, Edward Hopper.

Sickert had served an apprenticeship with Whistler from the days when he delivered at Whistler's instructions the portrait of Whistler's mother to the French Government and anxiously watched its unloading, swung by a crane, on a pier at Dieppe. When he had dropped an etching plate in Whistler's studio in Tite Street, he had heard him say, "How like you," and when Whistler dropped a plate, overheard the angry exclamation, "How unlike me!" He had left the Slade School when Whistler told him, "You've wasted your money—there's no use wasting your time, too," and followed Whistler; yet it was not extraordinary that once he had learned all he could from Whistler that he turned to Degas. In a sense, Degas represented to Sickert a relationship that Courbet once had had toward Whistler; the attraction was a realistic, contemporaneous view of life through art. Whistler had long discarded that particular attitude; Sickert rediscovered it in Degas' statement, "I want to look through the keyhole," and when a woman asked Degas why he made women ugly, he replied, "Because, Madame, women usually are ugly."

In bringing Sickert to his side Degas had the satisfaction of depriving Whistler of one of his disciples; Degas, sophisticated and gifted as he was, was also not above displays of petty malice.

To compensate for the loss of Sickert, Whistler encouraged Mr. and Mrs. Pennell—Joseph and Elizabeth Robbins, his wife—to sit at his feet and worship. The pair came from Philadelphia; Joseph Pennell was tall, handsome, and presentable; he had a talent for etching

which was of less durability than Seymour Haden; his gift and mind were mediocre, yet his etchings, quite like his personal abilities to dress well and to stride into a drawing room without upsetting chairs and tables, were acceptable. Elizabeth, his wife, was bustling, active, enthusiastic, and both were more than a little arrogant. They were industrious and humorless; both could be trusted to believe everything that Whistler told them. Whistler appointed them, male and female, to be his collective Boswell; they became his official biographers and no one writing a life of Whistler can afford to overlook what they have written. They quarreled with Whistler's "enemies" and catered to his vanity; in actuality they made the study of Whistler their life work, and although they lacked the tact and wit of Beatrix Whistler, their presence at Whistler's side at home and in his studio became a necessary tonic to his diminishing ego. As his lack of confidence in his painting deepened into a well of self-distrust (Graham Robertson told of the many portraits he rubbed out or destroyed), his dependence upon the uncritical praise of the Pennells grew. According to William Rothenstein, Joseph Pennell became adroit in stirring up trouble between the New English Art Club group which included Tonks and Sickert as well as Rothenstein and Whistler. Pennell, to increase Whistler's dependence upon him, probably spread gossip that he had overheard, and Whistler was, of course, always eager to overhear any mention of his name. In any case praise from the Pennells was enough to compromise Whistler's reputation among intelligent critics. Whistler lacked wisdom in allowing the Pennells to surround him as completely as they did, yet their outward appearance of respectability made them seem a safer deposit for confidence then several young men, including Mortimer Menpes, who clung to the fringes of the Aesthetic Movement in London.

Mortimer Menpes was a handsome young man, who in the mid-nineteen-eighties was proud to be known as one of Whistler's "Followers," and with Walter Sickert helped Whistler in manual tasks in keeping his studio in order. There is little doubt that for ten years Menpes was a devoted pupil and part-time servant of the "Master," yet Whistler was quick to avoid any emotional attachment to him. Menpes' own gifts were those of the overly "artistic" illustrator of books and magazine articles; he had taste, but no style, no marked distinction, good or bad, that could be called his own. Slowly he

drifted into "commercial art," illustrating as he did so, books of memoirs on bohemian London of the eighteen 'nineties. His book, *Whistler as I Knew Him,* is an unreliable, often emotional, often pathetic, at times spiteful document of his relationship with Whistler. Whistler did well to shake him off.

In the late 'nineties when Whistler was asked if he knew Menpes, his reply was "Menpes, Menpes? What *are* Menpes?" A strained and loud "Ha, Ha" followed the question. One feels that the reply was self-defensive. Whistler had washed his hands of the Aesthetic Movement.

1895 was the year of the Oscar Wilde trial, and the scandals that had circulated through London before and after it threw the Aesthetic Movement into the streets. As Whistler had said (but with other meanings in mind) in his *Ten O'clock Lecture,* "art was upon the town," and to those who eagerly followed the course of the trial in the newspapers, art was scarcely fit to be seen. As early as the 1880's Whistler had sharply disassociated himself from Wilde, yet in the minds of a generally ignorant public, Rossetti, Whistler, and Wilde were closely joined as triplets of the Aesthetic Movement.

Nor did the opening days of the Wilde trial dispel the likeness to the Whistler-Ruskin trial which had taken place sixteen years before. In both trials the artist was the plaintiff; both trials were suits for libel; in both trials the artist was the principal witness, and in the opening testimonies the witness turned the issues of the trial into a discussion of art.

That general resemblance of the two trials was lost upon no one; but several important differences between the two artists in the witness box remain. Wilde, in bringing suit against the Marquis of Queensberry, a suit for libel because Queensberry had left a written message to the porter at the Albemarle Club addressed "To Oscar Wilde posing as a sodomite," was courting literary suicide. He could have allowed the Marquis to gossip about his homosexual relationship with Lord Alfred Douglas, the Marquis' son, and there would have been small chance of overt action against him. Gossip had pursued Wilde from the moment Robert Hichens wrote and published a number of years before the trial *The Green Carnation,* a parody of Wilde's social manner and writings that in its cleverness

almost equaled the dialogue of Wilde's plays. Wilde's personal life had been suspect ever since the publication of his novel, *The Picture of Dorian Gray*, and Charles Whibley, Whistler's brother-in-law, had written a nearly libelous review of the book for W. E. Henley's *The Observer*. As far as rumor about Wilde's homosexuality was concerned, Queensberry's gossip offered the public nothing new.

But Wilde had led himself into a tragic net of circumstances. Both his mother (Lady Wilde was nearly insane, and certainly lacked judgment in household matters, even to the extent of telling the maid not to store dinner dishes in the coal scuttle, but to place them on chairs throughout the house) and Lord Alfred Douglas (to spite his father) encouraged Wilde to open suit, to air the case in court. Wilde had two plays successfully running on the London stage; there was no visible reason why he should expose himself to the risk of social and financial ruin. A not too easily unraveled set of motives for his action seems evident, and of these a hidden sense of guilt demanding expiation is the most important. Another was his Anglo-Irish sense of instability in London society and with it a melancholy sense of doom; he deliberately handed himself over to the "enemy"—which to him was upper and middleclass Victorian society—and waited for it to pass judgment on his fate.

As he stepped into the witness box his position in two respects at least was notably different from that of Whistler's sixteen years before. The sympathy of the public was on his side; he was the man of wit, and a successful one, who promised to talk over the heads of the public, and yet, at the same time, to entertain it. He emulated Whistler's skill in using the witness box as a platform from which to discuss aesthetic paradoxes and beliefs, but he was all too obviously adapting a part that had been played with effective sincerity by another man. He was hiding something; the public may not have known exactly what he was talking about, but it soon became aware that his plea of art for art's sake lacked righteousness—and Whistler's righteousness had actually wrung a farthing from a British jury— for the spirit of righteousness was something it could understand— and even in the person of a foreigner who insulted the public with the ease of Wilde, it could half admire.

Wilde went to his doom by admitting to Sir Edward Carson, his cross-examiner, another Anglo-Irishman, that he had no affection

for an Oxford servant boy because "He was, unfortunately, extremely ugly."

Wilde's defeat in court and his term of imprisonment at Reading Gaol were frightening in their immediate consequences. Wilde's collapse and his dubious martyrdom were victories for all the deepest dark brown shades of Victorian Philistinism. Every artist who was even remotely associated with the movement that Whistler and Walter Pater had brought into being in London felt the shock of Wilde's punishment and his decline into a pathetic figure, an alcoholic, an almost too substantial wraith, drifting through the streets of Dieppe, Naples and Paris.

Wilde's trial conclusively defined the distance between the artist and the readers of newspapers throughout the English speaking world. Wilde's opponent, the Marquis of Queensberry, arch sportsman, the nearly illiterate author of rules for boxing, had earned an ill-deserved position of moral heroism. And lesser artists of the aesthetic movement through Wilde's defeat were given the consolations of sentimental regret to be dissolved only by recurrent tears of self-pity.

The year brought Whistler a trial on his own account, the trial that he described later in *The Baronet and the Butterfly:* The facts in the case and the case itself produced nothing as clearly cut as the issue in the Ruskin trial, yet behind a façade of personalities in conflict, Sir William Eden and Whistler himself, the dim outlines of an issue and a principle do emerge, and they are relevant to the right of a painter to control the sale and possession of his pictures.

Sir William Eden had been introduced to Whistler by George Moore. And there was so much in common in the characters of Moore and Whistler that their meeting at all may be regarded as one almost certain to produce disastrous results. Moore was the son of an Anglo-Irish landowner and was nearly twenty years Whistler's junior; like Whistler he had spent a few of his student years in Paris; Paris was his university, and he knew the Paris of the 1870s in something of the same fashion that Whistler had known the Paris of the '50s. He studied painting and he came to know (on the easy and yet uncertain terms of a foreign visitor) Degas and Manet. His gifts were literary; he dabbled in art criticism in which he had flashes of keenly perceptive insight, and he "found himself" in the writing of

several excellent (and today underrated) Anglo-Irish stories and novels. He was a thin, tall, light-blue-fishy-eyed young man who was deceptively naïve in appearance, and at times deceptively brilliant in conversation; he was a confirmed aesthete, a follower of Walter Pater, yet like Sickert, he leaned strongly in the direction of Degas' "key-hole" realism.

Sir William Eden was a water-colorist in his own right; he was an English eccentric who had shrewd and well-developed tastes in art; he bought pictures and when he grew bored with them, promptly (and usually at a handsome profit) sold them. He also moved in the same large orbit in which the Marquis of Queensberry was a familiar figure; he could be and was both generous and brutal; and he had a remarkably beautiful wife. Through George Moore, he commissioned Whistler to do a portrait of her. From then onward misunderstandings, vague terms concerning how much Whistler charged for a portrait, clouded the scene. Whistler had allowed Moore to understand that his price varied from one hundred to a hundred and fifty pounds for a portrait sketch in pastel or water color. Moore retailed this information to Sir William. Whistler was enchanted by the amazingly smart good looks of Sir William's wife; instead of doing a water color he did a small portrait of her in oil and exhibited the portrait in a London gallery; Sir William admired the portrait but was angry at Whistler exhibiting it without his permission. On the 14th of February 1895 Whistler received a Valentine of a hundred pounds from Sir William as payment for the picture and a demand for its delivery; Whistler cashed Sir William's check, painted out Lady Eden's face and kept the picture.

The incident was not a pretty one. One element in the affair was Whistler's great and urgent need for money; the expenses of living en route between London and Paris and of medical care for Beatrix Whistler completely unbalanced Whistler's always precarious finances. He felt it within his rights to pocket a rich man's money and to withhold the picture. He knew the Baronet was a bully and he hoped to out-bully him. As Sir William stormed at Whistler in his Paris studio, he was warned that he would betray his nationality to an entire neighborhood. Sir William retaliated by opening suit against him. The moral issue in the case was cloudy; it was easy to see that Whistler should not have accepted Sir William's check, yet

behind the cloudy issue, intangible rights of the artist to paint as he wished, to distrust a hostile buyer who might at any moment resell the picture, were also at stake. A French court sensibly forced Whistler to repay Sir William the hundred pounds and to keep the picture. The intangible rights were upheld. The case dragged on through several phases and covered two years; Whistler was scolded (justly enough) by the judge for defacing his own work. Whistler acquired another grievance that he could exaggerate to such friends as the Pennells and receive flattering sympathy.

Of the Whistler who dropped into Carmen's school Arthur Symons wrote, "I never saw any one so feverishly alive"—he probably had fever which accompanied his sore throats—"as this little old man, with his bright withered cheeks, over which the skin was drawn tightly, his darting eyes . . . and above all his exquisite hands, never at rest."

Symons went on: "And his voice, with its strange accent, part American, part deliberately French, part tuned to the key of his wit, was not less personal or significant." All this was very well for the appreciation of Arthur Symons whose intuitive writings on the Symbolists contributed to the knowledge of their work in London, but Whistler's manner and appearance were far more suited to the environment of a café than to a studio filled with earnestly ignorant and worshipping young men and women. Whistler brilliantly talked over the heads of Carmen's pupils and left them impressed, bewildered and certainly no wiser than before. The school failed, but Whistler's vanity was shielded by the fact that his visits were infrequent enough to absolve him of any mismanagement of classes.

It was during this period that he questioned the lavish praise of an admirer who compared him to Velasquez— "Why drag in Velasquez?" said Whistler, and this phrase remains the best example of the play of his ego against his wit; the ambiguity of his remark should be interpreted as a declaration of his pride rather than of his vanity; he had never claimed to be the equal of Velasquez.

XVII

To offset Whistler's unhappier hours in Paris came the friendship, the sympathy of Charles Lang Freer. Freer was a multimillionaire, a railroad financier from the American middlewest, Detroit. He was a bachelor of austere and delicately perceptive taste. He had a lawyer, Howard Mansfield, who was less proficient in his knowledge of law than in his skill for collecting etchings, He had an "eye" and so had Freer, and on one of Freer's visits to New York, Mansfield showed him a set of Whistler's etchings he had bought. It was the sight of Whistler's etchings that converted Freer to visual aesthetics, to the buying of pictures and objects of Oriental art.

Freer was born at Kingston, New York, in 1856. He was one of those Americans who was never quite at home in the United States. He was small-boned, meticulous in dress and manner. His career began as a boy-clerk in a general store; his family was poor and came of cultivated French Huguenot stock. He had an almost abstract love of bookkeeping and the management of corporation funds. The expansion of railroading in the United States gave him a chance to exercise his superior skills in executive bookkeeping. He detached himself from immediate scenes of money-making, of industrial rivalries, of employees, strikes and conflicts of business management. He hated the crude approach to industrial warfare. His commands were on paper supplemented by rows of figures, his word was law, his word was final.

On visits to New York he sought out the company of Stanford White who was an aesthete of a kind Whistler could have understood and Freer admired. Though vigorous and redheaded, White the architect was as coolly poised as Freer. Legend has it that when

White was directing plans for a building he had designed near the lower tip of Manhattan, a workman was crushed by a pile-driver thrusting piles into the river. "Look," cried White, "what a wonderful color that man's blood makes on the water."

White had taste in the selection of beautiful girls at dinner-parties given to entertain his friends; so had Freer. Yet Freer's selection of women seems to have been more impersonal than White's, for Stanford White was shot dead by Harry K. Thaw in a fit of jealousy after marrying Evelyn Nesbitt, one of White's mistresses. Freer's signs of appreciating his women guests were shown in his selection of roses to be placed in a vase at the side of their bathtubs.

In the mid-eighteen-nineties Freer's millions permitted him to take extended trips to Europe and the Far East. On Monday, November 12, 1894 he walked into Whistler's Paris apartments in the Rue du Bac. All three, James and Beatrix Whistler and Freer, were delighted. Whenever Freer was in Paris, he saw the Whistlers. Because of the Oriental gifts he showered upon Whistler, Whistler called him "General Utility," yet it was clear that Whistler had found a patron who sincerely appreciated his tastes, who caught the meaning implicit in his art. Freer did not like the Pennells, husband and wife, and objected rightfully to their treatment of Whistler's wife's sister after his death. As her own death approached, Beatrix Whistler was greatly charmed by a lark that Freer had sent her from the jungles of India.

Proof of Freer's understanding of Whistler is in the excellent collection of Oriental art housed in the Freer Museum in Washington, D. C. In the United States it is Whistler's most enduring monument.

Through Freer's friendship with the New Englander, Ernest Fenollosa, a tangible link was established between Whistler, Freer, and Ezra Pound ten years after Whistler's death in 1903. Pound's enthusiasm over his readings in Fenollosa's manuscripts led to his discoveries in Far Eastern literatures.

When in London the wife of the American painter, John Alexander, asked Whistler why it was he kept on railing against Ruskin (Ruskin did not die until January 1900). "Why don't you let that old man alone?" she said. "He has one leg in the grave." Whistler replied, "It's the other leg I'm after." The grim joke scarcely brought a laugh; Whistler himself looked too old, and if not battered and in

the image of crazed King Lear which was Ruskin's look, so fragile
that his own death seemed a matter of months, not years.

Miss Birnie Philip, his wife's sister, took Whistler away from the
two cities he had adopted, London and Paris, into the country. Dur-
ing the summer of 1900 they went to Dublin but even that stay was
brief. He argued that London itself was beautiful; it had, he said, his
favorite landscape. His only pleasure in Dublin was the Hogarth in
the Irish National Gallery, the sketch of George II and his family.
Whistler had returned in his enthusiasims to his boyhood admira-
tion for Hogarth. He had no eyes for Dublin and its well-worn
eighteenth-century buildings with the red, almost insanely Victorian,
gothic pile of the Kildare Club settled down among them. He
turned restlessly away from Ireland back to London again. It was as
though, in his restlessness, he was trying to escape death. His
brother, William, the doctor, had died in February of that year. On
the day of his brother's death, he ran into an acquaintance, and
asked him to dine with him; he could not bear to be alone.

Yet his throat would not permit a stay through a London winter;
he went south to Corsica, to North Africa. A photograph of him,
taken in Corsica, shows a skeleton-like Whistler, shrunken into an
overcoat, looking away from the camera into nothingness. He went
down to South Africa, then to Marseilles, then back to London; he
had tried to teach himself to enjoy falling asleep in the sun and
failed. He moved from hotel to hotel in London. At Tallant's Hotel
in North Audley Street he was "offered," so he said, "a room where
Lord Somebody or other died; I tried to explain to them I wanted a
room to *live in*."

In London, the Pennells prodded him to tell all that his memory
would yield; they were his official biographers and were tremen-
dously businesslike. He had tried writing his autobiography for
Heinemann, but the effort was too great. It was easier to talk to the
Pennells; they were willing to listen to anything, everything; it
was as though their lives depended upon his; and in a sense they
did.

Miss Birnie Philip and her mother persuaded Whistler to build a
new house in Cheyne Walk with them. It was evident that the
Philips used their small income to augment Whistler's declining
credit. Whistler wrote letters to a New York dealer in an effort to

sell his lithographs and a few paintings; the dealer refused to believe that Whistler was in actual need.

Almost as soon as he moved into his new quarters with the Philips, "the Ladies," he called them, he received two visitors from foreign shores, one was Richard A. Canfield from New York, the other was Rodin from Paris. The year was 1902, and Rodin the sculptor was on the first large tidal wave of his reputation. His reason for flattering Whistler was clear enough; Whistler had been talked into handing over the presidency of the International Society of Artists to Rodin; Whistler could not bring himself to sanction Cézanne who had been suggested for the post. The entire premises of Whistler's painting, his love of two dimensional Oriental design, ran counter to the contribution made by Cézanne, nor could he reconcile the difference between them. Whistler was completely overcome by Rodin's praise which was neither honest nor perceptive.

The other visitor shocked everyone who met him, and as he stepped in to visit Whistler, he virtually took over the Philip household. He had the air of a dictator, a burly, arrogant, clean-shaven man— Canfield the New York gambler, who had sued the New York district attorney's office for six thousand dollars because his lavish gambling house in East Forty-fourth Street in New York had been raided by plainclothesmen. Canfield listed among his friends Vanderbilt and Frick, as well as leaders of the underworld whose control extended over houses of dubious reputation all the way from Saratoga Springs to New York City.

Canfield delighted Whistler; Canfield talked of money and not of art. Whistler painted a little portrait of him, the picture called *His Reverence* which made Canfield look like one of the characters out of Charles Whibley's *A Book of Scoundrels*. Canfield affected a taste for art, not respectability; he had a fancy for Chinese porcelain and an eye for Whistler's paintings.

In these declining days and months of Whistler's life it is reasonable to assume that the outrageous Canfield had taken Charles Augustus Howell's place in Whistler's affections. When news of Howell's death came to him in Paris, in April 1890, Whistler pretended to ignore the fact; he treated it as a characteristic Howell hoax, the latest trick of "The Owl" who could outwit both his creditors and death. Yet the point is that no one he had met since the

days of his friendship with Howell was as flagrantly *un*respectable as Canfield. Whistler's ill-health forced him into a routine of domestic boredom. Canfield's disreputable company was by no means mediocre. The fact that Canfield's face was that of a red-nosed, defrocked Anglican bishop increased Whistler's delight in seeing and talking to him.

Between the officious Pennells and the equally officious Canfield, Whistler became completely isolated. He was as far removed from the neo-Bohemianism of the youthful Augustus John who had just begun his career as an *enfant terrible* of British art as he was from the well-to-do Edwardians who sat for John Singer Sargent. His new patrons in the United States were Freer and Frick (and it is significant that his patrons were Americans), but in 1903 neither could bolster Whistler's prestige in London. The London press had begun to regard Whistler as a "left-over" from an earlier generation. His portraits of little London street children failed to arouse either controversy or curiosity. The pictures were not "pretty enough" in a sentimental manner to achieve post-card reproduction popularity; no one could weep over them or say "how cute." At the same time they fell into the now accepted conventions of vaguely realized Impressionism. These portraits were not Whistler at his best. His latest work could be dismissed without great loss, a disturbing fact which partly accounts for Whistler's destruction of many of his late canvases.

Meanwhile, when Graham Robertson sold his collection of Whistlers which he had acquired from the bankrupt estate of Charles Augustus Howell, Canfield bought them, including the *Rosa Corder* that he resold to Frick. Within a short time Canfield had bought enough of the contents of Whistler's studio to pay Whistler's debts and to leave an inheritance for Miss Birnie Philip. From Whistler's point of view he was a fallen Lucifer and the rescuing angel; and Canfield had amusing stories to tell of life in the United States. Canfield became Whistler's butler, warding off bores who came to Cheyne Walk; he also turned away fashionable people who shuddered at the sight of him and did not call again. Canfield's aura of ready money was irresistible, if not irreproachable. Whistler's ill health did not permit his leaving the house, and Canfield, standing guard at the front door, was a cheerful service which soothed the

nerves of Miss Birnie Philip and even kept the Pennells at bay. Whistler's throat, since he had been troubled by it from childhood onward, seemed a lifelong disease. His physicians warned him about his heart. He did not care to sleep in bed; he preferred dozing on a couch or in a chair; he walked about the house in a shabby greatcoat which served as a substitute for a dressing gown; he felt unbearably cold.

Kennedy, the New York dealer, was admitted; he brought him a bottle of American cocktails, which Whistler preferred to soup. He had all the pictures of his Paris studio sent to Cheyne Walk where he burned most of them—the collection he told some of his visitors was worth twenty millions, or any wild, fantastically high figure that came into his head. In the latter stages of his illness, was Whistler amusing himself by indulging in flights of irony? Perhaps he was. But it is also possible that his flights into high prices for his pictures were moments of exaggerated recovery from the lowest depths of his self-criticism. To be optimistic in the face of disaster was an early habit of Whistler's; he had preached joy and levity on many dark occasions. His optimism in the Peacock Room at Princes Gate was a frightening example (and not without valor) of a refusal to admit failure. That was one reason why the British, including their art critics, could never take his pretensions seriously. They preferred to regard him as a wit, as a clown—an unscrupulous one— and as a "joker" among artists.

The dying Whistler was not a man to change his reflexes, his impulses, his habits. Since he painted little, he increased his skills in histrionics. As he drifted through the house that his sister-in-law kept for him he scattered drawings and papers that fell in a wake behind him.

Through the winter of 1902–03 Whistler could not be kept in bed more than a day or two at a time, nor could he speak—except in flashes, brief as the telegrams he used to send to Oscar Wilde. He moved always in the direction of the room where he tried to paint. At the instigation of Freer (Freer sent the pictures to the United States), Whistler received a Gold Medal of Honor at the Winter Exhibition at the Pennsylvania Academy of Fine Arts in Philadelphia. He also received an LL.D from the University of Glasgow; he was pleased, but it took him many hours to write the short note

acknowledging the honor. Wrapped in his old greatcoat, he wandered through the house from bed to studio. On sunny days he was taken out for short drives by Freer or by John Lavery, director of the Scotch National Academy. MacColl, the art-critic, took him out to lunch—at which Whistler refused to speak of art at all, but talked about West Point.

Between sleeping and waking, still reluctant to spend twenty-four hours in bed, he floated through the spring months of 1903. He laughed over Elbert Hubbard's faked interview with him in a *Little Journeys* pamphlet which also told of how his mother and he came from Russia to settle down in Chelsea.* He said . . . "why the account of my mother and me coming to Chelsea and finding lodgings makes you almost see us—wanderers—bundles at the end of long sticks over our shoulders—arriving footsore and weary at the hour of sunset. Amazing!" His remarks had something of the same charm that had delighted his plain-featured, seriously minded mother when he was a boy. Whistler was alarmed when he heard that Montesquiou had sold the portrait he had painted of him, yet his optimism returned when he also heard that Canfield had bought the picture and resold it to Frick. Canfield had actually turned out to be as useful as Howell was in the old days, and Whistler refused to allow the Pennells to speak ill of him.

July had come; and on the thirteenth of the month, a Monday, Whistler heard of W. E. Henley's death the day before. Henley, though still in his fifties, had been dying for several years. He was a

* Elbert Hubbard (1856–1915) was an American version of the Socialistic wing of the Pre-Raphaelite movement; he popularized it so successfully that he made a fortune out of it. After leaving Harvard, he made a pilgrimage to England where he met William Morris, and inspired by Morris set up his Roycroft Press at East Aurora, New York. His passion was mass-distribution of culture with a capital "C" to the American middle-class. His pamphlets, *Little Journeys to the Homes of Great Men,* issued by the Roycroft Press, sold into the millions of copies. They were highly valued mines of general misinformation. He was on board the *Lusitania* when it was bombed by a German submarine. At the news of his death, a popular newspaper columnist, Walt Mason, who wrote in verse, remarked: "Down to the deeps went Elbert Hubbard/ with smiling eyes that knew no fear/ then all the lovely mermaids rubbered/ And Neptune shouted, 'Look, who's here!' " This was Hubbard's appropriate epitaph. Hubbard was a valiant, money-making forerunner of those who comment on books and culture on radio and TV programs in the United States today.

victim of tuberculosis of the bone, had been a vigorous, cheerful
invalid since youth; he shared Whistler's optimistic temperament,
his ability to carry forward public quarrels. Henley belonged to the
more virile elements in the 1890 Zeitgeist, a brilliant, complex per-
sonality, who attempted (because of his editorship of *The Observer*)
to transform his literary influence into a literary dictatorship. He
failed. But his courage was of a kind that Whistler instinctively
admired; Henley, near the end of his career, made the tactless, tacti-
cal, fatal mistake of attacking Robert Louis Stevenson (an old friend
and benefactor, recently dead) at length in print. He was honest
enough, but as self-destructive as one of the men he attacked, Oscar
Wilde. His death closed an era of public controversy in the arts. It
was natural for Whistler to feel the approach of his own death in
Henley's. Henley, though often wrong, had been as soldierly as he.

Four days later, on Friday the 17th, Whistler forced himself out
of bed and tottered into his studio, where early in the afternoon he
was found dead. At that moment Freer was on his way to take
Whistler for a drive. He came too late.

Whistler's funeral services took place the following Wednesday,
July 22, in Old Chelsea Church. The London police had received
orders to be in attendance, to hold back crowds. It was a gray day,
an empty London summer day. It was almost as if London's
holiday August had begun too soon. The fact was that Whistler's
isolation from the world that had known him as a public figure had
grown complete. Such notoriety as he enjoyed in London itself is
often brief. No crowds arrived.

The services had an air of being austere and private. Less than
fifty people attended. Although the Pennells, his biographers, were
indignant at what they felt was a slight from official sources, the
American and French Embassies in particular, the lack of crowds at
Whistler's services was appropriate. His public reputation had been
too spectacular and ephemeral to endure; the butterfly signature
stood for his public life; his private life was that of art. His art was
distinctly foreign to British art. It had no link with Constable or
Turner; it was never popular on British soil. There was no reason
for the British public to be moved at the news of Whistler's death—
his orbit was outside the constellations of an English tradition.

Meanwhile his pallbearers were not undistinguished: they were

Theodore Duret, Sir James Guthrie, Sir John Lavery, Edwin A.
Abbey, George Vanderbilt and Freer. Jo, Whistler's former mistress,
and mother of his son who changed his name and became an engi-
neer, had attended the services, and then, with her accustomed dig-
nity, withdrew quietly. Whistler was buried in Chiswick churchyard.

At Whistler's death, the fluctuations in his reputation as a painter
began their long career. *The New York Times* in its generous death
notices could not find, as it admitted freely, a standard by which
to judge his work, his life. The notices reiterated fragments of the
Whistler legend. They spoke (mistakenly of course) of Maud
Franklin as his "first wife." They reasserted that his etchings were
memorable.

His immediate reputation was in the hands of two American col-
lectors, Freer and Frick. Other American collectors of his work were
more attracted by stories of his wit, his elegance and his notoriety.
To possess anything he had done, and show it off, was very like
wearing a freshly cut, exotic flower in one's buttonhole. Yet such
display of taste was as short-lived as the wearing of that flower.
American collectors have the habit of always looking for something
"new." For a very brief moment it was good to own the work of an
American artist who had gained, however precariously, European
celebrity. Proof of that celebrity rested in the fact that the portrait of
the artist's mother occupied space on a wall in the Luxembourg.

Meanwhile there were efforts made to erect in Chelsea a memorial
to Whistler designed by Rodin. The time was 1908; the project
failed. Shortly before his death Whistler had been active as Presi-
dent of the International Society of Sculptors, Painters and Gravers.
Rodin was now in his chair, an imposing figure who inspired people
to think he looked like Michael Angelo. His designs for sculpture
were equally pretentious. Visibly, symbolically—and all too obviously
—they embodied big ideas. His idea was to sculpt an image of a
winged victory symbolizing the triumph of art over Whistler's
enemies, which he changed later to an image of Venus (a stupid
looking Venus at that) leaning over a bas relief of Whistler as if to
protect him. He demanded ten thousand dollars to be raised by
subscription for the job. American millionaires were not enthusiastic.
Nor did his plan attract the people of London's Chelsea. John
Singer Sargent brought the project to an end. He wrote:

I must confess to a real antipathy to the idea of artists
erecting monuments to each other the moment they die. It
seems to me to have no meaning at all unless it comes from
the public and after a lapse of years. I also think that
Whistler would have hated the idea. He never was funnier
or more sarcastic than on the subject of the monument to
Rossetti on Cheyne Walk.

Sargent was right. He understood his fellow American better
than most of Whistler's admiring or adverse critics. Sargent's rejec-
tion of Rodin's scheme may be read as an almost silent tribute to
Whistler's memory. Sargent was notoriously inarticulate. When
pleased he danced a jig in his studio; when angry he would roar
unintelligible invectives in a fast-driving hansom cab. He saw
in Rodin's project a fantastic ironic denial of Whistler's art, a
denial of Whistler's contempt for art that told a story. Sargent seems
to have respected the hidden seriousness of Whistler's aesthetic, con-
cealed as it was behind his public display of wit, sadism, bitterness,
and nearly childish levity. Nor was Sargent hypocritical. His way of
painting was so different from that of Whistler's that loudly spoken
praise of his work by Sargent would ring false.

Epilogue

TODAY several questions are pertinent concerning Whistler's art and his career. The first is: where lies the meaning of Whistler's influence? Some would deny that he exerts any influence at all. Is he merely, then, an historical figure of an American expatriate, a minor artist whose work shows less strength than that of a Winslow Homer or that of the patient realist, Thomas Eakins? His influence cannot be defined in terms of strength, nor is it entirely in the field of painting. Its meaning is diffused. It is cultural rather than held within a single art form. It is both literary and aesthetic, both concrete and abstract. Whistler's aims were high; his gifts, even his skills, were limited.

Perhaps it is best to begin at the point where Whistler's art was weakest and most belligerent, for Whistler's rhetoric was scarcely art at all, and in the heat of quarrels, a mere slashing at his critics. Who today can reread his *Gentle Art*? Almost no one. Its rhetoric is florid; it seems far more *affected* in a bad sense than it intended to be. Henry James, who had no love of Whistler, saw that behind the "off-hand, colloquial style, much besprinkled with French—a style which might be familiar if one often encountered anything like it," that Whistler had something of importance to say. That something was related to the general condition of art criticism in English, and here James joined in common cause with Whistler. He continued, "Few people will deny that the development of criticism in our day has become inordinate, disproportionate, and that much of what is written under that exalted name is very idle and superficial." He went still further. "Art is one of the necessities of life." For James to reach this conclusion there is no doubt that Whistler's pamphlet, "Whistler vs Ruskin, Art and Art Critics," Dec. 24, 1878, inspired it.

The serious aspect of Whistler's position was brought to light. To Whistler art was a vocation of the highest order, not a trade. He always regarded payment of his work in pounds a deliberated insult. He demanded the guinea, not the pound.

Whistler in Victorian London was early, if not the first, to perceive the distance between those who regarded art as one of the necessities of life and those of a middleclass society who merely patronized it—or worse, truckled to middleclass standards so as to *sell* works of art. He was less Bohemian than he often seemed. Like Baudelaire he was a "dandy—" but his example was drawn, not from Baudelaire directly, but from Delacroix. He had tried to enroll himself as one of Delacroix's students; Delacroix had rejected him. Yet Whistler's discipleship was retained in symbolic form. Delacroix wore delicately tinted lavender gloves, and later when Whistler's credit permitted that luxury, so did he. These were the lavender gloves that Marcel Proust observed, and as Whistler dropped them, Proust slipped them into his pocket and kept as a souvenir.

Whistler's manifestos, stripped of their personal references and quarrels, were of the artist poised against the mores, the aesthetic standards of middleclass society. He chose to ride above them, not below them. He was not, of course, a landed aristocrat, yet the strange complex of American Southern plantation mores and Scots Puritanism in his family heritage, and his West Point training, produced an aristocratic bearing that sustained his position. It was a position that placed him at the side of the latter-day French Symbolist poets, Laforgue and Corbière—and this without his having read a line of their poems. He memorized Poe, he admired Baudelaire.

It is therefore not surprising that when Ezra Pound arrived in London five years after Whistler's death, he emulated him. Art was as necessary to the young Ezra Pound as it had been to Whistler; for Pound Whistler provided, almost ready-made, an American precedent of behavior in London. Traces of Whistler's aesthetic made their appearances in Pound's early essays and verses, for Whistler's *Ten O'clock Lecture* was a significant turning point beyond art for art's sake toward recognition of art as a necessity for civilized being. Whistler's lecture had released too many arrows in all directions, yet his attacks on vulgarity, the Philistines, and

mediocrity were clearly voiced; all ages were included in his in-
dictment out of which only works of art endured—then came the
famous statement which both Pound and W. B. Yeats assimilated,
"For Art and Joy go together, with bold openness . . . dreading no
exposure." Whistler assumed that his audience was of the élite, and
in this assumption, Pound also found an example for his conduct.

Pound's lines "To Whistler, American," published in 1912, re-
flected his attitude—and with discriminations as sharp as Whistler's:

> You also, our first great,
> Had tried all ways;
> Tested and pried and worked in many fashions,
> And this much gives me heart to play the game.
>
> Here is a part that's slight, and part gone wrong,
> And much of little moment, and some few
> Perfect as Durer!
>
> * * *
>
> You were not always sure, not always set
> To hiding night or tuning "symphonies";
> Had not one style from birth, but tried and pried
> And stretched and tampered with the media.
>
> * * *
>
> Show us there's chance at least of winning through.

From Pound's essay, "Patria Mia" there is the following:

> Whistler left his message almost it would seem by ac-
> cident. It was in substance, that being born an American
> is no excuse for being content with a parochial standard.

And from Pound's *The Spirit of Romance:*

> Art is a joyous thing. Its happiness antedates even
> Whistler; apropos of which I would in all seriousness plead
> for a greater levity, a more befitting levity in our study of
> the arts.

In a literary sense the reaches of Whistler's influence extend into the mid-twentieth century. Since Pound and Yeats continue to be powerful agents of that aspect of Whistler's contribution to the arts this claim rests upon written evidence. One need not exaggerate or underrate it. So far the road is clear of speculation. Even at his weakest, for Whistler as writer falls far below his own standards of ease and brilliance, he has been fortunate in making his appeal to posterity. Had he lived to know the early Pound, he would probably have enjoyed a meeting with him—and afterwards, perhaps, a quarrel.

Beyond Whistler's aesthetic come the mutations of his paintings. His first picture of importance is his *At the Piano* 1858. The picture is a tribute to his association with Courbet. What the youthful Whistler contributed to it and made his own are in the placing of the child's feet, the crisp details of her white dress against the black piano, and the opposing dark mass of the woman facing her, head bent slightly over the keyboard of the piano. The picture has a levity that Courbet lacked; the child's feet, the crispness of her white dress save the picture from falling into static masses. Courbet even then was a far stronger painter than his young American disciple, whom, from time to time, he pointedly ignored. Yet Courbet's static qualities had been observed by Delacroix; these were qualities Whistler had to reject, yet for the moment, he accepted Courbet's realism, shown in *The Burial at Ornans* and *The Studio,* those spectacular paintings, admired by Delacroix and refused by The Exposition Universelle 1855. Since Whistler read almost not at all, he had probably overheard talk of Baudelaire's complete rejection of Courbet's realism and Baudelaire's remark, "No more imagination: therefore no more movement." Baudelaire also spoke of Courbet's "positive solidity" from which Whistler, the pupil, still had something to learn, something to hold him down to earth.

Signs of Courbet's example to Whistler continued through his portraits of Jo, his White Girl symphonies, all excellent of their kind, yet in the full length *Symphony in White. No. I,* Jo looking full-face from her white brocade back drop, Whistler's original genius and his distance from Courbet became clearly defined. In this picture Whistler abandoned both Renaissance and natural perspec-

tives; he had moved as early as 1862 toward two-dimensional design. Was this also a sign of his nearsightedness? That probability is great, but the point is that he had found an aesthetic means of accepting and surmounting a visual handicap—and of relating Oriental design to his painting. His gain was in linear movement; he dropped all signs of "positive solidity"; and with it, the "unabashed indelicacy" to which Baudelaire objected in Courbet. Courbet, great painter as he was, lacked brains, a deficiency which showed in the heavily portentous gestures of his bathing nudes. Whistler "flattened" his perspectives, a hint of which began in *At the Piano* and was extended throughout his studio portraits, most notably in his *Carlyle* and his *Miss Cicely Alexander.*

Toward the same end and away from Courbet's warmth and depth in recreating natural forms (for Courbet's non-intellectual aesthetic was a realistic embrace of nature and almost literal in its definition), Whistler turned to variations in color harmonies. He had also probably heard of Walter Pater's remark, "All art tends toward the condition of music," which gave him the right to speak of line and color harmonies, and later, symphonies, and which were more attractive titles than arrangements, and slightly less abstract.

Still other factors enter Whistler's choice in the mutations of his painting—and one in particular was to damage his professional reputation. Unlike Sargent's his disciplines in training were underdeveloped. Through Sargent's boyhood his art-school training was continuous; not so Whistler's. Whistler never acquired complete facility in drawing. There was a dangerous fragment of truth in du Maurier's charge that he had been an "idle apprentice." The psychological truth was that Whistler, all-too-readily, grew bored. He could not sustain his interest in an object long enough to give his forms internal structure. What amazed the friends he made in Paris was that he produced so much between 1858 and 1878. At his weakest, he sought and achieved the rewards of immediate effectiveness—and yet conceptually his art moved toward perfection in its several styles: "arrangements," "harmonies," "symphonies," "nocturnes." It was in the *actual painting* that Whistler sometimes faltered. Like an impatient child, he would lose his skill, misdraw, and after wasted effort, regain his inspiration. A good example of his success drawn,

almost torn, out of failure, was his portrait of Mrs. Leyland, now shown in the Frick Collection in New York. His critical sense was far too sleepless to give him ease.

In his painting it was easy enough for Whistler to evoke great charm, and in his portraits, to repeat designs. The Carlyle portrait repeats successfully the inspiration that guided his hand in painting *The Portrait of the Artist's Mother*. Had Whistler been content with repeating his successes, his establishment of a profitable career as a portrait painter would have been assured. At the very least a recognized "manner" in painting would have been acceptable to well-paying sitters and patrons. It is possible that his "manner" could have developed into a popular style—this in much the same fashion that he achieved a recognized measure of popularity with his etchings. But second-rate "success" of this order was not Whistler's destiny, nor did it suit his temperament or his conscience as an artist. As Ezra Pound observed, he "tried and pried/And stretched and tampered with the media." His way led through many failures, yet made no compromise with being mediocre.

Perhaps the most obvious of Whistler's failures (on display at The Freer Gallery in Washington, D. C.) are in a series of chalk drawings of the nude. These lightly draped female figures—who seem to have no bodies in the flesh, but dance and trip and seem to flash in air—are intolerably sweet, the work, one might suppose, of a middle-aged dilettante who failed his drawing-classes in night school. In their bad way, they exhibit charm and "taste." And the gravest charge against Whistler could be that he had too much "taste" to be a major artist. Even at best, his work is haunted by a shadow of "good taste" that cloys, that displays the art-collector or the dilettante. A display of too much "taste" in painting can be more destructive than the lack of it. That is one reason why Degas' remark to Whistler, "How tiresome it must be to be a butterfly! It's better to be an old bull like me," struck home. In painting Whistler's hidden danger was in his ability to make a charming picture. This was the other side of his medal that showed his courage, his determination not to bore himself, nor to repeat himself at second-best.

In his drawings of his lightly draped figurines it is as though Whistler's mother's "taste" possessed her son. Perhaps in a few unfortunate intervals it did. It should not be forgotten that little Miss

Alexander of his famous portrait wore a dress designed and stitched by Whistler's mother.

At this point it is appropriate to compare and contrast Whistler's work with that of one of his latter-day contemporaries—Charles Condor. Condor (1868–1909) was a British London-born artist, raised in Australia, who returned to England by way of Rome and Paris in the early 1890's. He grasped the essentials of French Impressionism more quickly and with more success than Whistler, but soon abandoned it in favor of recreating scenes inspired by reading Browning and Balzac. His inspirations taken from literary subjects were more mature, more independent of their literary sources than those of Beardsley. His interests in Oriental design and in his paintings on silk, his designs for women's fans, were points at which the works of Condor and Whistler meet. It is highly probable that Condor would have arrived at an appreciation of Oriental design, even if Whistler had not opened the way for renewed consideration of Oriental art. Yet in this field—particularly in London art circles—Whistler was there before him. One feels that the pastel tones in Condor's water-colors have their source, or at least a precedent, in Whistler's paintings. Condor was no mere imitator of Whistler; he had his own style, his own personality, his own approach to Oriental design.

Condor's sensitivity, his tendencies toward over-refinement in his work ran parallel to Whistler's. The great contrast between them was that Condor was apparently conscious of and knew his limitations. His fans were nearly perfect of their kind, and nearly succeeded in recreating standards of decorative painting that equalled French court painting of the early 18th century. Condor was a minor artist who fully realized and fully employed the resources of his genius. He produced rarities, and was notably unindustrious. Whistler in moving beyond his limitations fell into failures (witness his Peacock Room), yet his successes which include several of his Nocturnes justified his refusal to admit defeat or rather to admit his weaknesses.

Visitors to the restoration of the Peacock Room in The Freer Gallery of Art in Washington, D. C., will see the largest and most curious of Whistler's mementos. Its pendants from the ceiling, its dust-catching pseudo-Oriental shelfs ranged against walls, are at a great distance from the true genius of Whistler's art shown in rooms

where he lived in London's Chelsea. The Peacock Room, even before it was removed from Princes Gate to Washington, was among the most curious of large museum pieces. Even as settings for his paintings *La Princesse du Pays de la Porcelaine, Rose and Silver* and his *Rich and Poor Peacocks* the room fails in its intention—and fails to charm. It has about as much aesthetic value as the interior of a room restored in a Pompeian villa—with the disadvantage of reflecting far less light. Its only value is to commemorate a spectacular incident in Whistler's life. As an evocation of Whistler's personality it is as funereal as an exhibition of General Grant's starched collars and a half-smoked cigar in the room where he died.

Among Whistlerian artefacts the best are to be found neither in chalk drawings nor in details of the Peacock Room, but rather in the drawings of Chinese ceramics in Murray Marks' catalogues. These remains which held no pretensions to being original works of art reflect the lightness, the fine discriminations of Whistler's spirit, and are consistent with the pastel colors and austerities of line in the houses he redecorated in Chelsea, in Lindsey Row and Tite Street. These were environments he had made his own.

His art of decoration has a sustained relationship to eighteenth-century interpretations of Oriental design. It is two-dimensional in effect, and one in which the best of his paintings would look best, permitting only the showing of a single canvas hung on an entire wall. Freer in buying objects of Chinese art demanded of their salesman that he be shown one object at a time. Whistler's work demands the same singular presentation. Because of its two-dimensional qualities a picture by Whistler demands flat pastel tones behind it, and it is not too much to say that his art in decoration held this necessity in mind. In the Peacock Room he not only failed to find a place for his Arrangement in Rose and Silver, but failed to create it. The interiors of the White House in Tite Street were of an order that permitted his genius in design to find a habitation. In a late Victorian London cluttered with effects of warmth, "coziness," and cave-like richness, topped by a revival of Gothic styles in architecture, Whistler's cool interiors established a contrast of austere elegance.

Whistler then set the fashion for Eastern designs emerging from flatly painted walls and floors, a fashion that continued for forty years in Bohemian Chelsea and crossed the Atlantic to New York's

Greenwich Village. One secret of its success in Bohemian quarters was the low cost of reproducing its effects: a few sticks of painted furniture, a flatly painted wall, light streaming through windows, curtained and not draped, presented a gay environment. Clear yellows, blues and grays provided back drops for active linear movements in design. Historically at least he cleared the background for presenting non-objective art. In practice he stressed a tendency in the direction of "studio-painting." His references to nature were of forms of nature held in memory; this practice dominated the painting of his Nocturnes.

Whistler's painting was at opposite poles from the practice of Renoir, and, most notably, Cézanne (what little he saw and knew of Cézanne's painting he cordially hated). His animosity to Cézanne's work was far deeper than surface annoyance at the rise of a new generation beyond his own. Cézanne's treatment of nature was of another world from that which Whistler knew. With Whistler's drift away from the influence of Courbet's realism came his dismissal of painting natural forms by means of direct observation and detailed study. What he *remembered* had become sufficient. And what Whistler remembered was evoked in a way that ran parallel to the aesthetic doctrines of the Symbolist poets. What Whistler presented in his Nocturnes can be too thoughtlessly defined as unschooled impressionism. Yet the word "impressionism" does not explain fully why a Whistler Nocturne retains its character apart from the technics practiced by the French school. Whistler's Nocturnes evoke their individual character by the *associations* they inspire. Of these *The Falling Rocket* is a spectacular example; it is not inevitable that *The Falling Rocket* should represent a scene at Cremorne Gardens; it is an explosion of color against the dark. Cremorne Gardens (since it was a scene of firework festivals) could be *associated* for the moment with a like explosion of gold against black, but the place name is of less importance than the memory of color exploding against the night. The picture then is an "impression" that evokes associations, and is not evolved by seeing it through a veil of atmosphere.

The Falling Rocket which aroused so much controversy in the Whistler-Ruskin trial is the most famous of Whistler's ventures in the direction of non-objective painting. Today it seems relatively

close (closer than any other painting of the late eighteen seventies)
to the work of the American non-objective school. It seems less than
eighty years away from the painting of Jackson Pollock. Nor in the
company of mid-twentieth century painting should one find in
Whistler's two-dimensional perspectives true reason for adverse
criticism. Recent revivals of interest in Oriental art also tend to re-
establish the importance that Whistler credited to it.

By a far Eastern route, and also by closer cultural ties with Eu-
rope, those who appreciate current art in the United States are likely
to find Whistler—at his furthest extremes—less difficult to under-
stand than he was forty years ago. His Venetian etchings—which be-
came the means of his nearest approach to popularity in his own day
—are not likely to find new admirers in ours. They have "dated" more
to their disadvantage than anything Whistler did. To the critical eye
they seem both "fussy" and shallow; they "represent" too much and
say too little. The early London set of etchings are clearer and more
firm in line. The late London and Paris lithographs of Whistler still
possess their charms, but their charms seem to be related to polite
gestures recalling remembered scenes, scenes of his wife in the sick
room, as well as recollections of the Thames on misty evenings.
Through these minor examples of Whistler's art came his strongest
influence upon "artistic" illustration during the early years of the
twentieth century. That influence left its mark upon Joseph Pen-
nell's illustrations for Henry James's *English Hours*, a commissioned
book for which artist and writer wandered through English country-
side and town, jotting down their impressions as they went along.
Pennell's illustrations exhibit the refinements of "good taste" in such
fashion that the results are those of mediocre tastelessness. In book
illustration this kind of art, blurred in its outlines, a misconception
of impressionist technique, soon became a dying art.

It is clear enough that Whistler's diffused influences did not found
a school either in the plastic or the graphic arts. What he left behind
him were a half dozen etchings of scenes along the Thames, one
very extraordinary pastel of Venice (shown at the Freer Gallery in
Washington), and a series of paintings, starting with *At the Piano*
1858, and extending for twenty years. After 1878, the best of his
painting is less frequent and reaches its heights in the portraits of
Rosa Corder, Maud Franklin and Theodore Duret, all painted be-

fore 1890. 1890 opened the decade of his greatest notoriety—but his best work was done. He never recaptured the felicities of the best of his earlier paintings, and their number would not exceed twenty canvases. At the time of his death, his production was at its weakest, yet his notoriety attracted American collectors of art.

For his day he underlined Walter Pater's dictum: "All art constantly aspires towards the condition of music," and we may look no further than Pater's remark to understand why Whistler chose words from a dictionary of musical terms to describe the step he had taken toward non-representational art. There is no evidence that Whistler ever listened at length to musical compositions. His use of musical terms in painting was metaphorical, and brought with it the kind of associations he desired for those who looked at his paintings. In that sense his art was less purely a painter's art than literary. This distinguished his painting from the painting of his French contemporaries, who were far more firmly established in the media they had chosen. At the same time Whistler's distinction placed his work at a distance from the popular British painters of his day, who, from Sir Frederick Leighton of the Royal Academy to G. F. Watts, drew their inspirations from literary sources and became literal illustrators of ideas and stories.

Whistler's work then, even at its best—which admitted no compromise with aesthetic values—exists within a penumbra between poetic sensitivity and plastic art. This was his unique contribution to the art of the latter nineteenth century. And for that reason, tenuous and uncertain as his position seems today, his best work endures.

During the half century that has passed between Whistler's death and the present his fame has undergone several mutations. The most fitting memorial to his name is the Freer Gallery in Washington, D. C. It is appropriate to look at the Whistlers housed in a gallery so largely devoted as it is to Oriental art. The journey through its corridors recalls at a distance the days that Whistler as a child strolled with his mother and his brother William through Charles Cameron's Chinese Room of Catherine's Palace at Tsarsko Selo. The Chinese and the Persian rooms at the Freer have, of course, objects of greater authenticity than whatever Whistler and his mother saw—what they saw was a creation of an Oriental world to delight the senses of an Empress who was once a German Princess. But in its creation it had

also delighted its maker, the clever young Scot, who beneath his cleverness and his learning, had genius, a genius for pleasing the Empress one moment with a dressing-room so artfully designed that it was like a jewelled snuff-box, and the next moment presenting her with a view of the China he had never seen. The precision, the perfection of Cameron's art had no relationship to literal representation of things as they were; the room was a metaphor of China; its actualities existed in the imagination only—it was a world of elegance beyond anything that the Empress Catherine had ever known. Its nuances of color were compliments to the eye of the beholder; they flattered her sense of appreciation, just as they flattered the senses of the puritanical wife of an American engineer and her brilliant, quick-witted boy. They could not have known exactly why they were pleased; there is no proof that Mrs. Whistler knew that the Chinese room had been designed by a Scot, and had she known it there would have been good reason for her pleasure. It was enough for her to share the vision of an ideal China, an ideal world of a farther East beyond the Russia that frightened her, beyond the reach of servants who could not be trusted, beyond a language she could never understand.

Nor had her son ever heard of Cameron, yet he, like Cameron, was possessed by a desire to please, and, first of all, to please his mother—to please her, and then bring her around slowly to his will; the result was often a compromise. It was difficult, even in manhood, for him to circumvent her silences. Without sacrificing his aesthetic, he also wished to please others. If he could not please in one way, then he would try another; if not by a sketch or a drawing or etching or painting, then by verbal wit. Failing these, his desire turned to anger, and became a desire to shock, to amaze. "Amazing" was his favorite adjective—if he could do nothing else, he could surprise; if he did not please, revenge was in order, then insult, blame—until he peopled the outer world around him with all his enemies. His extremes of showmanship were of the same origin, and in his middle years the world through which he moved had its standards for showmanship in the acting of Henry Irving. There was nothing subtle in Irving's acting; there was nothing subtle in Whistler's loud "ha-ha's," in the glitter of his eye glass, in the dressing of his hair. His wit, more often than not, had the thrust of

a poisoned sword through the side of his opponent; it was seldom as light as he wished it to be; the thrust was too urgently pressed. The greater number of Whistler's subtleties went into his painting. Whistler's verbal style—particularly in the footnotes to *The Gentle Art of Making Enemies*—flashed with the lightning of melodrama. Behind the image of the Butterfly was du Maurier's image of the hypnotist, Svengali, in his novel *Trilby*, the man in black, with long curled hair, desperately fighting for his life. The fashionable world of London accepted the image of the Butterfly, but it distrusted the shadow of a Svengali behind it. It preferred bluntness, candor, anything but the faintest suggestion of trickery. And Whistler loved sensation and sleight of hand.

Whistler's worldliness had little or nothing of shrewdness in it; he wore his pretensions on his sleeve, or rather in the cut of his clothes, in the shrill falsetto of his laugh, and in the extravagances of living on credit. The luxuries of living were his all too obvious necessities. The professional artists among his London contemporaries, from the British Millais to the American Sargent, had solid professional training behind equally solid professional accomplishment; they had learned to work serenely, to fetch high prices for their work in an age when art commanded the highest material rewards that England had ever known. In their company Whistler was never the solid man, yet he had pretensions to the rewards that they had earned through professional skill. In their eyes and in the eyes of Victorian London he behaved (a fact that he admitted readily) as though the world owed him a living.

Whistler's optimism which served him so well in youth and during his first twelve years in London had begun to fail him after the Ruskin trial. During the earlier debacle of the Peacock Room, his air of cheerful accomplishment, his belief that unsolved problems would solve themselves, ran close to being a semi-tragic mask of self-deception. He could please neither Leyland nor himself; looking back upon it, the episode has much of the hysteria of noon-day panic. It had all the horror of wrongdoing in the brightest light of day without the shielding darkness of a nightmare. Neither Whistler's gifts nor his actions squared with his hopes. Leyland had to face the worst of Whistler, Whistler the worst of Leyland—and himself.

The experiences immediately preceding the Ruskin trial, the trial

itself, the bankruptcy, turned much of Whistler's optimism to bitterness. His self-confidence, never too secure, was undermined. His conduct during the trial, his urgent use of wit, saved his self-esteem, but the rescue of it was precarious; the trial involved a moral principle—the question whether or not Whistler was a charlatan. Ruskin's charges would have been less serious if the affair of the Peacock Room had been a clear aesthetic victory for Whistler. The general agreement that he was a good etcher held—but the quality of his painting hung in the balance. London patrons did not rush to buy his paintings; he had failed to please by means of his art alone; quickened wit and showmanship saved him from complete disgrace, saved him to the extent of exactly one farthing, no more. Much of his activity thereafter was in the art of showmanship; he became primarily "a talking artist," a writer of letters to *The World*; he became violently amusing at dinner parties; he became a critic of the arts. His *Ten O'clock Lecture* soon brought him an histrionic celebrity. But he feared to be alone. He could not, like his great French contemporary, Cézanne, retire to the country and paint.

Was Whistler "ruined" by the society in which he had to make his way? Did late Victorian London with its highest values placed on material success, on "personalities," hasten the growth of Whistler at his worst and submerge the best? Henry Adams' remark that he had become brutalized is the clearest answer to these questions; any further claim that society had ruined him is a flagrantly sentimental view of his life and character. It was Whistler who said "There never was an artistic period" and there is every reason to believe that he meant it. He had chosen London, not Paris, as the setting for his career; he came from Paris to London because he saw a chance of making a living there, and small hopes of doing so in Paris. Much as he loved Paris, London with its associations of his childhood, the place where his half-sister lived (all her life she believed he was a genius, whispered her belief to friends, even against her husband's opinion) became Whistler's spiritual home. It was also doubtful if Paris could have met with his mother's approval, and her opinion, however mildly expressed, carried weight with him.

To make London accept him on almost any terms was one of the central ambitions of Whistler's life—to conquer the greatest city in the world, to be known as he walked its streets, not as an Englishman,

but as the foreigner he was, became the romantic object of his histrionic art. And at evil moments when the devils of self-criticism made him face the possibilities of failure in his art, his public celebrity consoled him.

The psychiatrist would probably define many phases of Whistler's conduct as the behavior of a paranoid, and there would be some justice in that definition. But it is fortunate that he remained "uncured." Even at best, a "well-adjusted" Whistler in 1900 could not have restored his earlier brilliance—and a subdued, mild Whistler is almost unthinkable.

It is significant that we can readily find analogies in Whistler's paintings in twentieth-century poetry, in Ezra Pound's adaptations from the Chinese, in the glimpses of London shown in T. S. Eliot's poems, in the pages of Wallace Stevens' *Harmonium*. Twenty-five years after Whistler's death, Virginia Woolf, as she wrote of evening walks along the Thames Embankment, described the river and the streets of the city as though she were describing one of Whistler's Nocturnes; she had seen the gray lights of the Thames, the streets of hammered silver. Whistler's power of suggestion in his Nocturnes has an affinity with Symbolist poetry and prose; it is not surprising that Arthur Symons, historian of the Symbolists, admired him.

And what of the famous portraits of the *Artist's Mother* and the *Carlyle?* These were the pictures that gave him wide public recognition. They were, of course, good subjects for public praise; they could be easily understood, for both have psychological and literary content; one sees a resigned old woman, a tired, willful, elegantly dressed old man—one can easily read more into these pictures than what is actually there; one can build fancies around them. Both figures are in profile, both are in the perspective and flat tones of the Japanese print, but his portrait of Miss Cecely Alexander is the better example of Whistler's art. His light touch, so necessary to his work at its best, so evident in the portrait of the child, is absent in the two more famous portraits. *Carlyle* and the *Artist's Mother* are comparatively weighted and static; their design (which is much the same) has less variety and movement than that of the little girl in the white dress. In little Miss Alexander Whistler is the excellent painter of sensibility. One does not ask for a depth of emotion here; one does not ask for a profound reading of human character and its

trials. It is what it is, a child in a white dress, a surprising variation of Whistler's "white girl" theme seen in terms of Japanese design.

Today another aspect of Whistler's quality may be measured by placing his Theodore Duret at the side of a brilliant Sargent; Sargent's professional skill is in evidence and there should be no need of underestimating its value, its faithfulness to the kind of portrait his sitters wished to see. The portrait of Henry James in the British National Gallery is precisely that kind of portrait; it is good; it has lasting qualities; it is a document of considerable value. In saying Sargent gave his sitters what they wished to see, one does not mean that he merely flattered them; he enveloped them in the glittering fashionable atmosphere of the moment in which they lived—that was his art, and he was not a dishonest painter. But Whistler's art was transcendent; at his best he showed an impersonal elegance beyond style and fashion that his men and women aspired to; it is in the lift of Rosa Corder's chin, it is the texture of the pink wrap thrown across Duret's arm; it is in the design of the entire picture; it is what Whistler learned from the Chinese and Japanese; beside it Sargent's portraits look coarsely fibered and slightly less than works of art. Sargent caught the moment and registered it faithfully and well; Whistler moved in the direction of an immortality.

All roads in the best of Whistler's art lead back to the Chinese Room in the Catherine Palace on a summer's day; and Whistler's scenes, night or day, seldom reflect a winter's fall of snow; in little Miss Alexander a butterfly flutters against the gray screen, the heads of daisies lean toward the little girl in white. Whistler chose a single and, perhaps for him, an eternal season. His limitations are clear enough; he never was the greatest painter of his age. His official biographers, the Pennells, overstated the case for him, and as Oscar Wilde remarked of his brother Willy when he heard that Willy would help him in his suit against Queensberry, "such a defense would compromise a steam-engine."

Surely Whistler's affinities to international art can now be looked at with the same eyes that judged the paintings shown in Alfred Stieglitz's gallery, An American Place, or in the Whitney Museum today. By that token his work is less that of an "exile" than it seemed to be forty years ago, and has among its affinities the works of Arthur B. Dove and John Marin. Today when Whistler seems most foreign

he is most American. It was not unseemly, however ironically some of its implications may be interpreted, that in May of 1934 the portrait of Whistler's Mother was reproduced on a United States Postage Stamp.

In the United States tributes to the legend of Whistler have not been neglected. The Whistler House, his birthplace in Lowell, Massachusetts, is a public shrine. At West Point a simple shaft, scarcely more than a tablet, was set up in his memory.

Nor is Whistler's grave in Chiswick cemetery a violation of Whistler's aesthetic. Four semi-neo-classical female figures support the cornices of a marble slab. Their simplicity, their Caryatid-like austerity recall the eighteenth-century details of the Catherine Palace Gardens at Tsarskoe Selo.

Index